LEARNING ABOUT THE WORLD
THROUGH

MODELING

SCULPTURAL IDEAS FOR
SCHOOL AND HOME

LEARNING ABOUT THE WORLD THROUGH

MODELING

SCULPTURAL IDEAS FOR SCHOOL AND HOME

by

Arthur Auer

Illustrations by Elizabeth Auer

Waldorf
PUBLICATIONS

Published by:
 Waldorf Publications
 Research Institute for Waldorf Education
 38 Main Street
 Chatham, NY 12037

Title: LEARNING ABOUT THE WORLD THROUGH MODELING
 SCULPTURAL IDEAS FOR SCHOOL AND HOME

Author: Arthur Auer

Author Assistance: Ruth Riegel-Lamborghini
Supported by The Center for Anthroposophy

Illustrator: Elizabeth Auer

Editor: David Mitchell

Cover: Hallie Wootan

Proofreader: Swain Pratt

ISBN: 978-1-888365-30-6

Curriculum Series

Waldorf Publications is pleased to bring forward this publication as part of its Curriculum Series. The thoughts and ideas represented herein are solely those of the author and do not necessarily represent any implied criteria set by Waldorf Publications. It is our intention to stimulate as much writing and thinking as possible about our curriculum, including diverse views. Please contact us with feedback on this publication as well as requests for future works.

Patrice Maynard
For Waldorf Publications

GRATEFUL ACKNOWLEDGMENTS

The author is indebted to the sculptor Michael Howard for his contribution of "The Transformation of the Five Platonic Solids"; to Mercury Press for allowing inclusion of Dr. Elisabeth Klein's "Modeling as the Expression of the Child's Inner Being," from *Waldorf Schools*, volume I (Ruth Pusch, editor); to Patrick Stolfo for his article on "Sculpture in the Waldorf Curriculum," from *Renewal: A Journal for Waldorf Education*; to Anna-Sophia Gross for use of "The Idea of Metamorphosis in Connection with the Modeling Lessons of the Waldorf School" and to Michael Martin for "Some Thoughts Concerning the Methods in the Formative Lessons," both published in *Educating through Arts and Crafts* (Michael Martin and Martyn Rawson, editors); to the Steiner Waldorf Schools Fellowship of Great Britain for permission to reprint these two chapters as well as for "A Waldorf School Sculpture and Modeling Curriculum" from *The Educational Tasks and Content of the Steiner/Waldorf Curriculum* (Martyn Rawson and Tobias Richter, editors).

Three basic features of clay, its three dimensionality, flexibility, and manipulative qualities, allow children to actually think through the medium . . . Clay facilitates "trying out" ideas, allows for continuous change, and provides children with a sense of freedom of action and choice. Manipulation (is) recognized by most educators and researchers, particularly by Piagetians , as basic to the development of logical thinking and language. Without manipulative activities, children have difficulty or cannot progress to higher levels of thinking.

Sara Smilansky
Israeli researcher

In working with clay one receives new ideas that one did not have before. This means that the forces of imagination have been stimulated to develop. Soft, formless clay can be a willing helper in the process.

Michael Martin
German educator and artist

The curious, exploratory, improvisational interaction of the hand with objects in the real world gives rise to what we call "ideas." Ideas, in fact, are more intimately related in development with the interaction of the body with the world.

It ...seems most likely that (over the course of evolution) the brain elevated the skill of the hand as the hand was writing its burgeoning sensory and motor complexities, and its novel possibilities, into the brain...The brain keeps giving the hand new things to do and new ways of doing what it already knows how to do. In turn, the hand affords the brain new ways of approaching old tasks and the possibility of undertaking and mastering new tasks. That means the brain, for its part, can acquire new ways of representing and defining the world.

In the formative years of each human being, the hands need to recapitulate and play their crucial evolutionary role designing and building significant elements of our neural circuitry and capacities.

Frank Wilson,
Neurologist, Medical Director
Of the Ostwald Health Program,
University of California

The idea is a plastic form.
The movements of our fingers are to a great extent the teachers of the elasticity of our thinking.

Rudolf Steiner
Austrian founder of Waldorf Schools

The density of nerve endings in our fingertips is enormous. Their discrimination is almost as good as that of our eyes. If we do not use our fingers, if in childhood we become "finger-blind," this rich network of nerves is impoverished, which represents a huge loss to the brain and thwarts the individual's all around development. . . If we neglect to develop and train our children's fingers and the creative formbuilding capacity of their hand muscles, then we neglect to develop their understanding of the unity of things; we thwart their aesthetic and creative powers.

Matti Bergstrom
Swedish neurophysiologist

TABLE OF CONTENTS

AN APPEAL TO EDUCATORS AND PARENTS

*Let your children work with their hands
to imbue clay and other sculptural materials with
creative form, beauty, and wisdom!*

The hands-on activity of sculptural modeling works upon the mind and builds the brain through a rich complexity of sense experiences. Overall learning capacities, intellectual abilities, emotional intelligence, and the will to accomplish tasks are enhanced.

This accessible sourcebook has been created for the inexperienced and experienced alike and may be used by teachers and parents everywhere in all kinds of settings, including home and school, whether public, independent, Waldorf, Montessori, or other educational and artistic endeavors.

This manual grew out of an action research project by Arthur Auer for Antioch New England Graduate School in Keene, New Hampshire. He was a Waldorf class teacher for 18 years and is currently a core faculty member in the Antioch Waldorf Teacher Education Program. As a classroom teacher not professionally trained in modeling or the arts, he saw the need for a sourcebook that would aid others in similar situations. The enthusiasm shown by his many students and by his two daughters, Sonya and Sasha, for hands-on, experiential learning also helped inspire him to compose this book.

His thanks go out to them and to his wife, Elizabeth, for her illustrations and tireless support; to David Mitchell of AWSNA Publications for his steadfast encouragement and devoted help; to Michael Howard of Sunbridge College, to Patrick Stolfo of the Hawthorne Valley School, and to Frances Vig of the Chicago Waldorf School for going over the manuscript with a "fine artist's comb"; to the artistic work and publications of Anke-Usche Clausen and Martin Riedel, which inspired the author during his teaching career; to Peter Wolf and Michael Martin of Germany for sharing ideas and experience; to Julie King and Dr. Talu Robertson of Antioch New England Graduate School for guiding him in the graduate research process; and to other colleagues worldwide who have contributed to the production of this sourcebook. May it be useful and used!

The Whole World in a Child's Hands

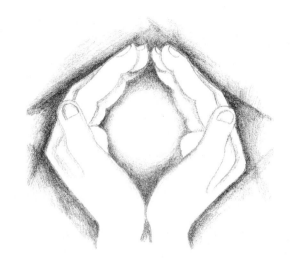

From an early age, children are instinctively drawn to shaping things with their hands, whether it be the wet snow, sand in the box or on the beach, or the mud in the puddle. Fortunate are those youngsters whose parents and teachers intuitively sense the importance of this most basic of human urges and regularly place special materials at their children's disposal.

Grappling with clay or other pliable material is a means of connecting and interacting with reality in a manner that is seldom afforded by any other activity. The child holds a piece of the world that has the special potential to be shaped in an infinite number of forms. Depending on how her hands move, express, or "impress" themselves, the soft material will respond in a all sorts of fascinating ways. Amorphous shapes discovered in the hollow of the hand can turn into a vast array of things on the wings of imagination.

The Intelligent Hand

Modeling becomes a stimulating and ever-changing dialogue between human being and world that allows for all kinds of discovery. It allows a child to form and reform a medium that flexibly and forgivingly lends itself to the exploration of ideas as one proceeds. The hand becomes the teacher of the mind and brain as it investigates and stumbles upon unexpected combinations and configurations of shapes. The eye reaches out to bear active witness and the imagination and intellect may have a result "in mind" for the lump of clay. It is ultimately the intelligent hand that guides the way with intuitive will and sensitivity. Our emancipated hands are essential to our full humanity, free will, and searching spirit.

The Dance of Form in the Hollows of Our Hands

Forms arise, in fact, out of a dance and dialogue between our two different hands moving cooperatively and asymmetrically. The hands discuss and achieve any of the infinite number of configurations possible in the space between them. In their interaction, they help us grasp, shape, and learn about space as well as substance. The space between the hands is indeed a sacred, living one in which worlds are born.

Even the simplest of animal or human figures made by young children can involve elaborate movements. Such motions result in complex topologies and landscapes of form that would challenge analysis by a higher mathematician. The art of modeling creatively simulates the intricate form-making of our environment and gives us access to important aspects of nature's workshop and to the fundamental language of universal forms. Through modeling we learn about the world and about ourselves. It strengthens our powers of observation and mobility in perception and thinking.

Khnum the Molder fashioned the world egg on his potter's wheel. Khnum the Potter shaped human beings and children in their mother's wombs and all flesh. He modeled the gods and the limbs of Osiris.

Egyptian Mythology

Modeling as a Formative Art and Force in Life and Learning

It is remarkable that in shaping a malleable piece of the world, the child is, in fact, taking charge of forming and informing his own being. Her senses, her feelings, her thoughts, and even the intricate cell tissue and neurophysiological web of the brain are affected. Clay becomes a microcosm that, when grasped and molded by a child, allows her to internally process and ultimately grasp the complex forms of a miraculous universe. Our motor skills, especially of our fine muscles, have been found to form our brain and influence the nimbleness of our thinking.

Children, like soft clay itself, are themselves in a formative state and are being molded by their impressions and by their active engagement with their surroundings. Modeling clay and other plastic substances allow them in a self-directed way to participate in a process that is wonderfully analogous to human development.

Molding, modeling, sculpting—whatever we call it—is one of the oldest basic human activities in the world. To do it is to unfold an important aspect of being human. This is true of all of the arts. They empower us with a sense of joy and reverential absorption. They allow us to carry through a process with will, struggle, transformation, and problem solving. We learn how to learn, and we find a universal applicability to all kinds of situations in life.

Head for the Hands with Heart: How to Use this Sourcebook

It may . . . be that the most powerful tactic available to any parent or teacher who hopes to awaken the curiosity of a child, and who seeks to join the child who is ready to learn, is simply to head for the hands.

Frank R. Wilson
Neurologist

Encouragement

Most children, I have found, do not do enough modeling these days, either in the classroom or at home. The most basic thing we as adults can do is to make materials available to them on a regular basis (at least once a week). Parents and teachers need not consider themselves "artistic" to encourage and guide their children or students in modeling activity. Children's hands usually know what to do.

My experience has taught me that every child has a natural artist within. Particularly after the age of ten, this natural artist can fade away if not fed and nurtured in the right way. Grades four–six are the crucial "bridge years" when adults especially need to encourage the efforts and emerging abilities of all children. Without such encouragement, many self-conscious students may artistically "shut down," giving up on modeling and other arts as things "they cannot do" and which are only "for the artists." This attitude can persist into adulthood. Many grown-ups find themselves "stuck" at the nine–ten year-old stage of artistic ability. Nevertheless, adults suddenly confronting such hang-ups can get themselves moving again and rediscover sculptural image-making as an essential and enjoyable aspect of human activity. In many an adult there is an artist suppressed or lying dormant.

Artistic expression is a part of our basic nature. In our highly intellectual and specialized modern society, which classifies only a certain segment of the population as "artists," natural, artistic expression is all too readily squashed. Art, or *Kunst*, as the Germans call it, is a word that derives from the root meaning "can" or "to be able" (können). My personal translation of its original meaning would freely render it as

Art = You *can do* it!

Part One of this Sourcebook is therefore dedicated to *Doing*. Part Two will be devoted to further *Pondering*, or exploring the value and significance of modeling in education and human life, and to resources for furthering our understanding of this artistic activity.

Whatever you can do beyond placing materials in children's hands will be a real boon to their efforts. As you yourself gain experience, your contributions to the children's efforts will increase. This book is meant for both the inexperienced and the experienced. For the inexperienced, it can start you on your way as teacher or parental guide. It is meant as a creative stimulus, a collection of inspirational starter or "seed" ideas and suggestions. It is not meant to be used as a rigid recipe book. Its aim is to help you bring yourself to the point of creating your own exercises. Creative modeling can result in a deep inner satisfaction and peace.

Developing the Eight Series

To begin, I have chosen to characterize a preliminary and preparatory set of generally applicable hand-gesture and hand-form exercises. Following are eight series of typical ideas and themes I have used, which have worked for me as a teacher during the particular stages of my students' growth. (Waldorf teachers ideally accompany the same group of children up through grade eight.) As seasoning, I have also sprinkled in some exercises for the various ages that I have derived from other teachers and sources.

Series One contains exercises that I found valuable and appropriate for students in grade one, Series Two for grade two, and so on through Series Eight for eighth graders. The exercises can be used in the developmental order I have established or can be selected according to your instinct for what your children need. You are free to pick, choose, modify, or design your own exercises depending on your curriculum in school or your family ideas. Many a theme can be adapted to more than one age level and degree of sophistication. The house-building theme, for example, which I describe as developmentally optimal as a third grade experience, can be used at many ages. Although the eight series focus on experiences below the secondary level, houses and human and animal figures are universal forms that can be taken up in all kinds of ways each year up through high school and beyond.

Ultimately, I would like to encourage you to develop your own sense for what is most valuable and appropriate in the lives of your children. For parents, it is always wonderful when you can find time to sit down and model side by side with your child. Explore, gain experience, and have fun learning from each other! The exercises in the First through Fourth Series are most readily adaptable to home use. Those in the Fifth through Eight tend to be more specialized and oriented to a school or homeschool curriculum.

For teachers, I recommend that you experiment and practice with the exercises as part of your preparation before the lesson. Then demonstrate the creation of a particular form in front of the class. You may show the students the whole exercise or just a part to get them started. Once your students are modeling regularly, you can decide how much of an exercise should be demonstrated before they start. Occasionally give only verbal descriptions or instructions and let them work out much for themselves. There are a variety of ways of guiding projects from the imitative to individual choice, and a whole range of variations in between.

When we form something through artistic activity, we are formed and changed in the process, and that spurs the developmental process.

Henry Schaefer-Simmern
Psychologist and therapist

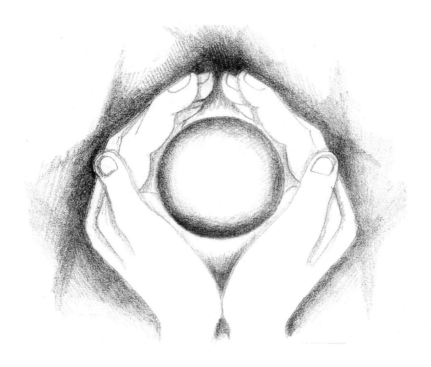

DOING

Only through the dawn gates of beauty
canst thou pass into the realms of knowledge.

Friedrich Schiller
Poet

In Touch with Our Hands

The dignity of the human being
Is given into your hands.
It can sink with you.
With you it can rise nobly upright.

Friedrich Schiller

Before you plunge into the specific themes of the eight series, take a moment to appreciate your hands. Hold them up, move them in various positions in relation to each other. Observe how the fingers can gracefully form arcs of movement, create different kinds of space in between (straight, curved, etc.). Have hands, palms, and fingertips touch and embrace in all sorts of ways. Can you experience the asymmetry of their strength and the dominance of one hand? Our hands can be quite playful and have been called a metaphor for our humanness. Observe the hands and hand movements of others. As a preparation before working with children, adults should reacquaint themselves with the miracle of their own hands.

Hand Gestures

Children love imaginative hand gestures, finger plays, and games with rhymes. Our hands can talk to each other. Discover all kinds of hand conversations and do them with children.

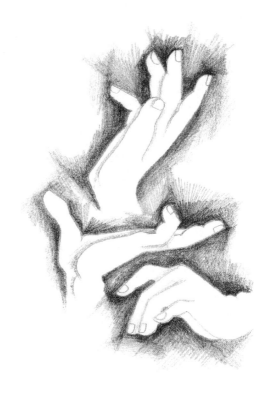

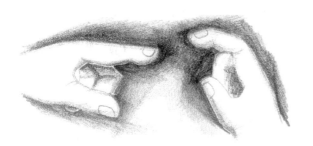

• Our opposing thumbs and fingers easily become very chatty mouths that can have lively face-to-face, hand-to-hand conversations. (When we take a pencil in our hand, it becomes a writing-speaking tongue.) Or stick up some fingers as ears, and animals start talking!

Try some of the following gestures with your children, and then invent your own.

Basic hand expansion and contraction (fist):

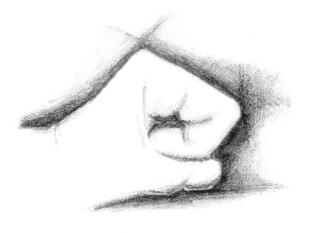

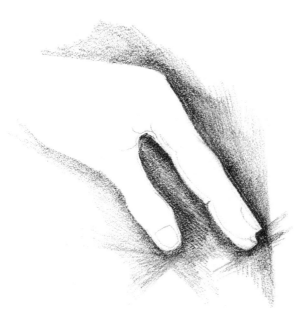

• curling up tight (snail in her house/ rounded head). The hand forms a living spiral!

Shadows cast by such creatures have traditionally delighted the imagination. Finger games are a related activity as is the whole realm of hand puppetry in which materials "costume" the hand in its movements.

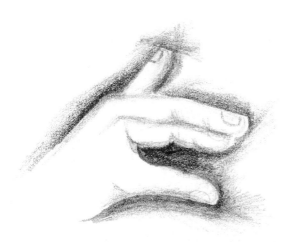

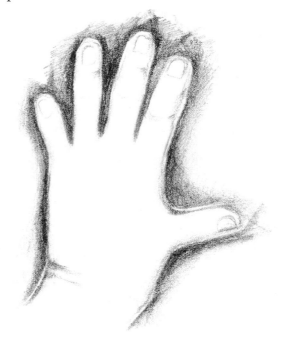

• opening, shining, and raying outwards (sun/radiant limbs).

15

Dialogue of two hands creating hand space.

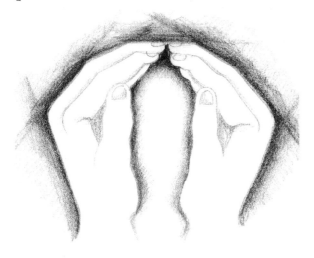

• hugging

• curving (halfway in-between—feeling space)

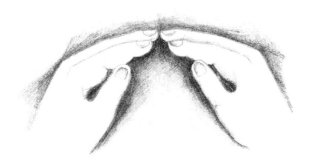

• arching over (rainbow)

• receiving/holding

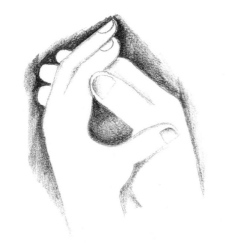

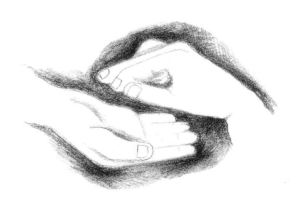

• greeting/embracing

• giving and receiving/taking (active and passive)

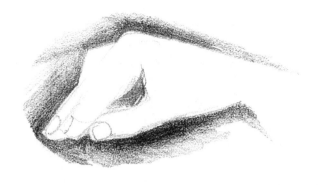

• covering/protecting

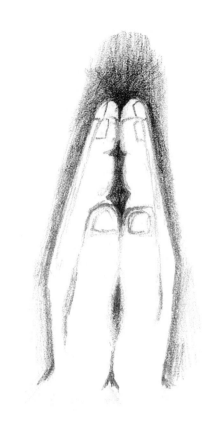

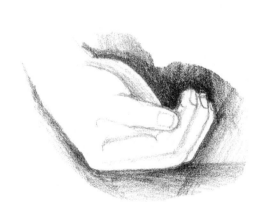

• joining/praying (1)

• treasuring/sensing/thinking

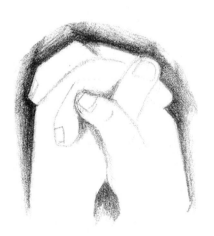

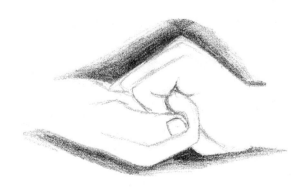

• fitting together (doing same together)

• joining/praying (2)

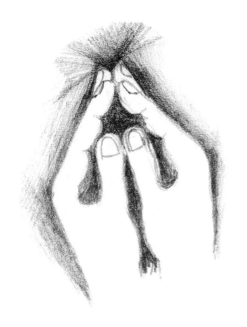

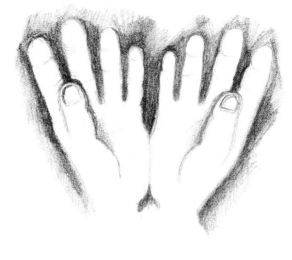

• into blossoming

• unfolding from a bud

• flying (wings of bird, butterfly 1)

• sprouting (winding vine or stem)

• flying (wings of bird, butterfly 2)

Single hands create movement forms:

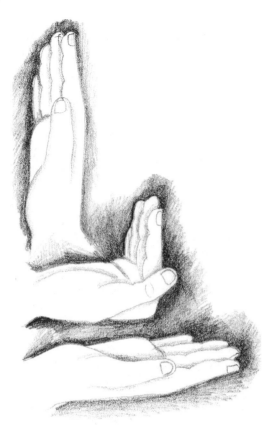

• lying or sleeping to awakening/standing upright

• bowing in reverence

Others to try:
- cower and tremble in fear
- crawl (turtle)
- run
- gallop
- slither
- creep/sneak along/ stalk (cat)
- jump/hop
- snap at, sniff/peck

Hand-Action Figure Stories

Enjoy the pure action of the hand gestures. As you make them, imagine a being or creature that goes with that characteristic movement. Children (ages four–eight) love grown-ups to invent and orally tell stories in conjunction with hand movements. They will then create their own tales out of their strong powers of fantasy and will move their own hands accordingly. Some hand configurations show specific forms that can then act.

Hands form more figurative shapes:

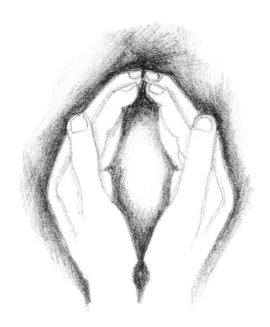

• opening the doors of my steep-roofed house

Work these out for yourself:
- open the door and see all the people
- scurrying rabbit or squirrel (two fingers /ears stick up)
- shell (listen to hole)
- hanging drop of water
- cutting scissors

Hand stories/dramas :
- talking mouths
- one hand bows / cowers before other upright (king)

- actions between tortoise and hare

Handshakes: Notice how people shake your hand and how your hands come together in terms of gesture, form, space, time, and warmth. It is a special and valuable individual recognition every morning when teachers look their students in the eye and shake their hands.

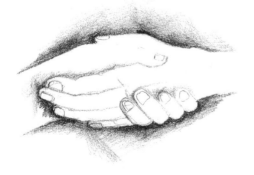

Words Translated into Hand Actions

Children may discover many of the foregoing hand configurations by themselves. Say words to them that they can turn into gestures using only the hands (not arms): curling, raying, shining, rainbow, hugging, giving, receiving, bud, blossom, sprout, fly, standing, sitting, lying, and so forth.

Language and Hand Gesture

You may have noticed in the preceding exercises that you were learning and speaking a universal language. Gesturing with the hands and speaking are neurologically related and have developed together intimately in human evolution. Certain cultures use more hand movements than others in accompanying the spoken word as outward expressions of feeling and emphasis. In foreign countries people who do not know each other's language often resort to universal gestures to communicate. Some Native American tribes, it is said, cut across linguistic barriers with a universally understood language of the hands. In modern times, signing was developed for the hearing and voice impaired. Working with hand gestures develops the speech and articulation of children.

Roundness and Hollowness: Convex and Concave

Our miraculous hands create changing forms of space in, between, and around themselves. They are "space-grasping organs" that shape space and matter. In their living spaces substance finds its form because our hands themselves are a manifestation of the creative forces active around us. Inherent in the hand is the entirety of the world's fundamental forms. The five-fold form of its fingers is reflected in the

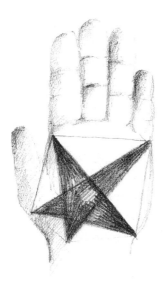

five-fold pentagon of the palm (see diagram above). Another pentagon is created by the four sections of bent arms (with hands folded) extending from the chest as fifth side. Our cupped or folded hands naturally come together in front of the sternum and heart region to create a "heart form" or bowl-like space of activity of their own. Hands and heart are both organs of feeling and sensitivity, motion and emotion.

Like the rest of our body, the hand is not formed out of flat surfaces. Its structure embodies the two elemental and dynamic kinds of curved surfaces—convex and concave. The back of the hand curves out convexly into the world, while the other, "inner, more sensitive" palm and inwardly bending fingers tend to concavely form a hollow, a cup, a "cave." Convexity bulges outward, full of life like a bursting bud. Concavity is more receptive, creating an inner world of consciousness and feeling. Our curved palms and the inside tips of our fingers are two of the most sensitive parts of our body. A closed fist emphasizes the convexity of a sphere, but we know that there is a hidden

world within. Our fingers curl inward like a water spiral or wave enveloping a warm pocket of air.

Both convex and concave are combined to create a multiform hand and world. One of the most intriguing forms happens when a curve unites both elements into a doubly curved surface that incorporates convex and concave. Look at the saddle-like curvature between two knuckles. See the concave curve down and up from knuckle peak to peak. Notice that perpendicular to this is a convex curvature traveling down between and in the direction of the fingers. The two kinds of curves blend and intersect. The human body and many other forms of life are full of these doubly curved surfaces.

Besides the polarity of concave and convex, there is another fundamental surface: the flat or straight that possesses a static quality in comparison to the curves. Together these three kinds of surfaces generate a myriad of other qualities of form such as angular, pointed, sharp, contracted, expanded, balanced, symmetrical, heavy, light, living, dead, and so on. Modeling helps us concretely explore the rich constellation of possible and imaginable forms.

When I hear my heart beat, I perceive the life force streaming into my body. When I stretch my right hand out, I know that I am a free human being; through the stretching of its muscles flows freedom.

The left hand, which moves and grasps more gently, brings what human beings make into beauty.

Matisse

Hand Movements in Space and Material

When modeling a piece of clay, our concave palms produce and experience convex, arched forms. Our hands press in and expand upon these shapes. The muscular arched balls of our hands and fingertips create hollowed, concave form that retreat, receptive to our touch. The bony structure of the hand itself contains all kinds of angular forms that also affect the clay.

Streaming into this miraculous hand anatomy, bringing about movement, is our life energy, blood, warmth, and will. Lifelike plastic forms arise as a result of the reciprocal interplay of polar forces in our hand movements. Surfaces are created through careful and sensitive application of pressure and counter-pressure. The hand gently and patiently "massages" the material through a series of gradual changes and metamorphoses. At a certain stage, the decision is made to stop. What has emerged as a "final" product is actually only one of many possible forms in a process that could have continued.

A Basic Exercise: Discovering Hand Space Forms and Imaginatively Transforming Them (grades one–five and up)

Now that you have become more conscious of the moving language and expressive image- and space-making possibilities of your sensitive hands, you are ready to have them leave traces of their rich activity on a piece of the world's substance.

• Take a piece of soft, malleable material (clay, wax, plasticine, dough, or the like) that fits comfortably in the hollow of your hand (about walnut-sized on average: adjust size depending on age and individual). Close the fingers of the same hand around it and gently let them press its mass against your palm. A form with surfaces will thus be created in the hollow of your grasping, gripping hand. This is called an interior hand-space form. Remove the piece carefully and look at it. It is both an image of the inside configuration of your hand space and a record of the end stage of your movements that formed it. Repeat this exercise with the other hand.

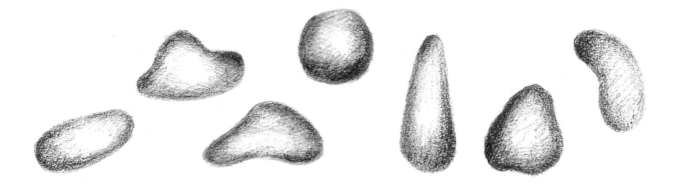

• Create other basic shapes by subtly moving each single hand around and changing the inside space and form of the substance. Notice how the cup of your hand naturally tends toward rounded and spherical forms, the ball being the most archetypal.

• Stop here, if you want. You need not turn your pure forms into any representations of things in the world. Or continue on to the next choices, using two hands:

(1) With two hands, continue to develop as a pure form the simple form you discovered in one hand. Stop here, if you want.

(2) Look at your basic, pure form. What does it want to be? Let your imagination guide you into forming it with two hands into a simple human, animal, or other form of nature.

• Basic forms may also be discovered by employing two hands from the very beginning. They may remain pure or be developed into representational figures. Use a bigger piece of clay or other material that fits comfortably in the spherical space created by your two facing, cupped hands.

This basic exercise will be developed further and is recommended particularly for children in grades one through five.

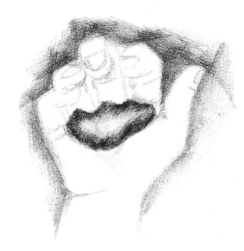

Single Hand Space
• Create a variety of simple shapes in one hand by moving the material around considerably, but only with that one hand—convex: rounded, elongated, oval; concave: hollows.
• Bring each piece out to your fingertips, sense its shape, move it about, and form it further.
• Bring each piece back into the hollow of your hand for grasping and forming, and then out again to the periphery for sensing and further shaping.
• Repeat the above in the other hand.

Simultaneous Forming in Two Separate Hand Spaces (age ten and up)
• Using the same process as above, in both hands at once, work a piece of material into any one of the basic forms described above. Make sure pieces fit the hollows of each hand and are not too heavy or too light.

Forming One Piece in the Shared Space of the Two Hands Working Together
• Take the two separate pieces of the exercise above and form them into one piece.
• Repeat the basic forms listed above, but this time having both hands shape one piece. Enjoy the marvel of right and left hands moving cooperatively around the same space, form and substance.

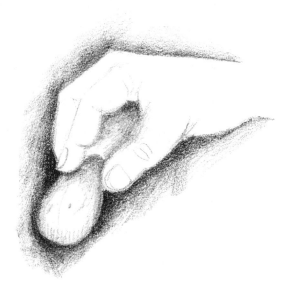

Hand and Finger Dexterity Exercise with Elongated Shapes

• In the hollow of each hand create elongated shapes using the same process as above.

• Practice holding their narrow ends with your fingertips.

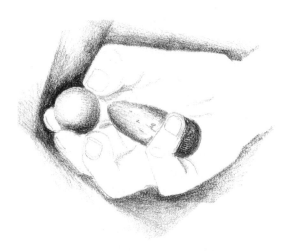

Two-Sided Double Dexterity Challenge (age ten and up)

• Save the two elongated pieces you made earlier and lay them aside for the moment.

• In a similar manner, make two small spheres that can be grasped by the finger tips.

• Now take back into one hand one of the elongated pieces and move both shapes back and forth around the hand space between the center hollow and fingertips. Next, do the same with the other hand so you are moving two pieces around in each hand. Keep feeling, forming, and practicing daring finger and hand nimbleness!

Regularly Practicing Dexterity

The foregoing hand-space and dexterity exercises are good for adults and for any age seven years and up. They can be imaginatively adapted for grades one through three using beeswax, plasticine, or small pieces of clay that are not too wet and cold. They can be revisited and recreated periodically in more sophisticated formats with older students. Gesture, hand-space and dexterity exercises can be done productively as a prelude, interlude, or quick warm-up to any modeling lesson or activity. Adults can do these as preparation for working with children in modeling.

Form Modeling: Learning the Language of Fundamental Forms

Playfully discovering pure forms in the hollow of the hand is a wonderful process and experience in itself. Children need not always develop these shapes further into representations or copy things from the world. They benefit immensely from learning to read a whole new language of fundamental forms arising out of roundness, flatness, concavity, pointedness, etc. There are infinite possibilities.

Such form modeling explorations exercised regularly can be very valuable and formative, especially for children in the earliest grades. They are encouraged to "slip into" the forms and experience them directly and vividly. Exercises of this kind are the sculptural counterpart to fundamental

artistic exercises in form drawing and painting. Just as one can come to know the language of colors in basic exercises by painting combinations of color patches purely out of the color, so can one learn to model or draw purely out of form itself, out of a "vocabulary" of archetypal form tendencies. Work with pure forms can continue right up through high school. Further development of them will be interspersed within many of the eight series.

Representation

Having renewed your relationship to your hands and practiced and explored manipulating various simple forms, you will now take a more formal step: making something specific. This exercise is derived from the Basic Exercise (p. 22) and starts with the sphere, one of the most archetypal forms that can originate in the hollow of the hand.

Out of the Hollow of a Single Hand Arises the Sphere, the Egg, and the Basic Human Form (Head, Trunk, Limbs)

The sphere is the form that most naturally fits in the space created between the two cupped hands or in the single cupped hand. A ritual of first forming a smooth ball can be an artistic way of taking hold of and conditioning a rough piece of new material.

A sphere also has great meaning as the most universal of forms. It is associated with beginnings, origins, inception, and conception. It lends itself to all kinds of organic formations and progressions, of which the most basic is the egg shape. In its oval cousin, the sphere in a manner of speaking is making a first basic gesture and stretching out toward the world. It is an excellent beginning for organically creating both human and animal forms.

• With one hand, make a small ball that fits in the hand nicely (walnut-sized).
• Work the ball into an egg shape, using only one hand.
• Still with one hand, grasp the oval shape firmly, with the narrow pointed end peeking out between the round hole created by your thumb and index finger. Gradually squeeze the end of the egg so that a head with a neck emerges.
• Now, with two hands, elongate the body, flatten its base, and stand it up .

Notice how this simple, two-part, upright figure already suggests humanness!

• Continue with two hands and shape suggestions of arms attached to the body, but no legs as yet.
• With this figure as a foundation, simple features can be added in later exercises.

Head, trunk, and simply indicated limbs are all that is needed to magically conjure up the archetypal human form. Children often instinctively know how to shape such simple figures. The process delineated above is a wonderful way to have children, especially in grades one through five, bring forth human forms out of the hollow of a single hand and an organic sequence of sphere and egg.

Who is Hiding in There?

In this wondrous process, one can speak to younger children of the form sleeping, or crouching, or hiding in the wax or clay. We help it wake up and come out. We find it. Even older children and adolescents can appreciate Michelangelo's statement that the being to be shaped was already in the fullness of the marble.

Forming the Human Figure—Smaller Format Starting in the Hollow of One Hand (ages seven to eleven)

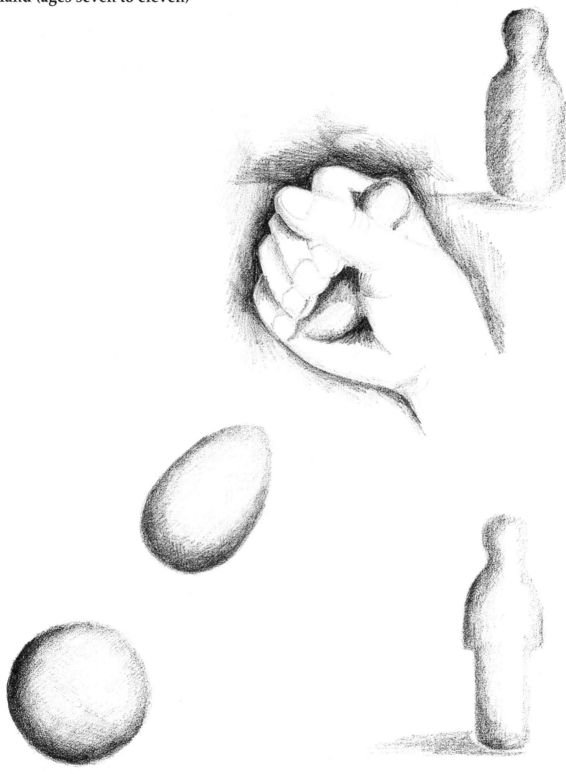

A Larger New World Between Both Hands

The greater hollow created between both hands is an exponentially richer space than the smaller bowl of a single hand. It contains all kinds of new possibilities for movement, relationship, and form. The two sides of your being come together to cooperate. Notice how bringing your two cupped hands together naturally forms a spherical space within, ready for making a ball of clay.

• Form a larger ball of clay or other modeling material that fits the space created when your two hands are cupped and just touching each other. Press it gently but firmly into shape with the palms and fingers of your two hands.

• Refine its surface and curvature with the sensing "eyes" of your fingertips. Shut your "head eyes" and let your "finger eyes" see and touch its wonderful roundness and ever-increasing smoothness. You might want to go on perfecting it forever, but you need to develop it further in the next exercise.

To feel a sphere in space is to feel one's Selfhood, the Ego.

Rudolf Steiner

Forming the Human Figure as a Living Wholeness—Larger Format

• Without breaking apart the large sphere you created above, elongate it into an egg shape.
• Embrace the pointed upper part of the oval with your thumb and index finger and gently and slowly start pressing in a neck and separating and forming a head.
• Similarly, press into the sides slowly to sketch out arms attached to the sides.

• Legs need not be overly differentiated. Keeping them together allows the figure to stand.
• Features can be added according to theme and desire.

The form should arise and metamorphose naturally and organically through gradual stages of differentiation. The key is always to proceed patiently from the general form and gesture to specific details without rushing toward the latter.

Keep the smooth surface or "skin" of your piece intact and unbroken. The amount and volume of your whole lump should remain the same as it is shaped. Go back and forth between emerging areas rather than defining or refining any aspect too quickly. Gently coax the form out. There is no need to aggressively pinch or pull out parts. Limbs can initially remain relatively unarticulated. Arms may stay attached or be only suggested. Legs may stay bonded together or hidden in an undifferentiated drapery. (Later, in junior high school, clay arms can protrude more and legs emerge in a stance. With plasticine or beeswax, younger children naturally make limbs sticking out.)

• Manipulate your piece up in the air in your hands in front of your heart (sternum) so that you fully embrace its changes and impressions. Your arms and elbows should be comfortable at your sides. (The foregoing process is valuable for the creation of most light pieces, especially ones derived from nature or pure form. Additive and constructive methods will be discussed later.)

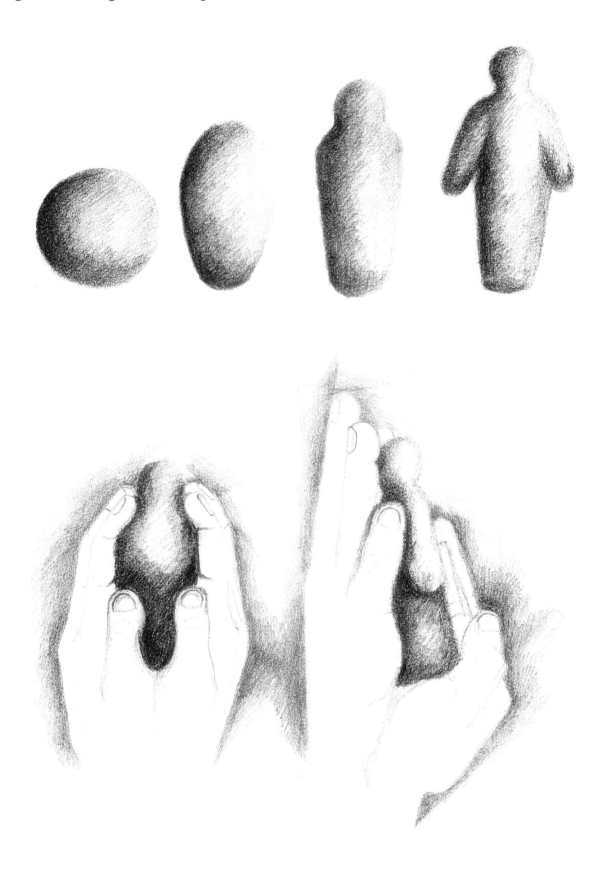

Notice how you tend to hold the figure as you work with it. Cradling the recumbent trunk and limbs in the hollow of one hand, you shape the head in the hollow of the other. The different postures of the human form are in your hands. Their positions can be done as pure hand gestures, showing them lying, sitting up, standing, bending, kneeling, crouching (see Fourth Series).

Notice the earliest point at which your figure starts to look human! You may leave what you started as a sketch, as a piece that leaves more to the imagination. Sketches can sometimes surprise us with the charm of their basic gesture and are sometimes more powerful and artistic than those with completed or realistic detailing. Each attempt can be a learning experience and revelation of some variation. Experiment with many sketches and do not worry about creating naturalistic masterpieces or reproductions. Do not let your overweening intellect tyrannize your heart's desire for playfulness. Enjoy whatever comes! You may choose to bring more detail into your piece. Generally, putting in more time results in more refinement and perfection, although failing to stop at the right moment can sometimes result in overdoing or ruining a piece. You can produce a five minute figure, or more complete pieces in thirty minutes, one or two hours, or more. It might

happen that you discover your five-minute piece had more charm and expression than the one that took two hours! Naturalism does not necessarily improve a piece.

Forming Animals in the Hollow of a Single Hand—Small Format

- Make a small ball that fits in one hand.
- Work it into an oval shape.
- In one hand grasp the egg shape firmly with the narrow pointed end peeking out through the round hole created by your thumb and index finger. Gradually squeeze the end of the egg so that a head emerges with a neck, but this time press the lower part of your thumb in more deeply to create the chest and front of a primitive shape. This I call the archetypal animal. Place it beside the basic human figure to contrast its horizontal orientation to the upright one.
- With this figure as a foundation, the characteristic forms and features of many different animals can be added in later exercises. The process described above is an imaginative way to have children, especially in grades one through five, bring forth animal forms out of the hollow of the hand through an organic sequence of sphere and egg.

Animals in Small Format (ages seven–eleven)

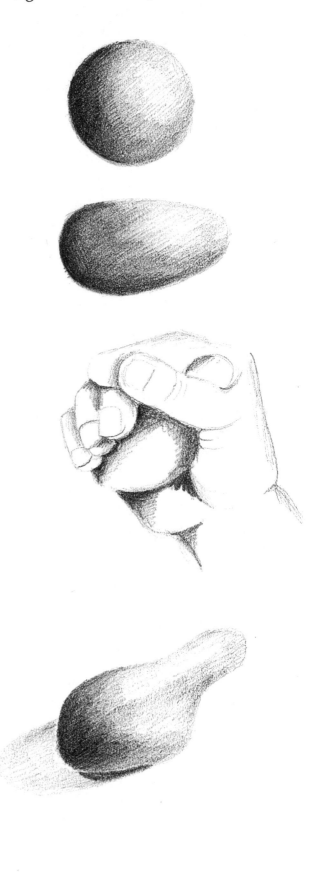

Archetypal Animal Gestures

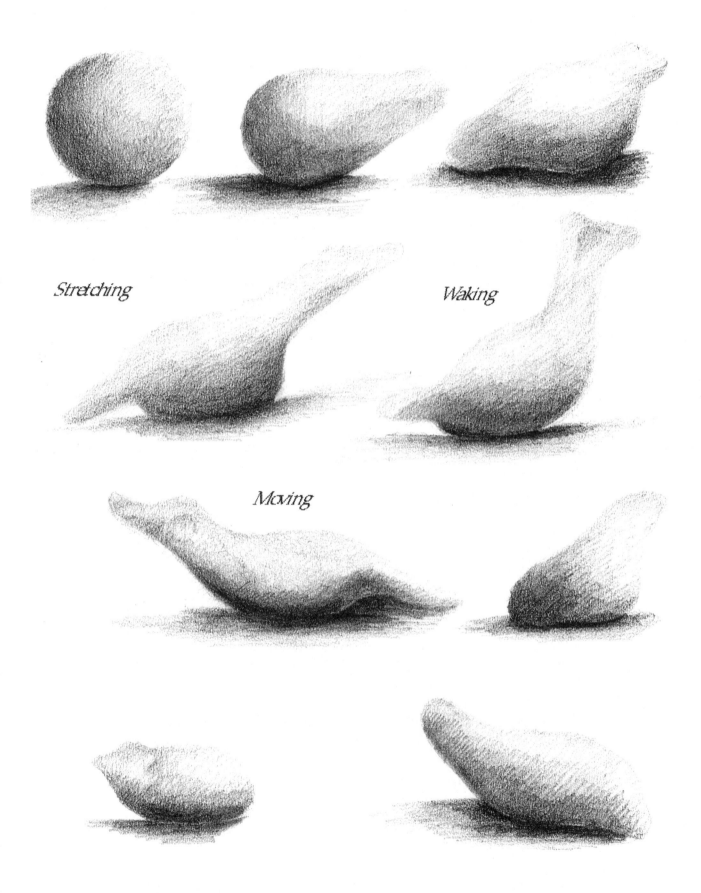

Stretching

Waking

Moving

Larger-Format Animals

The hands and strength of adults and children ten years and older increasingly can accommodate larger pieces of clay and other materials. (Fourth and fifth graders can use an alternation of small and large formats.)

• Start with a large ball of clay and, without breaking it apart, elongate it into an oval shape.
• Grasp the pointed part of the oval between your thumb and index finger and gently and slowly start pressing in a neck, separating out and forming a head.
• At the same time, have the lower part of your thumb and your palm press in deeply to create the chest and front section of an archetypal animal.

The shapes and gestures of particular creatures will be reflected in the positioning and gesture of our own hands. Discover a myriad of animal shapes in the infinite space of your hands! Find the squirrel in the nest of your hands, for example. Features such as large bushy tails are an exciting creative challenge to discover.

Capturing Living Gesture

At what point does a form first start to look like an animal in general and then like a particular species? Does it stretch out toward its surroundings? Does it lift part of itself up in alertness? Does it turn and move? Children are masters at sensing the wonder and power of emerging gestures that excite and strengthen their imagination. We adults can all learn from their open and lively intelligence. Above all, children love to perceive dynamic and characteristic gestures rather than static and fixed representations of outer form. They want to model the slippery sliding of the sleek otter and the playful pawing of the kitten. They love

the verb mode of reality rather than nouns or things.

Adults can help nourish this impulse by emphasizing the active, living qualities of nature and of the human being. The real joy and enhancement of life through modeling lies in the feeling of making, moving, and capturing a living gesture that emerges from the inner essence the subject. This feeling can sculpturally make its lively mark on a substance and be perceived as an authentic living expression, rather than a dull reproduction or copying of outer form. Figures should always be renderings, not copies. Allow children to become one with the exciting forces of the form itself. If they can become thus absorbed, they will feel a deep inner satisfaction and appreciate forms in their environment much more.

I liked to feel the clay in my hands and to make the body (of the squirrel) and to pull the head and ears and tail out of the body.

A third grader

Embodying Living Metamorphosis

Modeling can be thought of as a living process of movement that is frozen in its last stage of metamorphosis (unless, of course one models each stage and preserves it in a series). The fixed form is a final impression and memory of the innumerable transitions of form that have preceded it.

Natural forms often start off as simple seeds that differentiate slowly into parts. Analogously, the modeling process begins with an amorphous lump that is patiently articulated and refined.

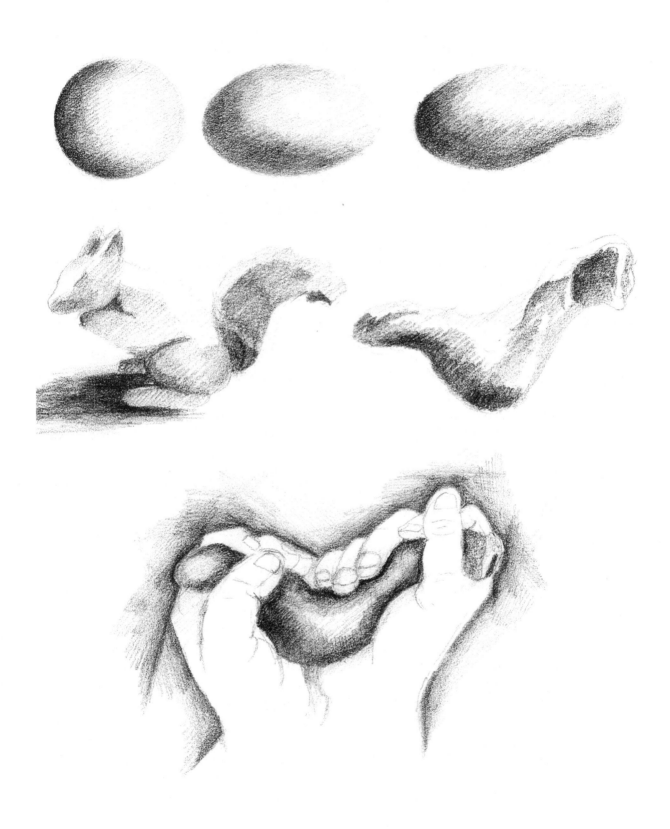

Organic Sculptural Process in Contrast to Construction

Whenever possible in modeling, try to have the process organically related and analogous to the subject and natural process of formation. For example, a bird can emerge from an egg form with its pecking beak first. With plants, have them branch upwards. With humans, heads can be developed first, with the trunk differentiating downwards and branching into limbs. With animals, the trunk can often stand out as the defining feature that is shaped first.

In such an organic process, the whole stays together and is slowly differentiated into special parts and features. One may at times choose to specially shape out and attach certain details as separate elements. Examples are horns or very long tails on animals. Most of the time, however, such elements can be configured out of the whole lump of material.

In contrast, making certain subjects such as a bridge out of clay may involve more of what I would call a construction process. In this, separate components are manufactured, stuck together and smoothed into a unified entity. Elements and material are added, subtracted, or dramatically shifted around to produce a figure. (Sculpture also has its own versions of the subtractive and additive modes in carving and building up figures out of small bits of clay or plaster.)

Modeling can broadly entail a combination of both sculptural and constructive approaches depending on the subject. The supports and road bed of a bridge, for example, may be formed sculpturally out of a whole lump of clay without adding to it or picking it apart. Railings and other smaller details can be made separately from different material and installed as a later step.

In general, however, in working with children, I have found it most satisfying to aim at shaping and differentiating most figures out of a single piece of material, preferably with no attachments. (I have found that pieces that are tacked on often crack more easily, separate, and drop off!) In this book, I refer to a cohesive process of modeling out of a whole piece as "sculptural modeling" in contrast to the constructive approach.

Sculptural Modeling as Forming "Plastically"

The word "modeling" is limited in that it can imply copying from a "model," rather than the freer exploration of forms I am recommending. A better word for the activity would be "plasticizing," meaning "forming plastically." The Greek root *"plassein"* means to "mold or form. Plasticity is the ability to have changes of form. Modern industry, however, has effectively appropriated the word "plastic," a term that is used elsewhere in art circles in a specialized sense for statuary.

Learning from Children as Architects and Sculptors

The seemingly unfinished and amorphous quality of children's modeling possesses a suggestive charm and magic that is hard to describe or to duplicate. Grown-ups may do well to simply rejoice in and learn from the lively expressions that emerge, and not pressure youngsters into making masterpieces that are too detailed and realistic. An artistic aim of modeling at any stage is not to make exact copies of natural objects, but to more freely render aspects of their essential gesture and form, thus heightening our awareness of the world and ourselves. In fact, models that are too naturalistic and overdeveloped in detail often come across as dead, leaving nothing to the imagination.

skills, perception, observation, and inner imagination, all qualities that go hand in hand with the healthy growth of the brain and overall intelligence during this period.

With guidance, children ages seven to nine can gradually evolve and discover the abilities to meet their need for more sophistication in rendering subjects sculpturally. And they can do so without losing the vitality of their early work. Teachers in grades one to three can help their students gradually make the transition from an inclination to stick pieces together to "whole piece" sculptural modeling.

Gradually, children will move beyond their younger phase as they learn more advanced methods. As students become increasingly self-conscious from the age of nine to twelve, they need to have as positive an experience of modeling and art as possible and be surrounded by the right attitudes. If, however, they mistakenly think they are supposed to achieve scientific realism in their work, they can all too easily become dissatisfied and frustrated with their results, no matter how beautiful, charming, and age-appropriate.

Interestingly, children in preschool and the early grades at first often tend to model by sticking pieces of material together. Then, imaginatively and symbolically, they see the most remarkable beings in their creations. The young child has within her a bit of the architect, and she loves to build up things like houses. These constructions can have static and convex quality. Combinations of soft beeswax lend themselves very suitably to this early stage of "assembly" activity.

Over the course of the early grades, children's senses gradually wake up to their surroundings, and, at the same time, to the world of pure geometric forms. More gesture and concave features appear in their modeling as they correspondingly develop sensitivity and an inner personal world. They increasingly need their artistic creations to look more realistic particularly after the age of nine. They become ready and eager to unfold new form-making capacities that enable them to render the essence of things more accurately and to capture movements and gesture. This new step calls upon them to develop greater fine-motor

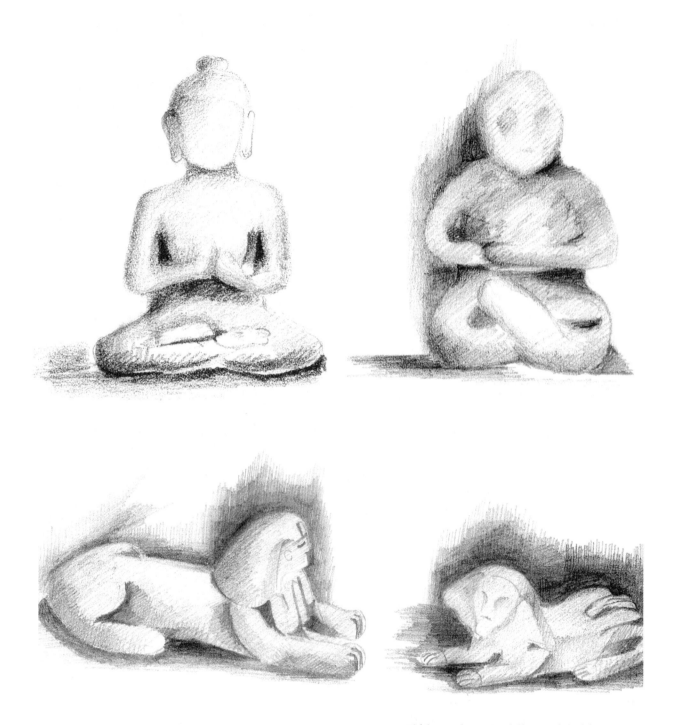

Adult's Buddha and ninth grader's Sphinx

Fifth grader's Buddha and Sphinx

Choice of Materials

The smell (of clay) connects you to the earth. The three dimensional aspect is . . . tactile, present, real.

Class teacher

Clay from the mineral kingdom

Clay is by far the most universal and readily available material and has mythical dimensions associated with the creation of the human being and the world. It is very malleable, creamy, and moist and connects us so wonderfully and tactilely with the good earth. Clay, like any soft material, has its limits and can sag in certain configurations. It is very suitable for many forms of animal, human, mineral (crystals), and geometric figures, but not for delicate planar plant shapes.

There is much scope for rendering many different forms using only the hands, without other tools and props such as armatures or inserted wiring or pins. For most sculptural purposes other than ceramic vessels, which need a certain durability to hold liquids, clay objects can be simply allowed to dry and harden for simple display. Forming and differentiating a figure out of one ball or lump in a nonadditive and nonconstructive way prevents protruding parts from cracking and breaking during drying.

Moisture is Magic: the Miracle of Water

Water brings "life" to the earthen element of clay. It enables us through our hands to plastically imbue clay with our forces of life, movement, and imagination. Proper moistness is critical. It makes clay quickly responsive to our touch and pressure. If clay is too wet, it will be sticky and unmanageable. If it is too dry, it will be resistant and crack. Make sure the clay is well prepared the day before. Unfinished pieces can be slightly sprinkled with water and covered with a wet cloth or plastic wrap for continuation the next day. Ideally, however, children finish most pieces in one session. Large projects in the upper grades may extend over days. Wetting clay and hands to work with prematurely drying clay can result in a dissatisfying, grainy texture and discoloring. In contrast, pieces worked with balanced moisture can be naturally burnished by the oils of our hands.

Kneading and Preparing

Clay shipped in a box with plastic wrapping most frequently has just the right moisture and can be worked immediately with only a bit of kneading. Boxes of sealed clay start drying out after a year, so use them up! Clay that has been dug or recycled often needs to be spread out to dry a little and to be kneaded strenuously like bread. It takes much effort and strength to condition and recondition clay. In some schools the older students knead and prepare the rough clay for the younger children. In the kneading process, the personalities and temperaments of students become clearly apparent!

Firing

Most clay objects when dried are hard and durable enough to keep as they are without firing. (Clay shrinks around five percent in drying.) Firing can be an option depending on a school's facilities, but it adds more work. The main value of modeling is the forming process and regular practice, not the finished product.

Dig Your Own

Take students out to dig their own in local clay pits as a way to connect to the geological source of the material and the environment.

Types of Clay

When obtaining clay, talk to your supplier about the best clays for children to use. Ask for sculpture-body clays that hold form and do not dry out too quickly. These have "grog," particles of grit added to help them maintain their given shape. Ask for samples and test them out before you invest in any quantity. Fine clays used for porcelain have no grog, dry out quickly, and do not hold shape. Clay from limestone areas can tend to feel as though it were "sucking" on your skin.

Recycling Unfired Clay

Clay can be reprocessed by breaking up figures into a bucket having a lid. (Avoid having younger children do or see this destruction of their work.) A walkway ice-breaker (hoe-like blade) easily reduces large chunks into the necessary one-inch-diameter pieces (golf-ball sized). Clay must be bone dry before soaking, or it will end up as lumpy mud. Add dry pieces to a few inches of water in a bucket and let it soak into a mush for a day. This process is called *slaking*. Pour off excess water. Chop into the mass with the blade to test it and to dissolve all lumps. This clay mixture is called *slip*. To achieve the right moisture, leave the lid off for a certain time. Periodically check the batch and chop into it with your ice breaker to aerate and condition it. It can take several days to achieve the right moistness. Cover the surface with a wet cloth and the bucket with a tight lid to prevent too much drying at the top. In spite of the above process, gobs of wet clay sometimes need to be set out for hours to lose more moisture before usage. Potters and sculptors have more sophisticated ways of processing larger amounts by spreading wet clay over plaster slabs called bats, draining off slurry, and absorbing excess moisture. (Note: Clay can be expensive. Most teachers cannot afford not to reprocess.)

Varying Sensitivities

Wet clay, especially when cold, can be a very strong and frustrating experience for younger children. It can overtax and drain their energy levels, particularly if handled in large lumps. Some overly delicate and sensitive children can even experience a revulsion if it gets on their skin and dries out. The right moisture and room temperature are critical. Students from fourth grade on are more robust and develop a tolerance for clay in larger formats and lumps. Fourth grade can be a stage of alternating small and large formats.

Playing in Warm Mud and Clay for Early Childhood and Early Grades

In warm weather, have a bucket of moist clay available for children to play in during free play. Even though one of the best modeling materials for early childhood is warm beeswax, children still can benefit from playing in warm clay and mud, learning to grasp, lift up, and know the good

Mother Earth. Mud balls and cakes are standard fare of early childhood.

If his parents can give the child beeswax to model with, then in the very act of kneading this noble material his creative will—working as it does in the circulation of the blood and warming his hands until they are all aglow—makes itself felt to the very tips of the fingers. Thus not only is the skillfulness of the hands increased, but his imaginative capacity is aroused and nurtured. For we know how similarly the movements and gestures of both hands and feet react when the child is learning to speak: how they help him to learn, to form ideas and to think.

Caroline von Heydebrand
Class teacher

Beeswax from the Animal Kingdom

This gift from the bees softens wonderfully in the warm hands of young children. Before they first use this precious substance, you should tell them a story about how it comes into being (see *Beeswax: Gift of the Hive Community*, p. 165). Reverence for materials is an important part of education.

Imbued with Human Warmth

Modeling beeswax is specially processed and treated to make it pliable. Even then it is hard at first and does not respond as quickly as clay to immediate pressure. It needs warmth to soften. Beeswax should initially be passed out to children in flat, thin, rectangular pieces that can easily be permeated and softened with the heat of their hands. Some youngsters do not have enough hand warmth and need an adult to help with the process. Others have enough heat in their hands to melt substantial lumps. If children listen to a story before modeling, they can at the same time warm beeswax under their arms or even by putting it down their shirts by the "oven" of their warm tummies.

As they grow older (eight to nine years), children have more strength and energy to transform this medium. Teachers and parents should be alert and not let small hands strain themselves on hard, cold lumps. For children with marked circulation problems who have very cold hands, an adult may choose to start off the softening. It is better to invest human warmth and patience into the material rather than to stick the wax in hot water or on the radiator (where it has been known to drip away). Warm weather is ideal modeling time, and beeswax can be warmed in gentle sunlight.

Shapes

Softened beeswax strips can be molded into a beginning ball or any variety of shapes. Young children can start by making all sorts of simple two-dimensional figures, which can be stuck onto window panes as shining transparencies (see First Series, p. 49). Unlike clay, this medium's relative stiffness lends itself nicely to many plant subjects (leaf, petal, and stem). As children mature and articulate more three-dimensional figures, they can add or overlay different colored pieces as details (a golden crown, a sword, an orange mane, a dress

with polka dots, and so on). Such additions, however, should not be allowed to distract from the main sculptural exercise and intent.

Dimensions

Beeswax pieces should be smaller than clay. A wax strip 1.5 in. wide X 2 in. long X 0.25 in. thick, for example, can be made into a ball with a 1 in. diameter. Large sheets of beeswax 4 X 9 by 0.25 in. can be scored with a scissor point into 12 such pieces. A strip 1.5 in. wide X 4 in. long X 0.25 in. thick, yields a 1.25 in. diameter. Six of these fit into a 4 by 9 in. sheet. Size and amount can increase as the children grow.

Color and Transparency

Beeswax can be obtained in its natural color or with colors mixed into it. Color is not, however, an essential aspect of the modeling process, and some people prefer material with plain, natural tone. It comes in rectangular pieces 0.25 in. thick or in very thin strips for transparencies, which warm very easily. Thin color transparencies are more a form of wax application resembling painting more than sculptural modeling.

The Glorious Scrap Box

Children do not have to bring home every beeswax piece they make. Teachers can break up old beeswax figures into unrecognizable bits. Store them in a scrap box for reprocessing into flat strips for future use or for creative sessions of picking and choosing random scraps and lumps for special projects. It is best if young children do not witness the dismemberment of works they have lovingly created, and they should never be allowed to wantonly destroy their pieces "for fun." Some of the best projects come out of the scrap box on a rainy day. Scrap bits can also be used to decorate larger

chunks to become belts, crowns, polka dots, eyes, mouths, or whatever the child envisions.

Plasticine—Mixed by the Human Kingdom

There are all kinds of plasticine, some more natural than others. Try them out and see how they vary according to contents, texture, and odor.

Natural Plasticine as a Transition

Natural plasticines come highly recommended. One of them from Switzerland, is an organic plasticine called Alkena that is composed of beeswax and clay, is reusable, and comes in three earth tones. It even smells very good. This can be a very good transition to pure clay.

Other Media

Salt dough is another organic modeling material that can be bought or made at home:

Mark Birdsall's Special Home Recipe

1 cup flour dough
1/2 cup salt
1 teaspoon cream of tartar
1 cup water
1 tablespoon vegetable oil

Mix ingredients. Heat over a medium heat until congealed (five minutes). Remove from heat and knead. Add color if desired. Store in covered container or plastic bag. A real mess until heated, then very smooth and creamy).

Bread making is also a perfect form of modeling for kindergarteners and very young children, and there are on the market various *modeling compounds* to which water is added to make a malleable substance.

Sand

Moist sand in a box or at the shore is always a delightful material out of which to build imaginatively.

Snow

Wet snow can be fashioned into all kinds of forms. Cover your outdoor play spaces with a fantastic array of snow and ice sculpture.

Suppliers

All kinds of clays and modeling materials are available commercially. You will have to investigate possibilities in your area. I particularly recommend the natural, nontoxic supplies of **Mercurius,** an international supplier of colored beeswax, Alkena plasticine from Switzerland, and other handcraft supplies of high quality. It has distributors in many countries, including:

Mercurius U.S.A
7426 Sunset Avenue, Suite C
Fair Oaks,California
Tel. 916-863-0411

Mercurius Holland
Cor van Empel
Fabriekweg 1
5683 PNBest
Netherlands

Soft clay when modeled is quickly and easily handled and affords great freedom in its manipulation.

Henry Moore
Sculptor

Practical Aspects

Can I take my piece home, pleeease?!

The universal plea

In addition to what has been described in the introduction, I would like to offer some practical tips that may be helpful, especially to teachers.

The Ritual of Sharing

Proper handling and reverently passing out precious materials sets the artistic mood of a lesson. Thin beeswax squares can be offered on a special plate or in a basket as if they were delicious cookies. Clay can be cut in slabs with a thin wire stretched between two stick handles and placed carefully on boards.

Starting from the Archetypal Forms of Sphere and Oval

As stated before, the sphere is the form which most naturally fits in the space created between the two cupped hands or in the single cupped hand. The ritual of first forming a smooth ball can be a natural and artistic way of taking hold of and conditioning a rough piece of new material. Students know each time how to start, and, immediately become engaged and focused. Formally starting by making a sphere lends itself to beeswax, plasticines, clay, salt dough, and other media.

In the Air and Space by the Heart

Many pieces can be modeled in the air and in the space created by the two hands in front of the sternum and heart region. Elbows should form comfortable angles by the ribs. The arms form four sides of a pentagon emerging from the trunk side, reflecting the fiveness of the hand's geometry. This position is important because the children should be using their entire upper body, shoulders, and upper arms as well as their hands.

In this way the process and the changing form are closely felt with more immediacy. Children are able to fully embrace a piece and sense its weight, mass, and overall shape. After the subject is generally articulated, it can be placed on a table for refinement. Very large pieces, usually executed in junior high school, are started on surfaces to begin with.

Size of Lumps

In a small format, one can start with a ball of clay that fits comfortably in one hand and can be shaped by both hands (about walnut-size on average: adjust it smaller or larger depending on age and individual). In a larger format, the lump of clay should fit comfortably between the two cupped hands. Bigger clay figures and construction projects require much more material and are placed on boards and tables for modeling.

With beeswax, very large lumps are neither practical nor necessarily desirable. Lumps should again comfortably fit in a cupped hand and not be too large to soften and mold. Warmed beeswax and plasticine pieces can be made ready for reuse by flattening them out into very thin pancakes for easy rewarming in the hands.

Using Imagination:
Who is Hiding in There?

In this wondrous process one can speak to younger children of the form sleeping, or crouching, or hiding in the wax or clay ball. We help it wake up and emerge. We find it. "Let's help him come out slowly."

From "Sticking Together" to
Sculptural Modeling

Young children in the early grades only gradually learn how to model more unified pieces with practice. More formal sculptural modeling lessons should not be overdone in the beginning. First graders, for example, may very well construct figures directly from flat rectangular slices of beeswax or lumps of other material without going through the stage of a ball. As the grades progress, teachers may more frequently guide the children in a more formal process of sculptural formation from the whole piece.

Articulation and Protruding Parts

In the early grades, children using beeswax and plasticine will tend to articulate human arms, hands, and other details. They should, however, be shown how one solid mass representing the dress and legs helps a figure stand up. Beeswax animals on four legs do stand up well. In contrast, both clay animals and human figures benefit from some sort of solid mass supporting them, or they may be modeled lying down. Human arms and animal appendages (tails, trunks, and so on) in clay are best subtly blended and attached into the main mass.

In rendering essential form, less is often more. Up through grades four or five figures can remain quite general and suggestive. Noses and other facial features need not be added. From grade six on, facial features, arm gestures, and leg stances can very gradually become more pronounced. Be careful that attempted realism does not eclipse simpler, more powerful artistic expression and liveliness.

Demonstration and Guidance

In conducting modeling sessions, varying approaches are useful. Particularly in the first four grades, it is very valuable to demonstrate how to make a piece and to closely instruct pupils in ways to achieve certain features. Such demonstration allows them to work within a common framework but at the same time to find individual expression based on their own sense, feeling, and experience. Students should not be expected to slavishly copy or reproduce a given subject, but each one should creatively make a free rendering. The diversity of expression within prescribed parameters can be amazing. Never underestimate the power of limits for bringing out human creativity and resourcefulness. Too much freedom of choice can often dissipate efforts.

Verbal Directions

Varying degrees of verbal direction, encouragement and advice may be given to the whole class or to individuals, depending on the assignment. As students build up skills and confidence, less and less needs to be said about basics. The teacher can increasingly rely on the cumulative experience

of the class and focus on key characteristics or gestures of new subjects. As a teacher, remember not to disturb the absorbed mood by talking too much.

You as Example

It is encouraging and inspiring for children to see their role-model teachers practice the arts and learn as they go. The teacher does not have to be a polished artist, only a striving, life-long learner.

Every human being is born with potential to be creative and artistic.

Seymour Sarason
Yale psychologist

Care, Reverence, and Respect

Forms gently arise in the special space between the two hands as they converse and organically work together to discover new possibilities. There is no need to pound, slap, or roll modeling material noisily and aggressively on a table. Reverence and respect for materials are an important part of the educational process. Table tops are not necessary in creating flat surfaces. The hands and fingers love to make surfaces. Tables or boards are useful to place figures nearing completion and for large figures that need to be shaped on a base.

The Hand as Primary Instrument

The versatile hand can achieve a multiplicity of surfaces and forms if it works patiently and carefully. The complex and sensitive way fingertips, pads between joints, and palms work together in harmonious sculpting movement is the heart of this rewarding artistic activity. Direct contact and dialogue with the material throughout an entire process of transformation are what really enriches our inner being,

including our brains. Tools interfere coming between us and the material. They eliminate the wonderful movements of the hand and its vital role as delicate sense organ and shaper of worlds. Touch nourishes us.

Silence is Golden

In many exercises, students can be asked to model silently so that they can become fully absorbed in letting their hands "speak" forth forms, a right brain function that need not be disturbed by left brain "chatter." Talking too much can detract from the deeper effects of being fully immersed in the sculptural experience. However, it should be noted that in certain circumstances where children suffer from lack of verbal stimulation at home, modeling has been used in schools to promote speech development.

Shutting the Eyes Occasionally

It is important for children to follow the forms they are making with their hands and learn to use their hands as unique sense organs. At special moments, children can be asked to be quiet, to shut the "eyes of the head." Ask them to feel with the "eyes of their fingers" how round and smooth their spheres are becoming, or how other shapes are expressing themselves in their hands. "Close your eyes and feel how your fish is gliding smoothly through the water." Sessions such as these help students learn to heighten their hands' touch sense. They can bring this special kind of perception into balance with their more highly developed and dominant senses such as sight. In general, however, the eyes particularly play an important and critical role in the learning experience. The eyes "reach out" to grasp both process and object. Modeling helps vitalize our sight and powers of observation. It brings what we see into connection with our hands and capacity of will.

Choices

For the most part, work on a given subject can be done together as a class experience. Periodically, especially in the upper grades, choices can be given. For example, during U.S. geography, you can ask the students each to pick a wild animal and work as a group to model a representative selection. On very special occasions, allow students "free" modeling, where they can make what they want within the framework of pedagogical and aesthetic expectations.

Small Group Projects

Although students do most of their exercises individually, from fourth grade on there can be more special occasions to work with partners or in small groups of three to four pupils. This strengthens interpersonal skills and tends, needless to say, to be a more chatty proposition. Large projects like mountains, bridges, and architecture such as a Roman coliseum call for many hands. Individuals making small pieces, however, can also put these collectively into a scene or common setting (example: see Noah's Ark—Third Series).

Five-Minute Form Exercises

In the early grades each of my students stored in their desks a plastic bag (with a zipped lock) containing two very thin pancakes of plasticine or beeswax ready for quick softening. As part of the morning lesson exercises for a number of days or even weeks in a row, we regularly combined them into a ball and then into all kinds of quick, simple forms and figures. It was similar to our regular morning recorder playing, but instead we were using our hands and fingers to "play" forms on the modeling material.

Gently Back into a Ball Again

In reusing and storing the same ball of clay or plasticine, older students (grade four and up) can gently, slowly, and respectfully compress an articulated form back into a spherical one and finally into flat discs. Features of a figure are experienced as folded into the round form from which it originally emerged, and then completely smoothed into a ball and pancake ready for future metamorphosis. The round form becomes a Proteus, the Greek sea god capable of assuming many shapes.

Display and Review

Areas around the classroom should be created for short- and long-term display. Children love to stand around collections of figures admiring and imagining. It is good for teachers to comment on pieces that show certain features and aspects the students should be aware of. Generally, pieces speak for themselves when they are seen comparatively in a collection. Even two pieces sitting side by side reveal much to viewers. Of course, this is best done in a noncompetitive way so that no one's feelings of adequacy are undermined.

Displays, arranged collaboratively by teacher and students, can be placed on colored cloth (felt), construction paper, beeswax (for beeswax figures), or natural settings created from moss, stumps, bark, gnarled-wood collections, and so on. Such displays need to be changed, freshened up periodically, and not be allowed to wallow forgotten in the gloom of dust.

Cloth-Covered Display Boards

Beeswax pieces can easily fall over unless they are firmly pressed onto suitable surfaces. One option is to develop a cloth or felt-covered display board, easily made

by hammering in little brass nails to protrude a half inch or so. Pieces can be pressed over these nails.

May I Take Mine Home, Pleeease?!

Students may take their figures home after a period of classroom display. Younger children especially like to collect pieces in their own home displays.

Modeling Boards

Small wood or masonite squares (six–twelve inches) can serve as platforms on which to model. These are particularly good for older children working with clay. Such squares are easily stacked and stored. Paper towels can be used also. Avoid letting children put clay directly on school desks. Paperwork will be soiled if the desks are not cleaned properly afterwards, which is often the case. Keep everything as simple as possible for both pupils and teachers. There will be enough wonderful mess anyway, and you want to joyfully bring out the clay as often as possible!

Storytelling

For children in grades one to three, try using modeling in connection with stories and their rich images. For example, you as a teacher can tell a folktale, fable, or nature story prior to modeling. Afterwards, when you demonstrate a shape, you can verbally conjure up again the story's pictures as part of the process. "And the fox stuck his bushy tail straight in the air just like this." For older students, descriptions of nature, history and geography can accompany the activity. "And the crater of the volcano, as we have studied it, is shaped like this at the top."

Journal

If you are a teacher, keep a journal of observations of how your students do the various exercises. Watching children model can give you new and valuable insights into their personalities. For some, modeling can be a healing therapy.

Nature Forms in the Classroom and Home

Our experience of nature's myriad forms shapes our inner sense of form. In addition to what we encounter outside, we can also have in our classrooms and homes nicely displayed examples of nature forms: moss gardens with crystals, beautifully gnarled roots, driftwood, stones sculpted by the sea, dried plant pods, etc. It is good for children to take such objects in their hands and know them directly through touch. Such tactile and visual experiences enhance their sculptural sense of a universal language of art forms in nature.

In my collection of found objects in my studio are: stones, pebbles, bones, pieces of wood—for me they are all interesting shapes, though some may find them exaggerated or distorted . . . The older you are, the more observant you are of the world, of nature, and forms; and the more easily you can invent . . . But it has to come from somewhere in the beginning, from reality, from nature. Space, distance, landscape, plants, pebbles, rocks, bones, all excite me and give me ideas. Nature produces the most amazing varieties of shapes, patterns and rhythms . . . observation enlarges the sculptor's vision. But merely to copy nature is no better than copying anything else. It is what the artist makes of his observation by giving expression to personal vision and from his study of the laws of balance, rhythm, construction, growth, the attraction and repulsion of gravity—it is how he applies all this to his work that is important.

Henry Moore
British sculptor

Summary of Suggestions

• Encourage a supportive atmosphere wherein you and your children develop confidence in participating in the arts, including modeling as a natural part of human activity.

• Bring out the materials regularly so that eager hands can explore and discover movement and form!

• Pay attention to the space- and form-creating possibilities of mobile hands, and cultivate playful hand exercises, finger games, and puppetry.

• In your work and theirs, emphasize the wholeness of the process and of the piece of material.

• For the most part, try to keep the smooth surface or "skin" of pieces intact and unbroken unless an exercise calls for breaking off or adding sections.

• Keep the amount and volume of the whole lump the same as it changes and is shaped.

• Most light pieces can be held in the hands in the air as they are shaped to fully embrace and directly feel their moment-by-moment transformation.

• Help forms emerge by moving your hands in a caring way. Gently press, counterpress, push and massage your piece toward forms. There is no need to aggressively pinch or pull out parts.

• Patiently observe, enjoy, and respect the gradual metamorphosis of each changing step. Go back and forth between emerging surfaces rather than defining or refining any aspect too quickly. Avoid forcing material too quickly into intellectually preconceived forms.

• Immerse yourself in exploring and discovering all kinds of imaginable nonrepresentational forms.

• Develop representational subjects out of the form you discover.

• Live with and appreciate forms in nature and art!

• Try to capture the gesture, movement and life of a subject rather than its static structure. Avoid overemphasizing naturalism and realism, which can so often lead to frustration.

• The hand is the only tool needed. Hands are capable of accomplishing the essentials, and they need their capacities of intelligence exercised. Tools distance us from the primary sensory experience and are not necessary in the elementary school years.

• A quiet atmosphere of reverence and wonder is best for good, absorbed work. Children's energy is best applied by allowing their hands to actively "speak" their special language. Mouth chatter is left-brained and can interfere with the real task. Avoid joking and being silly about pieces ("That looks like a Ninja turtle, " etc.)

Art = You can do it!

Illustrations throughout the text and recommendations for materials at the beginning of each Series are meant as helpful suggestions. You as teacher or parent may creatively alter them to suit various purposes.

THE EIGHT SERIES

*Starter and Seed Ideas
to Encourage You to
Develop Your Own*

First Series

BEESWAX
First tell a story of how the bees make this wonderful gift of nature (see Beeswax: Gift of the Hive Community).

Folk Tale Figures:
Golden Ball
Princess
Frog in Water
Rumpelstiltskin

Other:
Egg, Bird, and Nest
Acorn

Flat, Transparent Forms
Leaf
Flower petals
Butterfly Metamorphosis
Star
Guardian Angel
House of Light
Alphabet Letters and Numbers

BEESWAX, PLASTICINE, Salt Dough, or Small Pieces of Warm Clay

Hand-Gesture and Hand-Space Exercises
The Basic Exercise
Simple Human and Animal Forms
Cradled Forms
Harmony Exercise

SAND TABLE

Modeling brings intelligence to the fingers. It's like a feast to the fingers . . . and hands can demonstrate their inherent wisdom..

Fifth grade teacher

It is seeing with the fingers!
Weighing with vision!

Third grade teacher

Folk Tale Figures
Children around the ages of six to eight love the imaginative world of folk and fairy tales. There are hundreds to choose from diverse cultures around the world. The archetypal characters of these stories have been born out of a deep folk wisdom. In many tales there is often a beautiful princess. In Grimm's story of *The Frog Prince*, the princess plays with a golden ball.
• Tell the whole story first so that its images are fully living in the imagination. The modeling will then be done in a colorful context of meaning. Fingers will itch to create the activity and gesture of the subject that has just been emotionally experienced by the mind's eye.

Golden Ball

• Make a ball-like space between your two hands and then in each single hand.
• Warm a flat piece of yellow beeswax, warm it and work it in the hollow of the hand and out between the fingertips.
• Make it rounder and rounder and rounder, and smoother and smoother and smoother!

• Close your eyes and "see" the rolling ball with your fingers. Feel what a wonderful bouncing ball it is—as round and golden as the sun. But oh, it has fallen, rolled away, and been lost!

Princess

• Take a larger piece of flat beeswax and work it into another ball.
• Turn the ball into an oval and, without breaking the piece apart start gently pressing out a head and neck at the pointed end.
• Shape the larger part into a flowing gown and let arms be born at the sides.
• Carefully press out long flowing hair.
• Model or attach other details if desired: hands, a crown, etc. Oh, she is so beautiful!

Gestures: throwing, catching, holding, and beholding in wonder, bending to pick up, and so on.

Additions: You may make additions such as colored cape, necklaces, and many other possibilities. Young children are often satisfied, however, with just making the simple shape from one piece and letting it light up in and strengthen their imaginations. Detailing should not detract from the main process of formation.

Frog in Water (Further Suggestions)

When you have done a representative element or two from a story, you may want to leave it at that or, if you have time, go on to do more. A whole related collection and scene can be developed: frog, well, prince, and so on!

• Have your hand sit contracted and then expand into hops in the air.
• Again start by shaping out a ball into the universal egg form in green (if you have it).
• Coax out his bumpy-eyed head and slanting body. He sits there so nicely that it is not necessary to bother with his awkward legs in detail. But where does he sit?
• Do not forget his home. Make another ball and turn it into the universal drop form (preferably blue). With the thumbs, press down into it and spread it out concavely into a wavy nest of water.
• Plunk him in the pool with the ball if you want.
• Imagine that the well rim is all around the pool.
• Have the princess stand horrified by the ugly beast!

Gestures: expectant waiting, sitting (leaping is a challenge!).

Frog Pond : If more than one child is modeling, multiple frogs can be put in

larger pools that are patched together from many rippling pieces of beeswax. Stick them on cardboard, or wood, or simply on a rounded piece of blue construction paper for display.

Nature Experiences and Stories: The "frog and water theme" need not be derived from a folk tale. It could easily arise out of a nature experience or story. In this case, it would be wonderful to model the round egg form and shape it into the tadpole and maturing frog stages.

Egg, Bird, Nest (arising out of a nature experience, story, or folk tale)

• In the space between your hands, form an egg shape in the air and elongate it into the sleek body of a bird. Practice flying gestures.
• Make a ball of any color and subtly change it into an egg shape (a convex form).
• Shape a larger separate piece into a ball and then into the form of a nest (concave). (This method is similar way to making the pool of water described above.) Put the warm egg into the nest. Stop here if you want or go on to a further option below.
• Make a ball into an egg that then turns into a bird to keep the first egg warm! You will know how (stretch out body, then neck, head, beak, wings, tail).

Rumpelstiltskin (Fairy Tale)

Besides the humans and animals who inhabit the world of folk and fairy tales, there is also a rich population of the "little people." Sightings of fairies, elves (light), gnomes (earth), undines (water), sylphs (air), and other small elemental beings have been recounted in many a tale. Familiar is Rumpelstiltskin, that hot-tempered, choleric fiery spirit who flickers and flames in his dark forest.

• In the air, have your hand flit, flicker, and flame up.
• Make a red ball (of fire!) and shape it into flame-like body, head, and limbs.

Gestures: fiery flickering, flitting, angry, willful, etc.

Gesture: head turned, peering out protectively, quiet, still.

Acorn

*Both Rumpelstiltskin and the Bird loved
to be in the forest amongst the trees . . .*

Whenever you do an activity with young children, try imaginatively, and without intellectualizing, to place the subject within a meaningful context and ideally relate it to other things. Introducing modeling subjects with a story is an excellent way to provide such a framework, but the starting point might also be an experience in nature. For example, a child may have delighted in collecting acorns in the fall. Imagine them in the winter recalling this event and making up a story about Frisky the Squirrel and how he rediscovered the child's hidden treasure.

• Make an acorn shape in the air between your two hands.
• Give a ball a flat top and pointed bottom.

Gesture: convex, rounded, falling, bouncing, an excellent natural form for experiencing convexity and concavity.

Construction: Usually it is to be recommended that children shape a piece as an organic wholeness. The experience of taking off and putting on concave acorn caps so much belongs to the subject that constructing an acorn from two parts seems an integral part of the experience. A green cap on a red bottom part is a nice complementary combination of convex and concave. Color choices do not have to be realistic.

Flat Transparent Forms
(Two-dimensional)

Here we enter a new dimension of flat figure modeling where leaves and blossom petals astound us with their transparency!

Leaf

• Make your hands into flat leaves and have them flutter down.
• Form a flat piece of beeswax into the shape of an oak leaf with a stem (or any kind of leaf).

• Press and stick the leaf on a window pane but be careful not to leave it to melt in the hot sun!

Gesture: open, receiving.

Flower Petals

• Make your hands into two flower petals forming part of a blossom. Have three or more children join hands in hand-petal forms.
• Press and shape out delicate petals, which may be grouped in flower circles on the window.

Gesture: openness.

Butterfly Metamorphosis

Tell a story about the transformation of a caterpillar into a butterfly. This is a parable for the transformation of the human soul, which need not be intellectually discussed.

• Make a butterfly in the air with your two hands and fly!
• Make a ball (insect egg!) and roll it with your fingers into a very plump caterpillar form. Press out two wings from its sides. Are these perhaps leaves or petals that have taken wing and become an animal?
• Stick the butterflies on a glass window.

Gesture: flying, flitting, alighting, open to the sun—ah!

Option: Press on little spots of other colors if available to decorate the wings.

Reminder: It is most valuable for children to hold pieces in their hands up in the air and work with their fingers, palms, and in the hollows of their hands. Pounding beeswax flat into pancake forms on a table or desk with fists can be fun in some situations (pat-a-cake) but does not develop the same dexterity. Pounding also creates a different atmosphere and attitude toward the material.

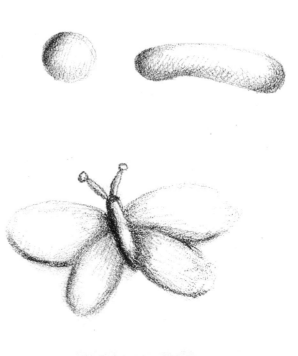

Behold the plant!
It is the butterfly
Bound fast to the earth.
Behold the butterfly!
It is the plant
Set free by the universe!

Rudolf Steiner

Star

- Radiate your fingers out as a star. Stand with your whole body (four limbs and head) in a five-pointed star.
- Make a ball of beeswax (the sun) and flatten it into a star with five points or six (Star of David).
- Create the shining heavens on the window.

Gesture: joyfully radiating outward like our active limbs.

Colors : yellow, white

Guardian Angel

- In the air make your hands into angel wings and fly.
- Make a ball (the universe!) and have an angel come forth from it with wings of glory to protect the little ones.
- Place her up among the stars!

Gestures: wondrous Ah!, protective surrounding O!

House of Light

- Make hand house spaces first.
- Mold flat pieces of warmed beeswax into rounded, glowing houses of light, which can look like caves with large, open entrances.

Gesture: enclosing, surrounding, sheathing, protecting special inner space

Alphabet and Numbers

Now is the time to make some old-fashioned modeling forms.

- Make the letters in the air with your fingers and hands first.
- With the fingers, mold thick strands of beeswax (better not roll them on the table).
- Break off sections, form them into letters of the alphabet and numbers, and stick them onto a piece of wood.
- Close your eyes and touch someone else's unknown letter or number and guess what it is (wax braille!).

Gestures: archetypal gestures of the straight line and curve (out of which God made the entire universe, according to astronomer and mathematician Johannes Kepler).

Option: Compose words and large numbers in this way.

Colors: galore! (use color to emphasizing phonics and word families).

Hand-Gesture and Hand-Space Forms

Remember, you may adapt for younger children some of the simpler, fundamental exercises described in the introduction. They can be interspersed with themes in this series:

hand and finger plays
simple dexterity exercises
hand and finger grasping practice with
 different shapes (elongated, round,
 oval, and so on).

The Basic Exercise

This exercise from the introduction should be regularly repeated as a fundamental experience and possible prelude to further transformations.

• *Take a piece of soft, malleable material (clay, wax, dough, or the like) that fits comfortably in the hollow of one hand (about walnut-sized on average: adjust size depending on age and individual). Subtly move the substance around in the hand and discover a simple shape. Stop here, if you want. Pure forms need not always be developed into representations of things in the world.. Or continue on to the next choices, using two hands:*

(1) With two hands, continue to develop, as a pure form, the simple form you discover in one hand. Stop here, if you want.
(2) Look at your basic, pure form. What does it want to be? Let your imagination guide you into

forming it with two hands into a simple human, animal, or other form of nature.

• *Pure, basic forms may be discovered by employing two hands from the very beginning. These forms may remain pure or be developed into representational figures. Use a bigger ball of material that fits comfortably in the spherical space created by your two facing, cupped hands.*

Cradled Forms

• Make simple forms that "cradle" in the curvature of the hand space: ball, "baby-like," or bean shapes.

Harmony Exercise

• Form a round ball of modeling material and divide it in two.
• Separately, in each hand, shape out forms that follow the curved hollows.
• Bring the two together and place them side by side so that they harmoniously complement each other: convex into concave.
• Before this process tell a little form story about two friends who argued but then

were able to sit down together and get along. In modeling, stories can be invented about the character and relationships of pure forms. (Similarly, in painting you can also tell stories about pure colors and their dynamics.)

Sand Table

Allowing children to play in a good pile of moist sand is a natural way to encourage spontaneous sculpture. In many places, however, the winter months preclude such activity outdoors. So why not bring a small sandbox indoors. A shallow box six inches high, for example, can be constructed on top of an old table and lined with a waterproof material. Young faces will peer over its edge and young hands will find their way into a fantasy world of movement and forms. If such a sand table is installed in a classroom, a teacher can assign children to make certain forms for all to see. This tactile richness enhances the educational experience.

Additional Ideas
from other teachers and sources:

• beaded necklace
• fruits and vegetables
• passing the wax around a circle of hands so that hot hands help warm it up
• nativity scene
• candle dipping is popular in the early grades, but can be done at any age

Your Own Ideas

After doing the exercises of the series, develop and record some of your own inspirations and variations:

Second Series

*Modeling is imagination materialized
within a short period of time.*

Fourth grade teacher

*You can make a mistake and reshape.
It is more of an exploring.*

Sixth grade teacher

BEESWAX

Animal Fable Figures
Fox
Lion and Mouse
Grasshopper and Ants

Human and Animal Legends
Monk Francis, the Wolf, and Fish
Knight George and the Dragon
Sheltering Forms

**BEESWAX, PLASTICINE, Salt Dough
or Small Pieces of Warm Clay**

Hand-Space Experiences
The Basic Exercise
Grouping Hand -Space Figures
Pebbles
Bowl and Friendly Forms
Mirror Images

SNOW SCULPTURE

Fables

Cultures all over the world have a rich diversity of fables. True fables have a way of driving home a point about certain human character weaknesses, often in the guise of animals, without moralizing. Avoid ruining a fable by telling the moral of the story. The events in the story should implicitly, powerfully, and morally speak for themselves.

Fox (Cleverness)

This wily fellow lurks in many a fable, ready to outwit other creatures and to intrigue children who are feeling inclined toward mischief. In addition to telling such tales as *"The Fox and the Crow,"* or *"The Stork,"* or *"Sour Grapes,"* you can give a little natural history: show how the fox looks (his pointing, sniffing nose, large ears, short legs, and above all his magnificent, bushy tail sticking straight up like a flame).

• Find fox forms and gestures in the air with your hands.
• Form the flat piece of beeswax into a ball and then an egg shape.
• Make the smaller end of the egg into a head.
• Gently press out legs, tail, nose, ears.

Gestures: sniffing nose up,
tail pointing up,and so on.
Colors : red, orange.

Lion and Mouse (The skills of the lowly rescue a mighty but powerless king)

Whereas the lion requires a regular-sized piece of beeswax, the mouse is delightfully small and calls for very fine motor skills. Children often like to put many tiny mice all in a row.

• Find mouse and lion forms and gestures with your hands.

The lion may have a yellow body and an orange mane added and pressed around the face.

• Form a ball into an oval.

• Shape the smaller pointed end into a head.

• Gently press out legs, tail, a nose, ears, tail, and mane (can be added separately).

Gestures: tangled , lying lazily, roaring.

The mouse may be in an active, scurrying red color and must have big ears, a pointed head and nose, and a cord-like tail so thin that it almost breaks off.

• Make a ball into an oval.

• Flatten the bottom of the oval and make the pointed, smaller end into a face and ears.

• Gently press out a tail.

Gestures: sniffing, sensing, sitting up.

Option: Children may want to weave a thin net to throw over the entrapped King of Beasts.

Grasshopper and Ants (industriousness and leisure)

"If you spent the summer singing," said the hard working ants to the cold, hungry grasshopper, *"you can't do better than spend the winter dancing."*

Because they are so delicate, insects are not easy to form, but many children have an uncanny sense of their forms. In a socially supportive process of learning, they can show others how to make the shapes. This is a great opportunity to talk about the life and characteristics of these fascinating creatures.

• **Grasshopper**: Elongate a green ball (insect egg) into the thorax and head and add features: wings at sides, antennae, legs.

Gesture: jumping, etc. Practice in the air with your hand(s).

• **Ants**: Children adore making several little spheres (black) and turning them into a parade of ants. This activity strengthens fine motor skills. Parents and teachers with big clumsy fingers will be envious. Children

love to work with the wondrous color black, which can also be used for ravens and crows, the messengers of secrets.

Gesture: ants moving as one body in line.

Human and Animal Legends

The literature of the world is filled with all kinds of legendary and historical personalities from whom children can learn courage, compassion, and other valuable human qualities. During medieval times, knights and saints roamed the land helping people and even warding off great threats. Many of these exemplary human beings, particularly the saints, had a special relationship with animals.

Monk Francis, the Wolf, and the Fish

Francis was famous for taming a wolf which threatened the Italian town of Gubbio. He was friend to all creatures and called them his sisters and brothers. Francis, with his reverence for life and exceptional attitude towards the natural world, was a true saint of ecology far ahead of his time (see his famous Canticle to the Sun).

• *Francis*: Make a ball into an oval and then elongate it. Form a hooded head at the pointed end, a monk's robe as the body, with arms to the sides at the rounded end.

Gestures: humble bending to listen to the lowly creatures, inner reverence, arms aloft in praise and joy, kneeling and so on. Practice these purely with your hands at first.

Option: Around Francis, group small birds or other animals.

• **Brother Wolf**: You may form him seated in front of Francis, perhaps with one paw uplifted and stretched out. His jaws can be open. See the Fox for the process.

Gestures: howling, sitting, raising paw.

• *Fish:* Francis loved to talk to groups of creatures great and small. Make a blue pool of water and place sleekly modeled bodies of fishes on its surface looking up at Francis standing at its edge.

Other creatures who might be with Francis, possibly in an entire scene:

• *Sister Birds in Brother Tree*
• *Brother Donkey*
• *Sister Worm*
• *Brother Stone*
• *Sister Moon*
• *Brother Sun*
• *Sister Water*

Knight George and the Dragon
(Courage against the threat of evil)

• **Dragons** come in all kinds of shapes, and children can find their own freely chosen forms.

Gestures: winding sinuously, breathing fire, etc. Practice some of these in the air with your hands.

• **The knight** faces the beast in the tension of struggle.

Sheltering Forms

• Find imaginative houselike forms in the air with your hands.

• Form different cave-like houses by first establishing an outside gesture (tall, pointed, elongated, rounded, squat, or low).

• Then, with your thumbs, press in an entrance and one room and continue to adjust the outside accordingly.

Notice what the gesture of the house is: standing, lying, leaning. I have found that house forms tell us much about a child's personality.

Hand Gesture and Hand Space Forms

Remember, you may adapt for younger children some of the simpler, fundamental exercises described in the introduction. They can be interspersed with themes in this series:

hand and finger plays
simple dexterity exercises
hand and finger grasping
 practice with different shapes

The Basic Exercise

This exercise from the introduction should be regularly repeated as a fundamental experience and possible prelude to further transformations.

• *Take a piece of soft, malleable material (clay, wax, dough, or the like) that fits comfortably in the hollow of one hand (about walnut-sized on average: adjust size depending on age and individual). Subtly move the substance around in the hand and discover a simple shape. Stop here, if you want. Pure forms need not always be developed into representations of things in the world. Or continue on to the next choices, using two hands:*

(1) With two hands, continue to develop, as a pure form, the simple form you discover in one hand. Stop here, if you want.

(2) Look at your basic, pure form. What does it want to be? Let your imagination guide you into forming it with two hands into a simple human, animal, or other form of nature.

• *Basic forms may be discovered by employing two hands from the very beginning. These forms may remain pure or be developed into representational figures. Use a ball of material that fits comfortably in the spherical space created by your two facing, cupped hands.*

Grouping Hand-Space Figures

Three sisters came together and talked about how nice it was to be in the same family.

• Make three spheres into three slightly different sibling forms that follow the contours of the hands and fingers. Make them elongated, curved, and thin at one end. Place them side by side so that they nestle close into each other without touching, forming a complementary grouping.

All kinds of variations of pure symmetrical and asymmetrical hand forms can be generated and grouped to practice the sense of form relationships and balanced composition.

Bowl: Concave

• Form a ball.
• Place it on the table.
• Impress it into a concavity (bowl) using rounded convex finger tips or ball of the hand (at the bottom of the palm) for larger pieces. This conversation between hands and substance can lead into the next exercise:

Bowl of Friendly Forms: Convex into Concave

• Make three or more convex forms that fit (complement) into the concave bowl-like form. These forms are "friends" who play nicely together. Make up a "form story," a tale about the character and interaction of different shapes.
• Take them out, arrange them in a conversation group and then put them back into their nest again. Just as the forms have a complementary relationship to the hand, they can also relate to each other. A concave bowl-like form asks for a convex one to fill it. Each form can ask for a corresponding form. The hands can explore how each form calls for and relates to others. Such exercises involving a variety of asymmetrical forms educate and stimulate the form sense immensely. They are like organic puzzles.

Pebbles

• Playfully form differently shaped pebbles in one hand, one at a time.

Form Drawing and Modeling

Children delight in the geometry of pure linear forms involving the straight and the curved. These two-dimensional entities have their counterpart in modeled shapes. For example, in the first years of elementary school it is good for the children's sense of symmetry and laterality to do two-sided, mirror images:

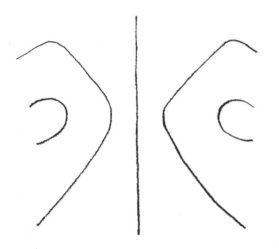

Mirror Images

• Make a flat form. Place it to the left and model and place its opposite, mirror image on the right. Mirroring can also be done in the up and down position and in all kinds of three- and fourfold symmetries and asymmetries.

Snow Sculpture

When snow is available and is sufficiently wet, take advantage of it to go outside and model a variety of forms, not just snowmen and snow forts. For example, all kinds of animals can be formed in a veritable winter menagerie. If you have an outside running-water source, use it to add water to snow. Be careful not to melt it.

Additional Ideas
from other teachers and sources:

• opossums hanging from tree branches
• seasonal themes: pumpkins, etc.
• grapes

Importing From The Preceding Series: Check to see if there are ideas in the preceding Series which you have not explored or would like to repeat, perhaps developing a variation. Remember, many themes can be adapted from other Series, so look around!

Your Own Ideas

After doing the series exercises, develop and record some of your own inspirations and variations:

Third Series

I liked to squish the clay and . . . smooth it.
I like the feeling of clay between my fingers.

Third graders

BEESWAX

More legendary people
Noah's Ark
David and Giant Goliath

BEESWAX or CLAY (or plasticine)

Spiral Tower
The Basic Exercise
Simple Human and Animal Figures
Farm Animals
Design Your Own House

CLAY

Adobe Village
Little Pots and Bowls (coil)
Form Groupings—outer and inner

SNOW HOUSE

And God formed man of the clay of the
ground and breathed into his nostrils the
breath of life.

Genesis

More Legendary People

Many myths from all over the world describe in mighty pictures the Great Flood and its survivors. Not only great mythical figures wandered the earth, but there were also giants in those ancient days.

Noah's Ark (Modeling the Family and Animals Two by Two)

Noah, his wife, and their three sons Shem, Ham, and Japheth become stewards of a renewed earth overarched with the miraculous rainbow. They are compassionate caretakers who rescue animals and plants for a new beginning of the world. The subject involves so many characters and creatures that it lends itself readily to a cooperative class or family effort.

• *Noah and his family members* can be modeled in all sorts of gestures and arrays of colorful clothing. Perhaps you can add other human beings who may have come along. Children can use their imaginations to shape out and decorate figures.

• *Animals* are made in duplicate, which offers an interesting challenge in replication, especially if two different children do the same animal. Choices are almost infinite and should be left up to them. Animals can turn, gesture, and relate to each other.

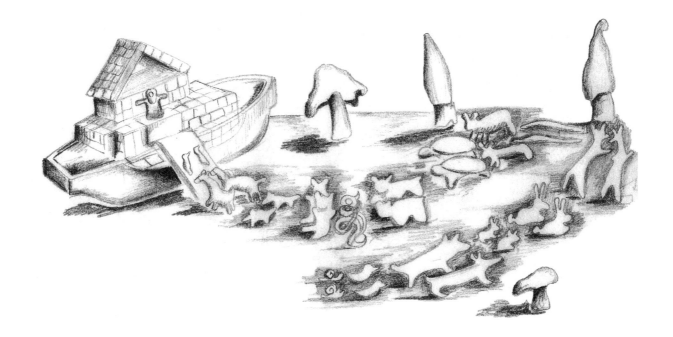

• **The Ark** can be creatively made of big sheets of beeswax or other plastic materials, or it may simply be made of wood. Shingle the roof with little wafers of colored beeswax.

Display: Set out a big colorful cloth. Place the grand vessel on it and let the animals approach in a long curved line, the snails at the tail end! See the family waving from the deck!

Examples: cows, lions, birds perched on roof, and so on.

Other materials: This subject can be rendered in plasticine or another material if suitable beeswax is unavailable.

David and Goliath

Stories of little fellows or delicate maids defying overwhelming forces is the stuff of legends and exciting history.

• As with the fierce dragons in the Second Series , allow the children to use their imagi-

nations to make Goliath. With his huge spear or sword, he can tower over the shepherd lad swinging his sling (which he usually employs on wolves). Children like the dynamic gestures of conflict and tension between the two figures. This is a good exercise in different sizes. With one hand facing the other, practice the gestures between giant and little hero.

Colors: David in quick red, Goliath in slow, lumbering, blue or green.

Spiral Tower

The Tower of Babel is an archetype of all such structures.

• Elongate a ball of clay into a cylinder.
• Stand it on a table and shape the spiral way up toward heaven. Other forms and kinds of towers can be designed.

Hand-Gesture and Hand-Space Forms

Remember, you may adapt for younger children some of the simpler, fundamental exercises described in the Introduction. They can be interspersed with themes in this series:

hand and finger plays
simple dexterity exercises
hand and finger grasping
* practice with different shapes*

The Basic Exercise

This exercise from the introduction should be regularly repeated as a fundamental experience and possible prelude to further transformations.

• Take a piece of soft, malleable material (clay, wax, dough, or the like), that fits comfortably in the hollow of one hand (about walnut-sized on average: adjust size depending on age and individual). Subtly move the substance around in the hand and discover a simple shape. Stop here, if you want. Pure forms need not always be developed into representations of things in the world.. Or continue on to the next choices, using two hands:
(1) With two hands, continue to develop, as a pure form, the simple form you discover in one hand. Stop here, if you want.
(2) Look at your basic, pure form. What does it want to be? Let your imagination guide you into forming it with two hands into a simple human, animal, or other form of nature.

• Basic forms may be discovered by employing two hands from the very beginning. These forms may remain pure or be developed into representational figures. Use a bigger ball of material that fits comfortably in the spherical space created by your two facing, cupped hands.

• **Chicken**: Make an egg into a bird again. Develop the head and tail at the ends of a curved body shape. Let the chicken lie down because the legs are too thin to support the body. Model her with the gesture of an alertly turned head.

Farm Animals

Children come alive on a farm and relate very strongly to the animals. Find different animal forms in the interplay of your two hands.

- Make a small ball that fits in one hand.
- Work it into an oval shape.
- In one hand grasp the egg shape firmly with the narrow pointed end peeking out between the round hole created by your thumb and index finger. Gradually squeeze the end of the egg so that a head emerges with a neck, but this time have the lower part of your thumb press in more deeply to create the chest and frontal section of the basic archetypal animal. Place it beside the basic human figure to contrast its horizontal orientation to the upright one.
- With this figure as a foundation, the characteristic forms and features of many different animals can be added.

• **Cow**: This great dreaming horned creature can be modeled in the gesture of lying down chewing the cud. The cow with its four stomachs is an archetype of the digestive process. Press the length of tail against the body so that it sticks and will not break off so easily. Horns can be shaped and added separately. Children who have brushed cows will touchingly model the rim of the backbone!

• **Pig**: Elongate a sphere into an egg shape and form the head. Let the pig lie down, and bring out distinctive features at both ends: snout and ears, cute spiral tail.

Gesture: sniffing

Other choices:
- *horse*
- *sheep*
- *goat*
- *rabbits*
- *dog*
- *cat*
- *geese*
- *ducks*

Materials: The earthiness of the subject lends itself to clay or plasticine for older children (nine to ten years old and up), but young children also work wonderfully with warm beeswax.

Designing Your Own
Wonder House

Between the ages of seven and eleven, children can be passionate fort and playhouse builders. They endlessly create spaces wherein they are constantly "finding the self inside." Their modeling tendencies from ages nine on more and more can reflect the urge to explore the qualities of concavity in contrast to convexity. House building is a profound archetypal activity. It helps children to come to terms with their own growing bodies. It enables them to feel at home in a growing personal space.

• Make different house forms in the air with your hands.

• Create a big ball of clay (our earth home) and begin to press an interior space (concavity) into it with your two door-like thumbs. Allow the children to freely and imaginatively design their own miniature one-room houses. Without any or much comment you will find appearing: windows, doors, chimneys, and unexpected and revealing features that tell you about the child himself. Houses may be done each year, and they will become more elaborate as the child's relation to his own body changes.

Gestures: protective, sheltering, enclosing. Each house will have its own gesture reflecting the personality and temperament of the child.

Other Materials: beeswax, natural plasticine

Native American Dwellings
Fort building

Children can enthusiastically relate to the types of natural housing such as the teepee (animal skin), wigwam (plant bark), adobe structure (earthen) that were used by various tribes of Native Americans. It is very meaningful for children around nine years of age to engage in the actual construction outdoors of life-sized teepees, wigwams made with poles and coverings, and other kinds of houses. Making small models can supplement but not replace this fundamental real-life experience. The enthusiasm of children will be all the greater when inspired by stories of the Native American way of life.

The earth and heavens are our great home
The floor's the ground,
* the roof's a starry dome*
We share this house with all mankind
A more beautiful dwelling we'll never find.

Unless we look at humans as well.
God gave us a body in which to dwell.
The roof of our head protects us inside.
The walls of our skin are a place to abide.

Through the windows of our eyes
We see the world and starry skies.
On pillars of legs our house stands upright.
Inside it's all warm and glowing with light!

Class teacher

Adobe Village

Tales of Southwest Indians can help children imagine the remarkable culture and dwellings of extensive settlements in a desert environment where wood is scarce. Like Noah's Ark, an adobe-village project ideally lends itself to a cooperative social effort of many hands working together. Such a village project is a mixture of constructing walls, roofs and floors and then modeling and smoothing everything together into a sculptural unity.

Size: Specifications here will be for a village that is approximately three feet wide, two feet deep, and one foot high, with three stories. Proportions may be adjusted as needed.

Materials : Clay is ideally suited for this subject matter and gives the children direct experience with the earth material used in actual constructions. Four or more fifty pound boxes of low-grade clay are required, depending on the village size. You can keep adding as you go along. It is better to have more than you need. You will also need some small sticks and stones.

Adobe: In your vivid descriptions to the children, tell them that adobe is actually a building material made of clay and straw made into bricks. On such a small scale it is not practical to make tiny bricks and build the walls, but small bits of straw can be mixed into the clay that is used for building the wall.

• On a piece of half-inch plywood (2 $^1/_2$ by 3 $^1/_2$ feet) lay a one-inch-thick rectangular base of clay, 2 by 3 feet.
• Allow children to design creatively their own interconnecting walls (approximately four inches high and $^3/_4$ inch thick), floors, rooms of varying size, and passageways by building up clay partitions strengthened by small sticks and stones.
• Doors and windows can be incorporated as walls are put up. Sticks can be inserted across the top of window openings and other places where support is needed. If wanted, more openings may be cut into walls later.

• Once a first floor of rooms is established, larger sticks can be put across the tops of walls as floor joists for the next story. Allow them to be visible and to protrude $^1/_2$ inch outside the clay.
• Cover the floor supports with a $^3/_4$ inch floor of "mud," and build second-story walls on this new second-story base.

• Repeat to establish a third story (or more!).

Details: Round ceremonial chambers called kivas can be planned in one or two locations; wooden ladders can be made by tying sticks together with string; bread ovens can be situated in open spaces and courtyards.

Simple Pottery

Related to the adobe project is making simple bowls and pots. This subject can arise from descriptions of tribal customs and arts.

Basic Pinch Bowl or Pot:

• Make a bowl in the air with hand space.
• Make a clay ball and form it into a bowl or pot. Hold it in the bowl of your hand(s).

Examples of Hopi designs:

Coil Method:

• Make one very long rope of modeling material.
• Coil it round to form a circular base and then let it spiral up into the sides of a vessel. The vessel can broaden outward and become a bowl, or contract inward at the top to form a pot.
• Firmly press and pinch all adjacent coils against each other so that they bond.

Option: add lids or handles as desired.

Guide the children to design creatively their own vessels and shapes. Encourage variety and experimentation and exploration of native motifs inscribed on their pots.

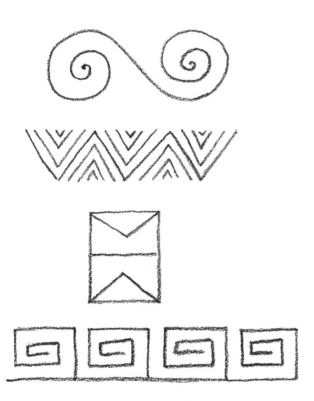

Form Groupings:
Inner and Outer

Pure hand forms can arise in the play between the two hands and generate multiple pieces of varying shape, size, and gesture. These can be placed next to each other so that sides complement and harmoniously "correspond" to one another. Groupings can be of three, four, or five pieces. Experiment with what forms are artistically balanced (or unbalanced!) with others.

• Four forms with one large one in the center (young huddle around grown-up).

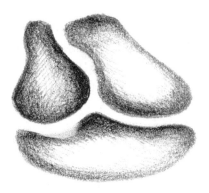

• Create three forms in balance (three friends whispering).

• Four forms with small one in the center surrounded by three large ones.

• Three forms, with a small one in the center and the larger ones outside (mother and father protecting their young one).

• Six forms with a group of three small ones in the center and three large ones surrounding them.

Clay

Speak to children at different levels of development about the special nature of this important earth substance. Connect clay with such subjects as farming soils, ceramics, and food storage. The mythical picture of God creating the human vessel of Adam's body from clay is a wonderful one to bring out of world literature. For more details on its geological and cultural significance, see the section in the second part of this book on "Clay and Water: Vessels of Life and Instruments of the Music of Forms."

Snow House

• Build an igloo-type dwelling with the universal shape of roundness in conjunction with learning about the old Inuit way of life.
• Add water to snow to make ice to build up and strengthen walls.
• Make a large polar-bear sculpture out front. The aim is to simulate a house made of snow and ice and to see what it feels like inside. It is not possible to make an exact replica without the right conditions and materials.

Additional Ideas
from other teachers and sources:
• beavers, lodge and dam
• figures of mother with baby, father, child
• household objects for house models
• little trees in wax
• make a real outdoor oven out of clay and use it for breadmaking or for firing simple clay vessels.

Importing From The Preceding Series:
Check to see if there are ideas in the preceding series that you have not explored or would like to repeat, perhaps developing a variation. Remember, many themes can be adapted from the other Series, so look around through them all!

Your Own Ideas
After doing the exercises of the series, develop and record some of your own inspirations and variations:

Fourth Series

BEESWAX

Mythological figures:
Idun and Apple Tree
Thor and Hammer
Loki and Midgaard Serpent

CLAY (or Plasticine)
The Basic Exercise
The Human Figure
Human and Animal Compared
Animal Studies: Habitats
Animals Arising out of
Hand Forms
Animal Form Grouping
Bear in Cave
Bird in a Nest
Mountain Relief Map
Bridges

Geometric solids:
Cube
Cone
Cylinder

Myths

Myths of how the ancient gods created the world and influenced human life appeal to the vivid imaginations of children. As they become more self-aware and awake, children sense in these accounts nourishing archetypes. They identify with the characters' qualities, gain self-understanding, and begin to comprehend profound questions of human existence. Myths are to be found in cultures all over the world, but those of Iceland preserve a deep human psychology and cosmology of the world.

Idun and Her Apple Tree

The Scandinavian goddess Idun tends the Tree of Life, which bears the apples that keep the gods young. When she is abducted by a storm giant, the tree suffers, and for the first time signs of age appear among the gods. Growing older and more conscious can be disturbing for anyone at any stages of life. The theme of ending childhood innocence and the beginning

of a new, exciting period in life pervades Norse mythology. This theme can be valuable for children going through analogous changes.

Tree: The Nine Worlds of the Scandinavian universe are held up by Yggdrasil, the World Tree. In the middle world, the first two human beings Ask (Ash) and Embla (Elm) were created out of trees. The tree with its branches is thus a picture of macrocosm becoming microcosm, or of world becoming human being. Children are attracted to drawing and modeling trees, which can unconsciously express their own personalities.

• Make a ball (a seed or the universe!) and elongate it into a trunk with a base that only hints at large roots.
• Form out branches upward; and make them thinner as they stretch upward.
• Shape little leaves and apples and press them carefully on the delicate branches.

> *Gestures*: growing upward, branching out.

> *Display*: A wide layer of thin green beeswax or colorful construction paper can be laid on a table. Press and stick the tree trunks onto this ground, and create a forest or orchard.

Idun: This lovely goddess might have a flower wreath in her hair, or other beautiful features of your choice.

> *Gestures*: holding, reaching.

Thor and His Hammer; Loki and the Midgaard Serpent

In a famous tale, the willful thunder god wakes up one morning and finds his ultimate weapon stolen by a frost giant. The clever trickster-god, Loki, helps the raging Thor retrieve it by disguising him as a bride. Later, however, in an apocalyptic story of the Final Battle, Thor succumbs to the gargantuan Midgaard Serpent, an offspring of Loki.

Thor: This choleric god's beard, hair, and body can bristle with restless gesture and action.

> *Gesture*: swinging hammer.

Midgaard Serpent: As with the dragon, allow the children to find their own "monstrous" forms.

> *Gesture*: winding.

> *Colors*: red or orange for the gods; green for serpent.

Loki: This mischief-maker fascinates many a child. He is portrayed in sleek, flame-like forms like Rumpelstiltskin.

The Basic Exercise

This exercise from the introduction should be regularly repeated as a fundamental experience and possible prelude to further transformations.

• *Take a piece of soft, malleable material (clay, wax, dough, or the like), that fits comfortably in the hollow of one hand (about walnut-sized on average: adjust size depending on age and individual). Subtly move the substance around in the hand and discover a simple shape. Stop here, if you want. Pure forms need not always be developed into representations of things in the world.. Or continue on to the next choices, using two hands: (1) With two hands, continue to develop, as a pure form, the simple form you discover in one hand. Stop here, if you want.*
(2) Look at your basic, pure form. What does it want to be? Let your imagination guide you into forming it with two hands into a simple human, animal or other form of nature.

• *Basic forms may be discovered by employing two hands from the very beginning. These forms may remain pure or be developed into representational figures. Use a bigger ball of material that fits comfortably in the spherical space created by your two facing, cupped hands.*

The Human Figure in Clay

Going from modeling the human form in wax or plasticine to clay can be exciting, but also challenging. Novices need to become familiar with clay's nature, limitations, and potential. It is a very pliable and responsive medium that stiffens and hardens. Less detailing and refinement are possible at first. The moist mass of clay can sag, break off, and respond to gravity in unexpected ways. In the clay figure, arms should remain only slightly suggested and legs draped for the ten- to eleven-year-old sculptor. (Later, in middle grades and high school, modeled arms and legs can gradually emerge farther out from the body.)

Human Forms in Our Hands

All the basic characteristic gestures of human form and development are implicit in the formative gestures and space-creating qualities of our hands.

Small Format

Figures developed in a single hand may be done as a review and prelude to moving on to larger lumps of clay that fit between two hands.

• With one hand, make a small ball that fits in it nicely.
• Work the ball into an egg, using only one hand.
• In one hand, grasp the oval shape firmly with the narrow pointed end peeking out between the round hole created by your thumb and index finger. Gradually squeeze the end of the egg so that a head emerges with a neck.
• Now with two hands elongate the body, flatten its base and stand it up .
• Take the piece up again and model further into a human form. Various positions are possible, such as the ones indicated in the next format.

Larger Format

- Take a larger lump of clay that fits between two hands comfortably and shape it into an ball and then an egg shape.
- Embrace the pointed upper part of the oval with your thumb and index finger and gently and slowly press in a neck and then separate and form a head.
- Form simple arms attached to the body. Legs can remain unarticulated or only partly suggested.
- Model your figure into characteristic human positions such as the following examples.

 All exercises may be preceded by first putting only hands in the characteristic positions and gesture of the exercises.

- We are in the horizontal after birth or during sleep. The bed of the hand cradles the *lying* human form. Hold your figure in this position.

 You may transform your figure from one position to another as indicated in the next steps, or model each stage as a separate piece.

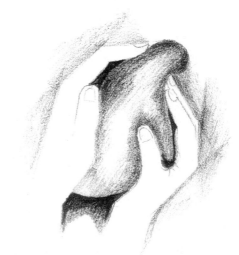

- We can also rise part way and *kneel*. One hand curves with our back; the other forms an angle with our front.

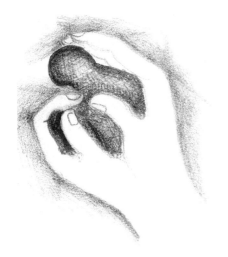

- We *sit* up and *crouch*. One hand arches with our back while the other embraces our knees and front.

- We stand in our full human *uprightness*, our heads freed toward the heavens and our feet on the ground. One hand holds the human form vertically; the other supports it horizontally; or we hold and behold our human form in the sacred space between our "up-pointing" hands. (Embrace the figure between your two curved hands, with its base on the lower palms).

Geometry of the Human Form: Round, Elongated, Straight

Children naturally sense how their bodies are closely related to and originate out of the substances and processes of the world around them. They perceive how the geometric forms of nature are reflected in their own physical make-up and vice versa. This awareness strengthens both their self-confidence and knowledge of self.

The roundness of our heads is echoed in the water drop and certain seeds and fruits, and in the shape of the sun and full moon. Our limbs radiate like branches of trees or light rays of a star. Children love to imagine being a star as they stand with the five points of their one head, two arms, and two legs stretched out.

Our trunk, standing somewhere in between the round and the linear, has its own combination of partial curvatures and elongation. The following exercise is different from most others in this book in that it breaks up a whole to demonstrate geometry. Children will enjoy it as a change and contrast.

• Model a ball of clay, the whole round world fitting comfortably between your hands.
• Have a snowman-like figure emerge that consists of small, medium, and large spheres.
• Gradually and gently separate the three spheres.
• Make the small one into a rounded head.
• Make the largest one into a cylinder, divide it in half, and then each half into quarter-sized cylinders. Elongate these four cylinders into two arms and two legs. Lay them flat on the table.
• Scoop out and set aside part of the middle-sized piece (about a third of the mass), so that what remains is a curved trunk form.
• Attach the head and limbs to the curved trunk.
• Compact the figure into a crouching, rounded position with its back curved like the moon.
• Take the remaining scooped-out clay and attach it to the back as a magic cape! You have come full circle from the original ball to a new spherical figure that is now differentiated and transformed!

This and other exercises in this book were inspired by the work of Anke -Usche Clausen and Martin Riedel.

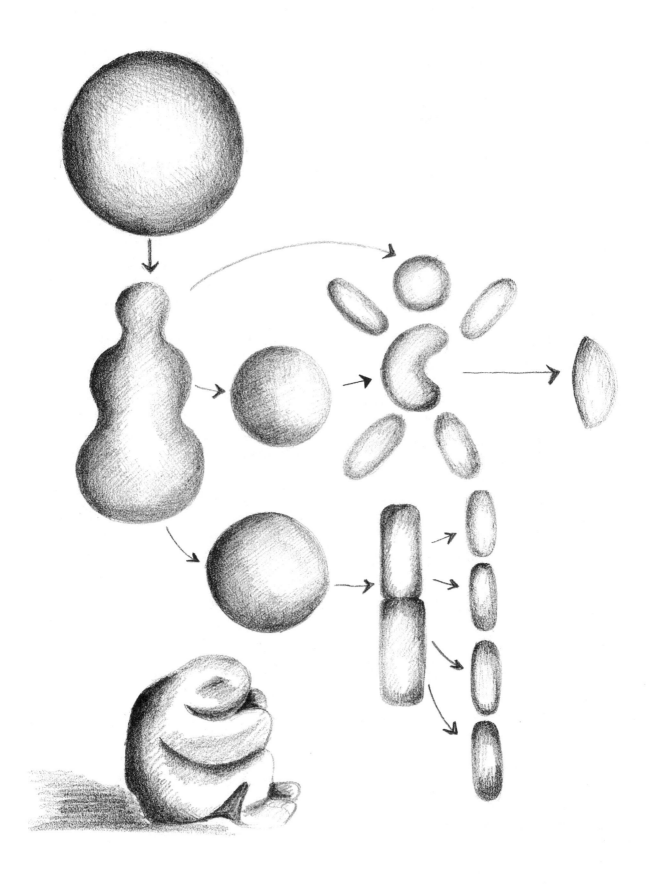

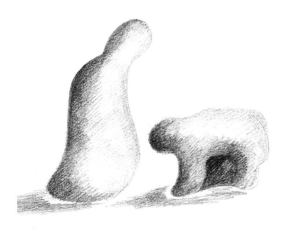

Human and Animal Compared In Basic Form and Gesture—Small Format

• Make a small ball that fits in one hand.
• Work it into an oval shape.
• In one hand, grasp the egg shape firmly with the narrow pointed end peeking out between the round hole created by your thumb and index finger. Gradually squeeze the end of the egg so that a head with a neck emerges. Press your thumb in more deeply to create the chest and front of an archetypal animal form. Place it beside the basic human figure to contrast the horizontal and upright postures.

With this figure as a foundation, the characteristic forms and features of many different animals can be added in later exercises.

• The animal form can have a lowered head and four legs that are lightly defined against the mass of clay that supports the animal's body.
• Have the human bend her head in sympathetic recognition and relationship.

Gestures: perpendicular rising/ standing upright, nodding; touching the parallel earth.

Option: Group: Make two, three or more animal forms surrounding the human figure.

Animal Studies, Gestures, and Habitats

As children mature and become more aware, they view their surroundings differently and more critically. Nature may lose some of its former magical glow, but a new interest in the natural world can light up on another wonderful level. Old animal friends are seen with new eyes and a natural desire grows to learn all sorts of facts about a great variety of creatures. Animal studies can serve as a lively way to tap a tremendous reservoir of interest and sympathy that exists in children and to connect them with the world and its natural history.

Gestures: Animals may be modeled as single figures, as groups (parent-young), or attached with the context of their habitat serving as a base (see examples below). Children often have the uncanny ability to capture the most wonderfully characteristic gestures of particular species (the playfulness of kittens or the slipping and sliding of otters, for instance). Adults can help by pointing out and modeling typical gestures as vital features that emerge from the inner being of this very mobile kingdom of nature.

Habitat is an essential element in the life of each animal. Every effort should be made to acquire the added amount of extra clay needed for this critical aspect.

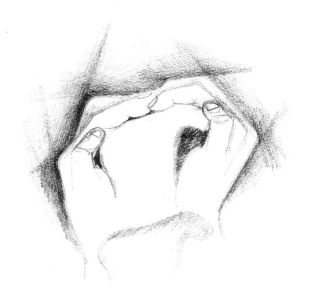

Animals Arising out of Hand Forms

The forms of all the creatures of the world lie in the space and movements between our two hands.

• Find different animal forms by playing with your hands. Guess which one is represented by the illustration above.

Moving Animal Forms into Clay

Clay fills our hand space and receives the imprints of our hand movements.

• In one hand, make a ball into an egg shape and grasp the oval firmly with the narrow pointed end peeking out between the round hole created by your thumb and index finger. Gradually squeeze the end of the egg so that a head with a neck emerges. Press in more deeply to create the chest and front of an archetypal, generalized animal.
• Look at the form. What does this particular form remind you of?
• Start forming it into a particular animal but only to the point that it just begins to be recognizable, and then stop.
• Have others guess what it is becoming and then continue to shape it.

Archetypal Animal Forms

Hand movements can discover the characteristics of typical animal shapes through their expansions and contractions of form.

Some animals have an emphasis of mass towards the front (lion—see Series Two), the middle (bison—Series Five) and the back (bear—Series Four), or are balanced (horse—Series Six).

Changing Gestures and Asymmetry

Hand movements can impart all kinds of changing gestures to typical animal forms during the process of modeling. Which one will be the final stage at which you stop? The most lively figures have gestures of movement such as turning, rising, crouching, and so on. They move beyond a static, symmetrical representation into an asymmetrical posture of action and direction.

Animal Form Grouping

Simple typical forms can be related to and complement each other in juxtapositions of convex and concave features.

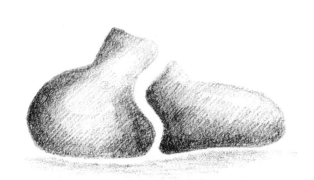

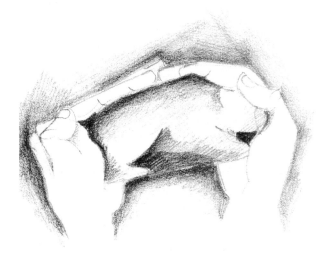

Bear in a Cave
(Study of Convex and Concave)

Like houses and forts, caves offer children an opportunity to artistically shape an "inner" world in which to discover themselves. Their modeling tendencies from ages nine on more and more can reflect the urge to explore the qualities of concavity (inner space) in contrast with convexity.

• Find a bear form in your hand space as preparation.
• In one hand shape an oval and generalized animal shape into the specific features of this wonderful shaggy being. Grizzly and brown bears have a distinctive angled bump on their backs.

Gestures: Is your bear going to lumber around on all fours, sit, lie, try to stand up, or turn his head? Remember, clay has its limitations, and you must adjust your figure to the medium. For example, you may want to try leaving a supporting mass of clay under the trunk depending on the slenderness of the legs.

Habitat: Shape out a shallow, rocky cave and place your bear within it or at its entrance. Or model the cave first and have the bear organically arise from its floor. The concave cave complements the convex bear.

Modeling is a remarkable process in that it reflects what we have observed (or not observed!) and, at the same time, causes us to look more intently. As noted earlier, children who work on a farm and have brushed cows will tend to model them with pronounced backbones, because of their intimate, daily connection and experience of the back. Then, once they have modeled a subject or seen someone else's model, they will look even more closely the next time. Hand, eye, emotion, soul, and mind support each other to create interest, connect children memorably with the world, and make it an experience.

Low on his fours the lion
Treads with the surly bear
But men straight upward from the dust
Walk with their heads in air.
The free sweet winds of heaven
The sunlight from on high
Beat on their clear bright cheeks and brows
As they go striding by.
The doors of all their houses
They arch as they may go
Uplifted o'er the four foot beasts
Unstooping, to and fro.

Walter de la Mare

Bird in a Nest (Convex and Concave)

In the First Series, there is the "Egg and Nest," a beginning exercise rendered in beeswax, which is the expression of the fundamental polarity of concave and convex. Stories and experiences of our feathered friends can stimulate children to make the most endearing birds snugly adapted to the immediate habitat of a nest.

• Find an egg form in your hand space. Stretch your hand into the sleek, aeroform body of a bird. Practice flying gestures.
• Make a ball of clay that fits nicely in one hand and change in into an egg shape. Hold it in the concave nest of your hand.
• Using two hands make a beak start to appear at the pointed end, then a head, neck, body, wings, and tail. Hold your bird in your cupped, nestlike hand.
• Press into another ball and shape out a large enough nest to receive your feathered friend. Hold them in the bowl of your two hands.

Gestures: turning head, protective concavity embraces convexity, fitting together, complementing.

Reminder: Whenever possible in modeling, try to have the process related and analogous to the subject and its natural process of formation. In the example above, the bird emerged from the egg with its pecking beak first.

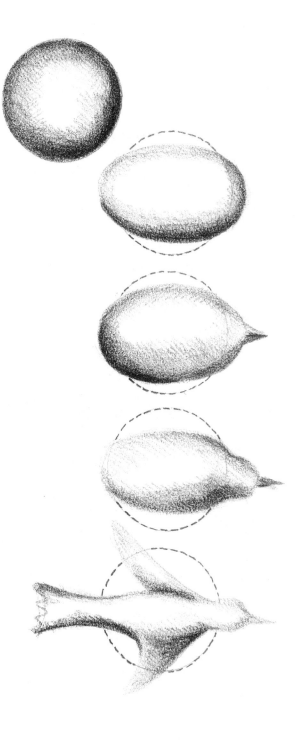

Mouse by its Hole

(Convex and Concave)

• Feel the sleek mouse form in your hand space first.

• In one hand, form a ball into an oval and press it into the generalized animal shape (small format).

• Still in one hand, elongate the form and make one end pointed and the other rounded.

• With two hands, shape out the pointed nose, large, sensitive ears, and the stringy tail (which you attach firmly to a side).

Gestures: sniffing, scurrying, turning, sitting up.

Habitat: a woody or earthy hole.

Option: Make groups of excited mice!

More Animal Themes for You to Work Out on Your Own:

- *Turtle(s) on a rock*
- *Beaver(s) on a dam*
- *Squirrel(s) on a log*
- *Duck(s) in the waves*
- *Rabbit by a hole*
- *Deer (lying down)*

Relief Map: Mountain Building

Part of growing up involves the expansion of one's sense of space and geography. Children first feel a natural affinity for the animals and plants as living aspects of the environment. Later, they become aware of the rocks and cliffs and striking features of the landscape.

Mountains are inspiring towers standing on the earth. They can be modeled very satisfactorily in clay. You need not exactly replicate a given topographical situation, but rather encourage your students to render a free approximation of a range or group of adjacent mountains that vary in height or try shaping the impression of a single mountain that has a unique form.

• On a piece of plywood, lay out an inch-thick base of clay to whatever size you want to take on.

• Guided by observations, memories, rough map drawings, and sketches, build up individual mountains by applying patches and chunks of clay and smoothing them out as you go. Watch the mountains rise higher.

Gestures: rising up, pointing to the sky.

Option: You need not make specific mountains. Children enjoy building up mountains in general. In fact, you will be surprised at the grandeur of the archetypal mountains they can conjure up with their hands.

Bridges

No matter how much you discuss the wonderful shape of particular local bridges, children will have a strong urge to design their own. These remarkable structures, that rise over rivers and precipices and connect one place to another greatly excite the imagination.

- Put hands together in bridging gestures (arched, flat, angular).
- On a small piece of board, lay an inch-thick slab of clay.
- Build up a bridge span with supports, and add details to its design.
- Model the currents of a river going beneath it.

After they have finished the bridges, children like to run their hands across them and dream. (Some children model boats gliding under the bridge.)

Gestures: arching, flowing water.

Finger and Hand Dexterity

Also remember to periodically practice exercises like those in the introduction: long and round shapes out to the fingertips and back to the palm, for instance.

Simultaneous Forming in Two Separate Hand Spaces (age ten up)

- Work pieces of material into basic forms at the same time in each hand. Make sure pieces fit the hollows of each hand and are neither too heavy nor too light.

Two-sided Double Dexterity Challenge

(age 10 up)

- Make two small elongated pieces and lay them aside for the moment.
- In a similar manner, make two small spheres that can be grasped by the finger tips.
- To them, add each hand one of the elongated pieces and move both around the hand space back and forth between the center hollow and peripheral tips. Next, do the same with the other hand so you have two pieces moving around in each! Keep feeling, forming, and practicing finger and hand agility!

Additional Ideas
from other teachers and sources:
- beaver on a dam
- sleeping cat
- houses along a street
- colonial pilgrims
- hand
- foot
- dig clay out of a local pit and process for use (perhaps as part of a study of local geography)
- simple solids such as prism form, cube, and rectangular solids modeled in the hollow of the hand

Importing From The Preceding Series: Check to see if there are ideas in the preceding series that you have not explored or would like to repeat, perhaps developing a variation. Many themes can be adapted from the other Series, so look through them all!

Your Own Ideas
After doing the exercises of the series, develop and record some of your own inspirations and variations.

Fifth Series

Modeling teaches patience and the capacity to carry through.

Full-time modeling and sculpture teacher, grades four to twelve

BEESWAX

Metamorphosis of a plant
Flower
Mushroom

CLAY

Mythological figures
Athena
Minotaur and Labyrinth
Prometheus Bound to the Rock
Gilgamesh and Enkidu
Gautama Buddha
Greek Temple
Tablet Inscribed with Cuneiform
Seated Egyptian Queen or
Pharaoh
Sphinx
Pyramid—Geometric form
The Basic Exercise
Animals
 Threefold Form
 Metamorphosis
 Seal
 Bison
Human Figures
Pure Form: Convex and Concave

SALT DOUGH

Relief Map of North America

Metamorphosis of the Plant

The growth of a plant in stages is an important phenomenon for young people to observe and imagine. Following its miraculous unfolding allows them to apply their growing powers of thought to the living process of metamorphosis. The modeling process of whole pieces in gradual stages, as has been described, helps students grasp the miracle of growth regardless of what theme or subject.

Materials: As older children take up clay enthusiastically, they may leave beeswax behind. Sculpture and modeling, however, particularly with clay, do not lend themselves artistically to many of the delicate forms of plants. (Some partial features of plant form, however, can be captured in clay.) Returning occasionally to colored beeswax for specific purposes such as a botany project can be a welcome change.
• Before modeling specific plants with colored beeswax, model a sphere of green beeswax one inch in diameter into a bulb form.

Have students imagine how this form would change as a plant in the earth. Perhaps they could shut their eyes and picture the process.

• Have a thick shoot grow up out of the bulb, show small rootlets developing at the bottom, add two leaves at the sides, and a thick bud at the top of the growing stem.

• Open the bud out into the chalice form of a blossom, both calyx/corolla with a small pistil arising in the middle.

This gives students a sense of the plant's growth as a flowing process and a cycle in time from seed to stem/leaf to bud/ flower to fruit/seed. Buds, fruits, and other plant forms can be explored separately.

Flower
Flowers of any kind can be done intricately and colorfully in beeswax. They call for a combination of sculptural forming and constructional additions.

• Shape a ball of green beeswax (seed form) into a stem, a couple of branching leaves, and a bud form. Pay attention to the form and position of leaves and other parts on actual plants.
• Open the bud into the five sepals of a calyx.

• Form delicate, transparent petals and insert them carefully into the calyx chalice as the folding forms of the corolla. The minuscule pistil and stamens need not be attempted if you model a rose, but might be tried with other flowers.

Gestures: Unfolding, enfolding, expansion, contraction.

Options: The main form of other flowers can be tried (lily, daffodil, and so on). Younger children love to invent their own flower forms.

Mushroom
These strange babies of the plant kingdom are part of organisms that exist mainly underground, with fruits above the surface.

• Out of a round ball, form the stem and, at the same time, shape out the cap. Make the stem have a broad stodgy base to stand on.

Materials: These substantial earthy forms are well suited for rendering in clay or beeswax.

Option: Take a pencil tip or another sharp point and make serrations (gills) under the cap. If beeswax is used, add colors to the mushroom.

Mythological and Legendary Figures

Athena

The Greeks knew the secret connection between mind and hand. The majestic goddess Athena inspired their culture (and hence our own) with wisdom and power. She was also patron of weaving and handwork. She was born by springing from the head of Zeus (thus curing him of a terrible headache).

• Make a ball of clay into a head-like form without refining any features.
• Have the upper part of Athena's figure emerge and then shape the rest of Zeus's head into her lower body.
• Add features of folded robe, hair, helmet, shield, and spear.

Gesture: Springing forth, emerging.

Minotaur and Labyrinth

Within King Minos's labyrinth on Crete there lurks the savage Minotaur, half man, half bull, prowling for victims. The sacrificial Athenian youth Theseus is helped out of the labyrinth's terrible convolutions by the princess Ariadne. She gives him a golden thread, which, like thought, guides him through the twists and turns of a dangerous and complex world. She offers a clever device along with her love and saves Theseus from falling prey to the beast.

• Have the horned bull's head emerge from the ball of clay. Shape out the rest into a human body, except add a tail !

Option: If you have enough clay, design a labyrinth or maze with clay floor, rising walls, and dark passageways. Like the adobe village, this can be done on a large scale as a group endeavor, or small models may be done individually. All sorts of sizes and approaches are possible.

Gesture: Charging forth.

Prometheus Bound to the Rock

The human figure emerging from the rock can be a very moving subject to depict. Study Michelangelo's unfinished sculptures ("Slaves," for example).

Gilgamesh and Enkidu
Wrestling: Stormy Friendship

The Epic of King Gilgamesh and his moving friendship with Enkidu, innocent stranger from the wilds, is a tale of life and death to be told and retold. They meet their match in each other during a dramatic bout of wrestling.

This theme may be connected with Greek Olympics or simply be portrayed as a struggle between two human beings. (See Wrestling Figures, in Series Six.)

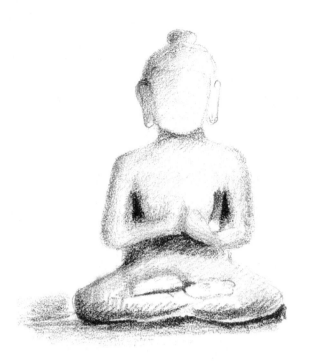

Greek Temple Relief Facade: Parthenon of Athena (simplified)

• With a stiff wire, cut slabs of clay one inch thick, and put the pieces together on a small board to form a rectangular slab five inches by eight inches (the approximate proportions of the golden rectangle used by Phidias and other ancient architects in designing temples such as the Parthenon).

• In relief, superficially model the forms of the front of the Temple of Athena (Parthenon) using a sketch or picture: three protruding steps (stylobate), the front curves of eight Doric pillars (only four are shown above) with vertical fluting (entasis), simple capitals, and, horizontally above them, a decorated cross beam (entablature) and triangular roof gable (pediment).

• Forms can be impressed with fingers in the clay to a depth of half an inch. Roof and steps stick out a little. Work out the depths yourself. This is a good exercise for sensing proportion.

• Detailing such as fluting of columns and the decorations of triglyphs and metopes on the entablature can be inscribed with a sharp pencil tip.

• After these temple reliefs dry flat, they can be leaned upright against a wall or glued onto a board and hung on the wall.

Options: In three dimensions, try modeling an entire temple, a combination of construction and sculpting, or try making single pillars of different types. Doric and Ionic are the easiest to render; Corinthian is a wonderful challenge. Remember not to overdo exactitude. These are beautiful "sketches" that give memorable impressions.

Gautama Buddha

The biography of Siddhartha and how he encounters the realities of life is a moving story for young people. The calm and contemplative sitting position is a wonderful contrast to the wrestling dynamics of the previous exercise.

Temples

Temples from many different cultures can be modeled in part or as a whole.

Tablet Inscribed with Cuneiform

The Babylonian legend of the Epic of Gilgamesh, one of the first stories ever recorded, is five thousand years old. Many versions were discovered in cuneiform writing on dozens of clay tablets.

• With a wire, cut half-inch slabs of clay and make a square or rectangular tablet.
• Refer to a text of cuneiform and imprint letters into the clay with a wedge-tipped stick that you whittle yourself. Originally, inscriptions were made with a stylus.

Cuneiform examples for copying:

Uruk

Euphrates River

The Bitter River

The Mountains
Without End

Hear me, great ones of Uruk
I weep for Enkidu, my friend
Bitterly moaning
I weep for my brother.
All the wild tailed creatures that
nourished you weep for you.
All the paths where we walked together
 weep for you.
The mountain we climbed weeps for you.

The Epic of Gilgamesh

Seated Egyptian Queen or Pharaoh

Egyptian clay and stone figures stare at us from eternity and into eternity. No other culture in the world has left such a sculptural and architectural legacy as this one from Africa.

• Square off the sphere of clay into a rectangular solid, and, from the upper part of the standing block, shape the head and upright torso first. Next, form upper arms at the sides and show the lower arms on top of the thighs, hands by knees. The feet can protrude out from the bottom of the throne.
• The throne may remain a solid block with a solid back. The body of the figure fits and follows the throne as a seated right angle. Egyptian figures often give the impression of being still part of the rock from which they were carved.
• Add features such as Egyptian headdress, beard, scepter of guidance, and flail of power. Sometimes Horus, the falcon-faced god, covers the back of the head and whispers wisdom and advice.

Gestures: Rigid, upright, serene gaze.

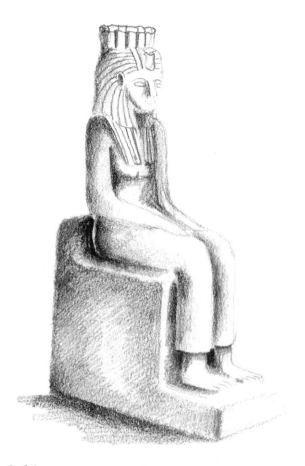

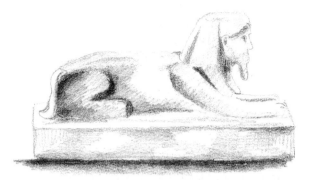

Pyramid: Geometric Form

These wonders of the world were once covered with white shimmering limestone and topped with a shining point. Pyramids of angled light rays can be frequently observed in the atmosphere with sun as the apex. The name also refers to a basic geometric shape with a square base and four equal-sided triangles as sides. You can relate this subject to mathematics, history, legend, or science.

• Make the universal sphere into a pyramid by working on all four sides (equilateral triangles) and base (square) as simultaneously as possible. Try to keep each side at the same degree of completion as the others.
• Smooth the sides and sharpen the edges so that it is a crystalline form pleasing to the eye and mind.

Option: Make the three pyramids of Gizeh, two large and one small. Align them in a row.

Gesture: wakefully, rigidly pointing up, light-filled, weighted down, grounded.

Sphinx

Many legends surround this mysterious mixed being, with the body of lion and bull, the wings of an eagle, and a human face.

• Lay a rectangular block of clay on its side and form the trunk of the sphinx, leaving a half-inch-thick rectangular platform base on which it rests.
• Shape a pharaonic head with headdress.
• Make the front legs those of a lion, the back those of a bull, and add a tail. Form wings close to the sides of the body.

Gesture: Rigid, timeless serenity.

The sphinx will pose a riddle to you: what walks on four legs in the morning, two at midday, and three in the evening?

The Basic Exercise

This exercise from the introduction should be regularly repeated as a fundamental experience and possible prelude to further transformations.

• *Take a piece of soft, malleable material (clay, wax, dough, or the like), that fits comfortably in the hollow of one hand (about walnut-sized on average: adjust size depending on age and individual). Subtly move the substance around in the hand and discover a simple shape. Stop here, if you want. Pure forms need not always be developed into representations of things in the world.. Or continue on to the next choices, using two hands: (1) With two hands, continue to develop, as a pure form, the simple form you discover in one hand. Stop here, if you want. (2) Look at your basic, pure form. What does it want to be? Let your imagination guide you into forming it with two hands into a simple human, animal or other form of nature.*

• *Basic forms may be discovered by employing two hands from the very beginning. These forms may remain pure or be developed into representational figures. Use a bigger ball of material that fits comfortably in the spherical space created by your two facing, cupped hands.*

More Animals

You can always return to the study of animals and never exhaust their countless forms. They can be easily related to the study of ancient cultures. For example, Egyptian gods may be modeled with human bodies but with their characteristic animal heads (jackal-headed Anubis, Thoth the ibis, Hathor the cow, Horus the falcon, and so on.)

Animal Metamorphosis:
Eagle to Lion to Cow

Much can be learned by comparing the different forms of various kinds of animals (birds, cats, and hoofed ruminants, for example). One way to compare them is to turn one form into the other and experience the change as you emphasize of various areas the body.

• Model a ball of clay into an oval and then into a perched eagle.
• Bend the eagle down horizontally and gradually reshape it into a lion by amplifying and shifting clay to the head.
• Transform the lion into a large-bellied cow.

Options: Transform the cow back into an eagle! These animals may also be done separately and stand side by side.

Seals on the Rock

The body of the seal is an expression of its watery habitat.

• Experience how the water-drop form (sphere of clay) gradually elongates into a forward-moving, sleek creature with propelling, planar flippers. Seals may also be shown basking on a rock, the curves of their bodies closely blending with and complementing each other.

> *Other possibilities:*
> • *Otters*
> • *Fish*

Other possibilities include:
• *Tadpole into frog.*
• *Salamander into frog into turtle.*
• *Beaver into squirrel into mouse.*

Animal Threefold Form

Different animals have different characteristic to emphasize in terms of the front, middle, and back of their bodies. Simple models of various animals may be made and compared (see Michael Martin's article in Part II).

Examples of emphasized characteristics:
• front: *lion*
• back: *bear*
• middle: *bison*
• balanced: *horse*

American Bison (Geography)

These awe-inspiring plains creatures were imbued with great wisdom, according to certain Native American cultures. Emphasize the mass of the hump in the middle similar to the cow's belly, and note the character of the large noble head as it bows to the earth.

Human Figures: Movement
Sequence

Lying on stomach

• Model an infant lying on her stomach and then lifting her head.
• Change this form to crawling, kneeling, and standing.

Lying on back

• Model a figure lying on her back and then lifting her head, sitting up with legs stretched out, and finally sitting with knees close to her chest and arms around her legs.

Option: The stages of these movements maybe done as separate pieces. Let them stand side by side.

Relief Map of North America

Very satisfying relief maps are made of clay, beeswax, or salt dough to enhance geographical awareness of the landscape and elevations.

Salt dough can be easily concocted from flour, salt, cream of Tartar, and coloring if desired (see recipe in *Choice of Materials*). Flatten and mold it on a thin piece of plywood (for example 16–18 inches square) or other stiff base.

• With the visual aid of a two-dimensional relief map of North America, first rough out the general shape of the entire continent, showing the most striking coastal features but leaving out the many island components and tiny inlets surrounding the main mass. (These will have to be left to the memory and imagination.)
• Make the mass much thicker on the left and call attention to the fact that the western side of the continent is still rising and inclines upward, whereas the eastern part of the continent is sinking!
• Push up the high sharp ranges of the Rockies, the worn, old Appalachian chain, and assorted other mountain ridges.
• Smooth out the coastal plains and the flatness of the interior plains. The aim is not to replicate exact detail, but strive for a general impression and location of the main continental features.
• Allow the map to dry overnight and the next day paint it with your choice of watercolors (warm colors for the desert areas, blue for the great lakes and major rivers, light green for the coastal plains, dark green for areas of heavy vegetation areas, brown for the mountains).

Mounting: Place a second piece of board or cardboard gently on top of your

continent and carefully turn your "sandwiched" map upside down. Lift off its original base, and brush the underside of your land mass generously with white glue. Center the base back over it. Flip it right side up holding the map and base together. Allow it to dry. Such mounted maps may be hung on the wall for display, but make sure that the base is not bendable. Otherwise, unexpected earthquake faults will appear throughout the land!

Options: Relief maps can also be made from other materials such as layered beeswax, clay, and powdered modeling mixes. Students can build mountains and form the earth's surface by pressing the clay from underneath simultaneously shaping it from above.

Pure Form: Convex and Concave

With older students, use and discuss the geometrical terms "concave" and "convex." Have students explore these in pure, nonrepresentational form, and then observe them in nature.

• Model two pieces of clay, one with predominantly convex forms and one with concave. Compare.

• Make a shape with a balance of both.

Finger and Hand Dexterity

Also remember to periodically practice exercises like those in the introduction: long and round shapes out to the finger tips and back to the palm, etc.

Simultaneous Forming in Two Separate Hand Spaces (age ten up)

• Work a piece of material into any one of the basic forms listed above at the same time in each hand apart. Make sure pieces fit the hollows of each hand and are not too heavy or too light.

Two-sided Double Dexterity Challenge (*age ten up*)

• Make two small elongated pieces and lay them aside for the moment.

• In a similar manner, make two small spheres that can be grasped by the finger tips.

• To them, add in each hand one of the elongated pieces and move both around the hand space back and forth between the center hollow and peripheral tips. Next, do the same with the other hand, so you have two pieces moving around in each! Keep feeling, forming, and practicing finger and hand mobility!

Additional Ideas
from other teachers and sources:
• plant buds, fruits, other plant forms
• Greek pillars: three types (Doric, Ionic, Corinthian)
• Greek temple and tomb reliefs (see Series Six)
• Greek vase (amphora)
• Greek drama mask
• fruit (pear, apple)
• model huge honeycomb cells and mold together
• wolf

Importing From The Preceding Series: Check to see if there are ideas in the preceding Series that you have not explored, would like to repeat, or to vary. Remember, many themes may be adapted from the other Series, so look through them all!

Your Own Ideas
After doing the exercises of the series, develop and record some of your own inspirations and variations .

Sixth Series

CLAY

Limestone Cave
Roman Coliseum (Group Project)
Medieval Castle
Reclining Figure (Mesoamerican)
Human Figures in Groups:
 Wrestling
Animals in Groups: Turtles
Horse

Geometry
 Sphere: A social exercise
 Cube
 Rectangular solid
 Cylinder
 Cone
Relief
 Horse and Rider
 Spiral

MODELING COMPOUND
(or salt dough, clay, beeswax, plasticine)

Relief map of South America

*When children gradually transform
one thing to another, as they do in clay
work, they get to experience all of the
"unfinished," incomplete phases. This
experience mirrors their own development
in which they are constantly . . . changing.
Unconsciously, I think the children know
that everything they model is themselves
and that the process is their own.*

Sixth grade teacher

*Modeling develops a good feeling for
metamorphosis.*

Seventh grade teacher

Limestone Cave

In their "colt-like" stage, young people undergo changes in the mineral structure of their elongating skeletal systems, which result in awkwardness and temporary "disorder" of their movements (see Eighth Series—Bones). Within them, however, new cognitive abilities concurrently wake up. Older children begin to grasp and appreciate logical order and they seek to understand cause and effect in physical phenomena. Formations in the mineral kingdom and their fascinating geometries, for example, can captivate the crystallizing thinking of children on the threshold of adolescence.

One such phenomenon of the natural order is the building up of stalactites (Greek = "dripping") and stalagmites ("dropped") in limestone caves.

• Take a large sphere of clay between two hands and press a cave into it with your two thumbs.

• From the ceiling of the cave begin to build "down" an icicle-like stalactite in stages. As it grows, switch to the floor of the cave directly underneath and build "up" a corresponding stalagmite. Go back and forth and recreate the geological process.

Other minerals: Other crystalline figures can be inserted in this geode-like format or modeled on only a base and without a surrounding enclosure. Beeswax may be used to make crystals. Examples: six-sided quartz or amethyst crystals, cubical pyrites.

Roman Coliseum

The down-to-earth, realistic Romans were practical builders of many architectural and engineering marvels such as roads, aqueducts, triumphal arches, and heated baths. The round Coliseum in Rome with its many-arched three stories can be constructed by an individual but ideally lends itself to a group project.

• As with the Adobe Project (see Third Series), make a thick one-inch base on which to construct the rounded, rising walls (best if they are one and a half inches thick). The building's diameter is up to you. Twelve to twenty-four inches is a good size depending on the amount of clay you have. Try to have plenty! You may also want to build these structures on a piece of plywood.

• Erect one story at a time. Make the walls solid at first, and then impress arches into them.
• As you build up each story wall, support it on the inside with corresponding stepped amphitheater seating around a central arena ring. Leave several spaces at ground level for the gladiators to enter.
• Use drawings or photographs of the coliseum to guide the formation of the model. You want to capture its marvelous shape without becoming bogged down in an inordinate amount of detailing.

Medieval Castle

Design a castle, another wonder of architecture. Students love to shape out the contours of its walls with towers in the corners.

Reclining Figure: Mesoamerican Geography

Sculptures of ancient Central and South American cultures can be studied in conjunction with geography and history. For example, the reclining Central American rain spirit, Chac Mool, is an interesting one to render freely in miniature. Pictures of various statues and figurines easily serve as the basis for clay models.

Human Figures in Groups

Relationships between individuals and in a group (peers) become increasingly important as children mature.

• Wrestling Figures

Tension and conflict between personalities can be expressed and captured in various kinds of wrestling positions. Differentiate a large ball of clay into two opposing figures rising from a base. Keep the piece unified in the process of metamorphosis.

Gesture: Lean the figures in toward each to create tension. Figures shown in the diagonal communicate motion.

Options: Two people may each model one of the wrestling figures and bring them together onto a base.

• *Mother and child(ren)*

• *Two vertical figures— short and tall*

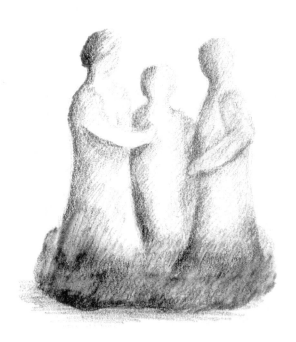

• *Three or more standing
figures of different sizes*

Animals in Groups

Studies can be made of animal parents and their young. Try to show groups of three or more subjects in dynamic relation to each other. These are excellent group projects, with each person contributing one figure to a cluster piece.

• Make a thick base of clay.
• Form animals from spheres and attach them to the base in characteristic and dynamic positions. Figures should blend into the base.

Option: Individual project: Using a large piece of clay, have multiple figures rise up from a base ground.

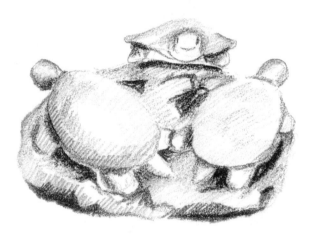

Other Possibilities:
• *Turtles, penguins on a rock*
• *Lion, lioness, cub*
• *Wrestling young: kittens, bear cubs*
• *Herd of sheep (option: with shepherd)*
• *Goats on a cliff*
• *Rabbits by a hole*
• *Bird perched on nest with hungry young*
• *Two penguins around an egg*

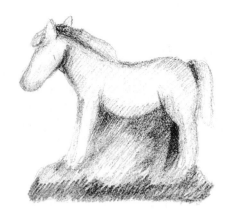

Horse

Many children love to draw horses, but find this challenging. Modeling this human companion can be a satisfying and accessible way to come to know its form.

• Make a large sphere of clay into an oval.
• Press the pointed end into a head and neck.
• Elongate the body.
• Form legs, indent concavities between them, and leave supporting material under the belly.
• Form finer features (curve of back, face, eyes, nostrils, mouth, mane, tail, hoofs). Study the hind leg and the origin of the hock (elevated heel).

Geometry

Like drawing, the manipulation of clay and other modeling materials supports and strengthens an increasing geometric intelligence. New powers of mind and emotion love to reach out to the mental challenges and beauty of geometry.

Geometric Solids

From age nine and ten onward, children gradually develop a new awareness for mass, volume, solidity, and proportion in the world around them. Hands-on experience of regular, solid forms paves the way for advanced mathematical concepts.

Most of the exercises described up to this point have actually involved quite complex topologies. An analysis of the form of a bear, for example, reveals quite a complicated set of mathematical relationships. Children create such forms, however, relatively naturally and often with an almost dreamy ease.

In contrast, geometric solids appear deceptively simplified but can actually prove to be more of a challenge because they demand a new exactitude to attain satisfactory results. Making these regular forms has an awakening effect. Children of earlier grades can do them, but it is the eleven-to-twelve year-old student (and older) whose new clarity of thinking and perception really enjoys the clear, defined edges, points, and surfaces of these regular geometric forms. In addition to the pyramid (Fifth Series), there are other regular geometric solids that can be considered:

Cube (Hexahedron)

• Make a sphere of clay and gradually press, flatten, and square its surface into six equally square sides (three pairs of parallel sides).
• Concentrate on making the six square sides as regular as possible.
• Make the cube's twelve edges as straight and distinct as possible.

Revisiting the Universal Sphere: A Social Exercise

Different people imbue their pieces with surprising variations of qualities—different shape, surface texture, warmth, weight—even when working on identical exercises. This exercise strengthens the sculptural sense of touch as well as the appreciation of creative diversity.

• Have the individuals of a group each make a tennis ball-sized sphere of clay.
• All stand in a circle, close eyes, and pass the spheres slowly around from person to person until someone senses he or she has his or her sphere back.

Rectangular Solids

These right-angled cousins of the cube can have both rectangular and square sides. Design your own!

Cylinder

• Round the sides of the rectangular solid above to form a cylinder. Then, remake the cylinder into a rectangular solid.

Cone

Pure Form Characteristics

As you model, periodically explore and bring to the attention of children the basic characteristics of form, their qualities and combinations:

convex

concave

flat planar

convex and concave meet and form an edge

concaves meet and form an angle

convexes meet and transition from one to the other gently and smoothly, or with a marked crevice

doubly curved/ bent surface is a saddle-like form that is simultaneously convex and concave and can be found in the human body

Many free forms in clay can be playfully discovered by the hands. Free forms incorporate many of the above characteristics.

• *Make up your own combinations and variations.*

Shadows and Drawing

We perceive and "read" sculptural forms by touching and seeing them with our hands and with our eyes. As we look at them, we discern their contours in the interplay of light and shadow. Geometric solids lend themselves readily to a study of how different shapes cast various kinds of shadows.

• Place a lit candle next to a cube of clay (or other geometric solid) and see how the shadows falls.

• In charcoal or pencil, sketch the object and the configuration of shadows on it and around it. With older children, occasionally drawing sculptural forms teaches them to see the forms more clearly.

Relief

There are all kinds of motifs and themes that can be done in relief. This might be called sculptural picture making. This method allows for quite dramatic positions, since the figures are so firmly attached and imbedded in the substructure of a base. Study Greek and Roman temple and tomb reliefs for ideas and examples.

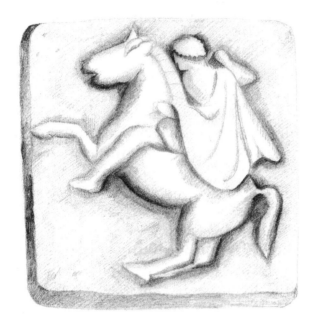

Horse and Rider

• On a modeling board, form a rectangular piece of clay twelve inches wide, by eight to ten inches high, by one to two inches thick. (This can be done in smaller dimensions if less clay is available.)
• Press into the clay and form the general impression of a rearing horse with a rider on its back.
• Bring more form into the main parts and then start detailing. This horse can have an arched, extended tail as well as refined legs and sharp hoofs.

Spiral

The logarithmic spiral of life is found in many aspects of nature. Spirals can be captured as dynamic motion in clay.

• Prepare a square slab of clay one inch thick.
• Raise up and shape the rope-like body of an outward-curving spiral. Its width need not be uniform and can go from thick in the center to narrower at the end, or vice versa.
• Be playful with the sculptural effects that should impart a dynamic of movement.

Option: Other kinds of spirals (Archimedean, helix, for example.)

Relief Map in Modeling Compound

Art suppliers carry various compounds that can be mixed with water to form a very malleable and useful medium. While salt dough is an easy and inexpensive option, students may also like to experience another more sophisticated material. These substances when wet adhere to plywood and make excellent relief maps that can be painted when dry.

• Follow applicable instructions for relief map of North America (Fifth Series).

- *crystal forms*
- *characteristic forms of mountain ranges: granite, chalk, volcanoes*
- *waterfalls with boulders*
- *Roman oil lamp / Roman head*
- *cathedral*
- *farmer and horse*
- *dig clay out of a local pit and process for use (as part of modeling lessons, study of mineralogy/ geology*
- *shaping gardening beds (earth sculpture)*
- *design simple furniture shapes: chair, throne, couch, table, cradle*

Importing From The Preceding Series: Check to see if there are ideas in the preceding Series that you have not explored or would like to repeat, perhaps developing a variation. Remember, many themes can be adapted from other Series, so look around!

Your Own Ideas
After doing the exercises of the series, develop and record some of your own inspirations and variations .

Seventh Series

CLAY

> *Human Hand with Wrist*
> *Human Foot with Ankle*
> *Human Organs: Lung, Kidney*
> *Masks*
> *Puppet Heads*
> *Human and Animal: Girl and Dog*
> *African Animals*
> *Candle Holder*
> *Geometry: Tetrahedron,*
> * Octahedron*
> *Relief Forms:*
> * Heights /Depressions*
> *The Four Elements*

Renaissance

The very beginning of the teenage years is a rebirth and a time in life when young people are acutely conscious of their changing physical bodies and emotions. It is an perfect time to study physiology and admire the miraculous and beautiful forms of human anatomy. At this stage it can also be valuable for students to become familiar with the art anatomy of such sculptors as Michelangelo. After admiring details in a work such as the marble Pieta, they can appreciate the challenge of modeling their own hand or foot in clay.

Hands at this age enlarge, grow stronger, and can manipulate larger pieces of clay (grapefruit-sized and bigger). Older students can enjoy tackling larger and larger formats.

The Human Hand with Wrist

The hand is very expressive and speaks with gestures all its own. It can be modeled in a variety of positions. Try to imagine all the different possible configurations before you decide on one to model.

Although the hand can be modeled by itself, it is more satisfactory to give it a one-inch wrist. Vertical hands can stand nicely on the wrist as base. Hands in more horizontal positions often need a supporting base. Note that clay fingers are less apt to break off if structurally positioned close together or attached to a support. Such technical measures are not absolutely necessary, however, in this context of artistic playfulness and in the process of educational exploration.

• Make a ball of clay a little bigger than fist size.
• Rough out a mitt-shaped form and begin to articulate fingers and palm. Study your own hands.

• When the hand is nearly formed, you may lay it down or stand it up to work on it. It may be attached to a rough base if you have one.

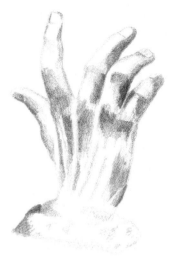

Hand by Rodin: *"Sculpture is the knowledge of hollows and bumps."*

• The amount of detailing is optional. Marvelous gestures and other features can be captured in an hour's work and left at that. If there is more time, knuckles, joints, lines, and nails can appear in two or three hours (more time is useful, too). Each "sketch" has a virtue of its own. Don't be dissatisfied if a piece is not absolutely realistic. Some of the most expressive and charming studies are quick renderings.

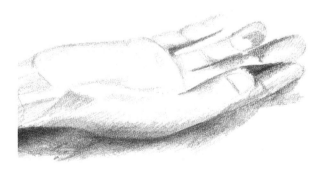

Gestures: All kinds using basic positions: upright; horizontal palm up or down; cupped receiving; clenched fist; fingers straight or curved, pointing, splayed, or together; thumb or pinkie in or out; opposing thumb touching other fingers; two hands praying; handshake; virtually anything is possible.

Options: (a) make a rough, rock-like base one to four inches high upon which to attach the hand; (b) model the subject as one piece with the hand rising up out of the base.

The Human Foot with Ankle

Before you model your foot, try writing with one of your feet by holding a pencil or crayon between your toes. You may well find that there is an interesting contrast between the capabilities of your various appendages! At a minimum it will probably bring a little levity to your serious anatomical absorption. Humor is a secret ingredient in the education of adolescents.

• Articulate a large elongated piece of clay into the three parts of the foot: toes/ball, arch, heel/ankle. Study real feet as you work.
• Feet need no base, and if not on tiptoe can stand on their own.

Gestures: tiptoe, toes up and apart, and so on.

Human Organs

With clay, students can explore the fascinating forms of internal organs. Good examples are the asymmetry of the lungs and heart, or the symmetry of the bean-shaped kidneys.

Lungs

• In relief, map out the lung's two-part left lobe, and the three-part right lobe, the trachea, and branching bronchi.

Kidneys

• Modeling two kidneys is an anatomical mirror-image exercise.

Masks

Teenagers are in the process of finding their own new identities and personalities. The term "personality" is derived from the word "per sonare," meaning "to sound through the mask." The classical Greek drama was the source of this device. Making a mask of a human face can be a powerful and significant exercise in expression.

Masks can be done in a variety of modes: self-portraits, general human faces, caricatures of human types or moods (choleric, angry, melancholic, sad, frowning, happy, smiling, etc.). Facial proportions need to be studied and taken into account (see Eighth Series—Head in the Round). More abstract masks can be made in conjunction with studies of the art forms of other cultures such as African tribes.

There are many ways of and materials for fabricating masks. Here are two methods:

Example 1: Heavy Decorative Clay Mask
One of the simplest ways to make a mask is to take a large sphere of clay, press it on a table into a oval hemisphere, and model facial features into it. Such decorative masks cannot be worn, but serve the basic purpose of modeling a face. When hardened, they can be leaned up against a wall for an impressive display; or when the solid masks are half dry, you can scoop the clay out from behind, leaving the mask between one-half to three-quarters of an inch thick. (This can be fired in a kiln.)

Example 2: The following combines the sculptural advantages of clay with the lightness of cloth.

Greek mask showing fear

Stage 1: Light Decorative Clay Mask

• Make a face-shaped oval of crumpled newspaper that is thick in the middle and tapered toward the edges. This base conserves clay.

• Overlay the paper base with a layer of clay three-quarters of an inch thick. Smooth the clay into a face-shaped oval.

• Indent eye sockets and pull up nose, lips, cheek bones, and chin.

• Add clay where needed to enhance features.

• Allow a day to dry, remove newspaper, and you have a lighter, more delicate clay mask.

Stage 2: Very Light Wearable Mask

If you want a still lighter mask that can be worn, leave the newspaper underneath the clay and continue as follows on a second day:

• Cut a piece of felt that is a little larger than the clay face, enough to cover the clay completely when smoothed down over its contours.

• Saturate the felt in plenty of white craft glue and carefully mold it over the face.

• When it bunches up in places or forms unwanted wrinkles, perform plastic surgery with scissors by slitting the felt into flaps that can be overlapped. A good place to do this is often at the sides of the eyes, where you can either control the wrinkles or leave the wrinkled felt for an aged look.

• Allow the mask to dry and brush on two to three or more layers of glue.

• On the third day, pull out the newspaper and very carefully pry and crack out the clay with a screwdriver or comparable utensil.

• Coat the inside and outside with more layers of glue to strengthen the mask. Let it dry thoroughly.

• Paint it as you wish and glue on yarn or other materials for hair. (You may stop here and have a light decorative mask to be put up easily on the wall.)

• Cut out the eyes and mouth with a mat knife.

• Attach an elastic to the sides so that the mask can be worn on the head, or add a stick to the chin to create a hand-held version.

Facial gestures: all kinds: wide-eyed with mouth open in laughter (comedy) or horror (tragedy), smiling, frowning, and so on.

Preparation Tip: As a matter of principle, especially for teachers, it is always best to practice making prototypes and go through the process first yourself before you launch into it with children.

Puppet Heads

Performing a puppet show allows older children to connect with the younger ones in a very worthwhile way. They re-live part of their own imaginative younger years on a new level.

Puppet heads can also be made using clay and felt (refer to previous mask method):

• Make a fist-sized ball of crumpled newspaper with a neck.
• Cover it with a half-inch-thick layer of clay and shape it over the base into a head and neck.
• Mold facial features and allow the puppet to dry.
• Cover the dried head with a suitably sized square of felt soaked in white craft glue and mold it to its contours.
• When it bunches up in places and forms unwanted wrinkles, slit the felt into overlapping flaps.
• After the head has dried, brush on more coats of glue to fortify it.
• Pull and pry the newspaper and clay out carefully and you have a light little head to paint and decorate.
• Trim the neck evenly to go over your fingers.

• Design clothes to go over your hand and wrist. You may sew them to the neck if it is first softened by soaking it very briefly in hot water.

It is beyond the scope of this book to describe all the marvelous elements of puppetry that can fully engage older children. Needless to say, it is a total work of art and involves most of the arts as you sew costumes, invent props, draw and paint backdrops, scenery, act, play music, and speak.

Human and Animal

Revisiting the forms of our sisters and brothers the animals keeps us in touch with kindred souls. Special relationships between humans and animals can be shown in various combinations.

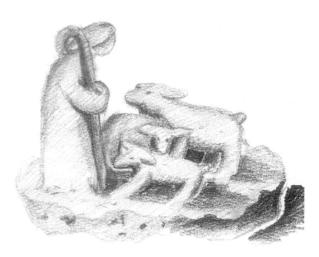

Girl or Boy and Dog

• To a rough clay base (ground) mold two figures in conversation. The human figure can be at least eight inches high. Each should have a gesture towards the other. For example, the human could be sitting on the ground and leaning forward with the dog looking up (or licking the person's face!). Think of other juxtapositions that have movement in them .

> *Other possible subjects :*
> • *Shepherd and two or more sheep*
> • *Rider on horse*
> • *Child and kitten*

African Animals

The continent of Africa lies between your hands and its extraordinary forms are waiting to emerge.

> • *Hippopotamus*
> • *Rhinoceros*
> • *Camel*
> • *Giraffe*
> • *Elephant*

Contrast and compare the animals by modeling separate pieces, or turn one into the other:

• *hippopotamus—camel—giraffe*

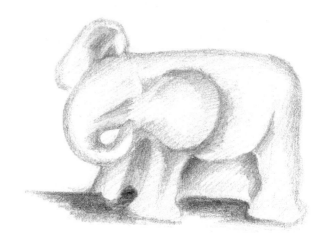

Candle Holder

• Design your own single or multiple candleholder by pressing a hole into a clay form with the actual candle.

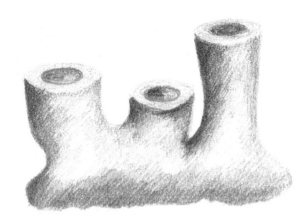

Geometry

There are only five regular solids, and you may have already modeled one (the cube) in the Sixth Series. Two more appear here. The final two, the dodecahedron and icosahedron, will be added in Series Eight, in which all five will be modeled as a set.

Tetrahedron

• Press a sphere systematically and evenly from four sides and create four equal-sided triangles, four apex points, and six straight sharp edges. Looking directly down on it, you should see an equilateral triangle.

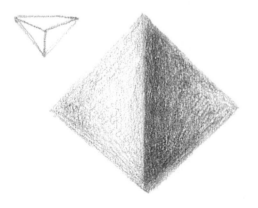

Octahedron

Figure out how to make this so-called Platonic solid with its eight equal-sided triangles, six points, and twelve edges. *Hint*: How does it relate to the pyramid?

See "Transformations of the Five Platonic Forms" at the end of the Eighth Series.

Relief Forms

Simple relief exercises can be done to give a sense of the transition from the two- into the three-dimensional.

Heights and Depressions

• Take a large sphere of clay, let it fall on a surface, and let it naturally flatten out to form a flat base.
• With the fingers and thumb, grasp the clay so that high, medium, and low areas of height arise.
• With the ball of the hand, add some deep depressions.
• Explore and refine this "form landscape" of concave and convex with the sensitive tips of your fingers.
• Display pieces together and discuss the character and feeling of each.

The Four Elements

Model forms that show the dynamics of single elements or of combinations of them:

- **fire meets air**
- **air meets water**
- **water by hard rocks**

Additional Ideas
from other teachers and sources:
- Renaissance bas relief
- plaster fresco
- ship hull (caravel, galleon)
- moving figures: turning, bending, pointing, reaching (use minimal facial features)
- African masks and sculptural figures
- Relief map of Africa

Importing From The Preceding Series:
Check to see if there are ideas in the preceding Series that you have not explored or would like to repeat or like to vary. Remember, many themes can be adapted from other Series, so examine them thoroughly!

Your Ownv Ideas
After doing the exercises of the series, develop and record some of your own inspirations and variations.

Eighth Series

Modeling cultivates limb wisdom, brings the children who tend to be talking heads into their hands (potent medicine), builds spatial comprehension, promotes artistic sensibilities (balance in composition, feelings about lightness and heaviness, beauty in line, grace in movement), and promotes a sense of completeness.

Sixth grade teacher

CLAY

Human Anatomical Studies
 Human Head in the Round
 Ear
 Bone (Femur)
 Joint: Ball and Socket
 Skull
Human Figures in a Group
Stages of Human Development
Faces
Geometry: Five Platonic Solids
Reliefs
 Musical Modes
 Concave to Convex
 Coast of Maine Rock
 Multiple Sections
Box with Lid: Slab Construction

The Octave

Young people reach a point where they are bursting like a bud, ready to flower in a new stage in life. They want to experience the world on a new level and find their own new insights. The adolescent soul thrives on contrasts and polarities.

This is the last series, the octave, a completion, a final stage in an artistic process that will hopefully continue into the future. Many seed exercises come to fruition and lead us through archetypal forms of the world.

Anatomical Exercises: The Human Head in the Round

The human head is a fullness in itself, rich and round like a heavenly body. Growth builds within us to form our bodies. How is it that the head's contours and features so distinctively and magically mirror a unique, mysterious personality? A head in the round is more than a mask. Its volume is the reflection of a whole deep, personal world and microcosm.

• On a board, build up a thick neck out of fat coils as is done with a coil pot (see Third Series)
• Pinch and meld the coils together as you proceed.
• Gradually extend coils out into a chin and form the back of the head.
• Continue coiling up into an oval-shaped head but leave a hole into which you can put your hand for inside work.

• From the inside, use one hand to gently push the finer contours of the face and head while the other hand holds and shapes the outside (forehead, nose, lips, chin, cheekbones, ears, etc.)
• Add clay inside to reinforce the structure. Heads can be made life-sized if you have plenty of clay .
• Close up the hole and smooth the top.
• Hair should be added as a broad shape. Texture it later with your fingers or with a small, sharp piece of wood. Experiment with different techniques and effects.

The front of the head has three regions: the domed upper part; the middle, with its concentration of senses and breathing; and the lower area with mouth, movable jaw, and transition into the neck. Consult figure-drawing books to learn many interesting features of forming the head and face, particularly the aspect of proportions. For example, the eyes should come at the midline of the face. Many people instinctively place them too high up at the expense of our lofty brow. Notice where the tops of the ears come in relation to the eyes. Modeling again can teach us to observe properly and appreciate the wonders of creation. The entire human body is architecturally designed on the basis of a remarkable mathematically principle called the Golden Ratio or Divine Proportion (see Doczi,*The Power of Limits: Proportional Harmonies in Nature, Art, and Architecture*).

The Ear

The human ear can also be rendered as a separate fascinating study to give it a more concentrated focus. Like the head, it has its characteristic proportions and three similar areas: the upper curve, the sensitive middle cavity, and the downward protruding lobe. You may want to research the names of its parts.

• Flatten a softball-sized piece of clay into a thick tablet.
• Shape out both the ear's outer curvature and its inner cavity by pressing the clay up and down in a raised relief.
•Refine your features by looking at someone's ear. This exercise lends itself to working in pairs, with each partner copying the other's ear. Look at your own ear in the mirror.

Look up the names of the different parts of the outer and inner ear. The forms of the human ear are born out of the waves of sound that stream to it from the universe.

Bones

Young people must adjust to the new relationships of leverage resulting from the growth and lengthening of their bones and limbs. They "feel" their bones in a new mechanical and often awkward way. Appreciating the amazing functions and beauty of our skeleton can be a timely and age-appropriate study.

Our framework of bones and cartilage is an exquisite and intricate sculpture. The British sculptor, Henry Moore, loved the organic forms of bones, which he portrayed in many of his works.

Depending on their availability, you can model and copy many kinds of human bones. As a contrast to the roundness of the head form, it is interesting to model the femur or thigh bone. It is essentially elongated, but curiously it has head forms at both ends, particularly the ball that inserts into the pelvic socket.

• Take a softball-sized sphere of clay (head form) and elongate it into a tubular form.
• Reproduce the subtle twisting planes of the shaft as well as the more interesting ends. You may want to place your femur on a clay base and place a prop under the middle to keep it from sagging.

Joint: Ball and Socket

Another polarity can be experienced by modeling a pelvic socket into which the ball of the femur above can fit (convex/concave).

Skull

Modeling the curved spherical human skull is a further step in exploring the head. It stands in polarity to the radial, linear femur with which it can be contrasted.
• Cover a human skull with cheese cloth.
• Have students model the general shape and proportions.
• Reveal the skull to expose the finer details. Capture the noble human forehead and dome. Avoid having it become ape-like.

Human Figures in a Group

From year to year human and peer relationships continue to be of paramount importance for older students. Two or more figures can be modeled in relationship to each other with gestures of recognition, contact, or action together.

• For instance, as a dramatic example of movement, three figures could take hands in a circle, leaning back and swinging each other around in a dance-like form.

Other examples:
- *Two figures shaking hands, side by side with arms around back, tastefully embracing*
- *Taller adult bends over to speak to a shorter young child who is looking up*
- *Mother, father, child*
- *Old woman and man in conversation*
- *Child riding on adult shoulders or back*

Recommendation : Attach figures on a common base or have them rise up out of it.

Stages of Human Development

An increasing awareness of self can entail a certain looking back on earlier phases of life. Modeling can capture certain stages and aid in this important reflective process. Try to develop some of the following special moments:

- *Baby lying on back or stomach (lifting head)*
- *Baby sitting up*
- *Child kneeling*
- *Child crawling*
- *Child's first steps*

Multiple pieces can be developed side by side to show progression.

Geometry:
Five Platonic Solids in a Series

• Revisit the cube, tetrahedron, and octahedron, and then add the last two to your set: the icosahedron (20 equilateral triangles) and dodecahedron (12 equal-sided pentagons). These last two are very difficult to approximate.

Option: Discover how to change one form into another, starting with the cube. See "Transformations of the Five Platonic Forms" at the end of this series.

Faces (Convex and Concave)

Interesting faces or caricatures with various themes can be modeled as reliefs: old, baby face, wicked, princess, king, wizard, witch, fearful, grinning, scowling, surprised, etc. Young faces are characterized by a convex, roundness bursting with life; old ones have sunken, concave features, showing the burden of more experience and awareness. (see Leonardo da Vinci's sketches of caricatures.) These reliefs need not be turned into masks.

Reliefs
Musical Landscapes and Contrasts

Clay has been described as an instrument of the music of forms. Imbue each form with a particular "minor or major key" mood, quality, and character, and compare them. Relating music to sculpture is an interesting challenge. Try to integrate the two arts!

• "Minor" form character: rounded, soft, mellow, vowel-like, touch of melancholy, dissonant, and so on.

• "Major" form character: pointed, consonant-like, prominent features.

Caricature

- Try a balanced or unbalanced combination of both of the above.

Contrast: Concave to Convex Landscape

- Impress a concave form into a large piece of clay.
- With another same-sized piece of clay, model a solid convex counterpart in the shape of the nonmaterial concave space.

Coast of Maine Rock

Certain rocks on coasts are beautifully sculpted by the surging sea.

- Your hand becomes the sculpting water and shapes a little mound of clay into a world of hollows and curves reminiscent of the working of the waves.

Multiple Sections

- Shape three forms to complement each other harmoniously and place them side by side.
- Amalgamate them into one relief form that retains as far as possible their original gestures.
- Try this with other multiples (two pieces, four, five, six)

Growing Upward

- Make a simple convex form on a base and have it grow upward.

Slab Construction:
Box with Lid:

- Roll out slabs with rolling pins on a canvas-covered table top.
- Measure and cut out sides, top, and bottom of the box and let it dry to leather consistency.
- Score, moisten, and press together the connecting edges.
- Make and trim a lid to fit and give it a handle.

(See the illustration at the bottom of the next page.)

Importing From The Preceding Series

Check to see if there are ideas in the preceding series that you have not explored or would like to repeat or would perhaps like to vary. Remember, many themes can be adapted from other sections, so examine them thoroughly!

Your Owm Ideas

After doing the exercises of the series, develop and record some of your own inspirations and variations.

Transformations
of the Five Platonic Solids

by
Michael Howard

Of the infinite number of possible polyhedrons (three-dimensional geometric figures formed of plane polygonal faces), only five are regular-regular meaning that all the faces of each one are congruent regular polygons. These five are also known as the Platonic solids because of their significance in Plato's cosmic scheme. Three of the five are formed of equilateral triangles: the tetrahedron with four faces, the octahedron with eight, and the icosahedron with twenty. One, the familiar cube, or hexahedron, has six square faces. The fifth, the dodecahedron, is formed of twelve congruent regular pentagons. The reason only five are possible will become apparent upon careful consideration of the number of degrees in each angle of the equilateral triangle (60°), the square (90°), and the regular pentagon (108°): the number of each size angle you can fit together to coincide at one point without any overlapping of sides, and the fact that the common point must by raised out of the plane in order to form the necessary polyhedral angles of the solid.

— Swain Pratt

The Platonic Solids are often made as paper constructions. They can also be made in clay. The finished forms in paper construction are usually quite beautiful. As educators we must consider not only the finished results but the pedagogical experience. In other words, we must ask: What faculties are exercised using a constructive technique compared with that of modeling? Both are equally valid, but the constructive approach exercises analytical thinking and skill, while modeling engages an intuitive thinking and organic formative capacity. The one is head and hand, the other head, heart and hand. The one process creates physical form directly from an archetype, while the other process brings the archetype to physical expression through a sculptural process involving living formative forces within us.

In addition to these considerations, modeling the platonic solids in clay makes it possible to transform one solid into the other. In this manner the students experience not only the lawful beauty of the individual forms but of the magical order that allows one solid to metamorphose into an-

other. Just at puberty, when we begin to question the objective validity of external authority (suspecting that it is merely a subjective construct of adult tyranny), the transformation of the platonic solids offers a powerful experience of an objective lawfulness that transcends any whims of the mere mortal teacher. They also reveal that the world is not limited to a static fixed order but is permeated by a living and mobile order.

1. Transformation from a Ball into a Tetrahedron

• Form a ball of clay that fits the space created when your two hands are cupped and just touching each other.

• Place the ball in your open, flat right hand. Position your open and flat left hand with the palm facing down so that it is both parallel and at a right angle to your right hand (see Figure 1a).

• Press the ball with both hands so that instead of making a curve they create two right angles. The 2 × 2 surfaces thus created

by your hands will form the four surfaces of the tetrahedron (see Figure 1b).

Without necessarily having ever seen or heard of a tetrahedron, this beginning is enough for the students to visualize the ideal archetype. The students can be helped to recognize the various elements which they need to bring out fully: four flat and equilateral triangular surfaces (tetra = four), four corners created through the intersection of 3 flat surfaces, and six straight edges formed through the intersection of two flat surfaces. In addition, it is important that they are helped to see the form elements that do not belong, such as convex and concave curves, in order to change them to the elements that do belong.

The primary orientation that will enable the students to see the right relationship of all the elements is from above.

• In the beginning rotate the form quite frequently to the four different surfaces so that from above you can check that the emerging corner at the top is in the middle of the equilateral triangular base (Figure 1c top).

2. Transformation from a Tetrahedron into an Octahedron

Students can be challenged to try to imagine which of the remaining four platonic solids could arise from the tetrahedron, and by what orderly process.

• Usually someone will see that in pressing down carefully on each of the four corners will create four new triangular surfaces (Figure 2a). The four new surfaces added to the four original surfaces suggest the octahedron. While this is correct, it is good to direct the students' attention to the changed shape of the original surfaces—they are no

longer triangles, but irregular hexagons, which, as the triangles continue to enlarge, will eventually become regular hexagons (Figure 2b). This is an important half-way point that it is essential to insist the students get right before continuing. The hexagons become irregular again before finally becoming the triangles that produce the octahedron.

• Press on the corners only when they are at the top so that the resulting triangle can be seen to be parallel to the opposite base. Do not make the new triangles too large before rotating to another corner. Try to keep all the new triangles about the same size, always looking for the smallest to enlarge so as not to lose the symmetry.

• Through the first half of the transformation, it is natural to see the form as a truncated tetrahedron with the corners cut off. After the half-way point, the students can be helped to see the emerging octahedron by seeing where the corners will appear. With one of the new triangles on the top and parallel to the base, there are three corners visible. Positioning themselves directly facing one corner, students will see that each corner should be in the middle of a square with two edges parallel to each other and the base, while the other two edges are parallel to each other but perpendicular to the base (Figure 2c).

• The octahedron has eight equilateral triangular sides, six corners, and twelve edges.

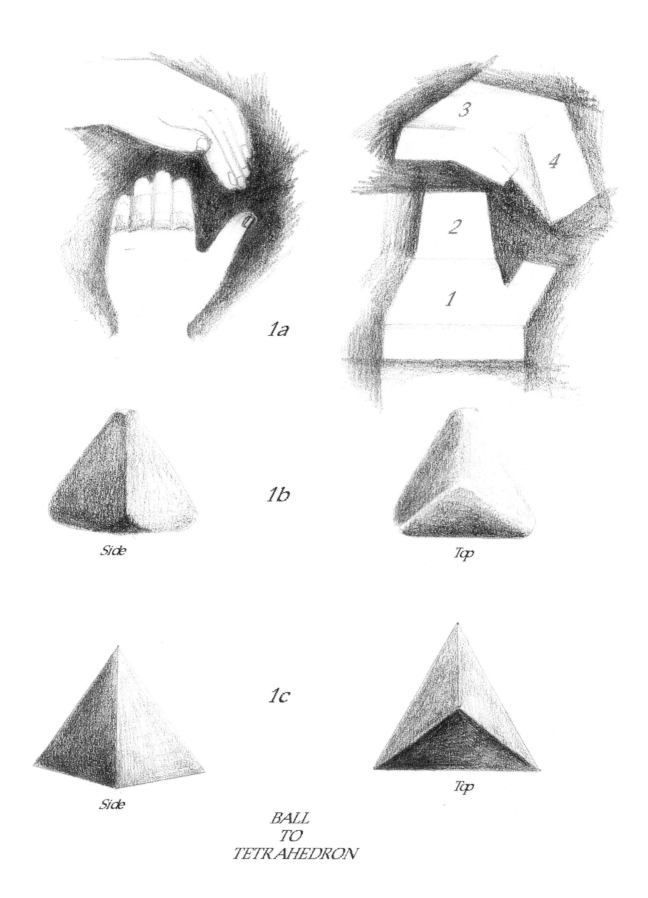

1a

1b

Side

Top

1c

Side

Top

BALL
TO
TETRAHEDRON

Side

2a

Top

Side

2b

Top

Side

2c

**TETRAHEDRON
TO
OCTAHEDRON**

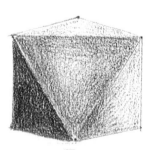

Top

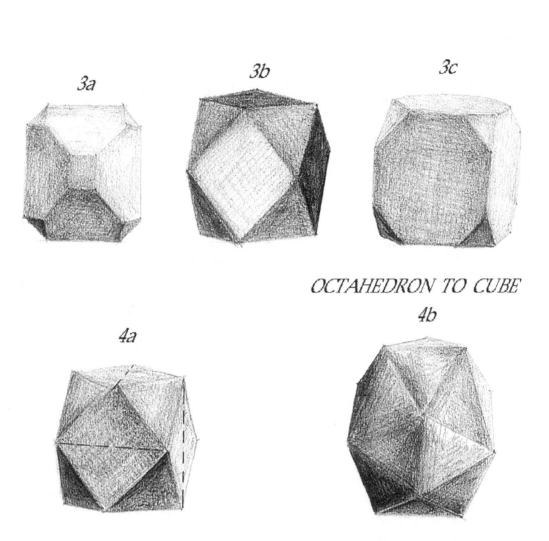

3a

3b

3c

OCTAHEDRON TO CUBE

4a

4b

CUBE TO ICOSAHEDRON

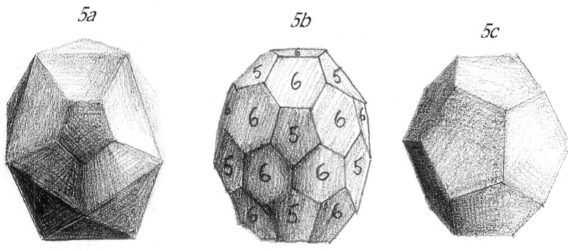

5a

5b

5c

ICOSAHEDRON TO DODECAHEDRON

3. Transformation of an Octahedron into a Cube

• Based on the same transformative principle, students will easily recognize that pressing the six corners of the octahedron, will create the six square surfaces needed for the cube. Again, this is correct, but they should be cautioned not to be lulled by such a predictable outcome, for there are challenges along the way—one surprise in particular can lead to confusion, if not a chaotic result. The challenge is not to achieve a cube any old way—anybody can do that—but to obtain the cube through the proper intermediate forms. The care and control developed in the first transformation must be sustained all the more.

• Carefully press on the top three corners of the octahedron to create squares no larger then one inch to a side. Invert the form to do the same on the other three corners. Again the eight original triangles will become hexagons. As the first of three primary steps, the students should be required to form the six new squares so that they create eight hexagons before going further (Figure 3a).

• At this point the squares should be large enough so that from now on you set the piece down on the square surfaces and not the triangles. This encourages you to press only on the square surface on the top, checking that it is parallel to the base. Furthermore, it becomes easier to see the relationship of the square surfaces to ensure that they are appropriately parallel or at right angles to each other. This orientation enables you to see the emerging second intermediate form where the squares will eventually touch corner to corner (Figure 3b).

• This is an important intermediate form to examine with the students. They will see the cube, but the eight triangles create the impression that it is a cube with the corners cut off. So close and yet so far! What is not right? The six squares should touch edge to edge, not corner to corner. But how to get this?

• Stay faithful to the process—keep pressing on the squares. Any resistance to doing this does not come from the clay but from the corners touching corners which give the impression of being rigid and fixed. In fact, if you continue pressing on the squares, but now on two surfaces at the same time, say the top and one side, the surfaces will interpenetrate so that the corner becomes an edge. When this is done to all four corners of the top square, it will no longer be a square, but an octagon.

• Rotate in turn the other five squares to the top in order to do the same and thereby have six regular octagons (Figure 3c). This is the third essential intermediate form. It now becomes clear that the new edges creating the octagons are in fact the edges that will allow the squares to touch edge to edge and thus form the cube.

• The cube, or hexahedron, has six square surfaces, eight corners, and twelve edges.

4. Transformation of a Cube into an Icosahedron

Here the transformation of the whole sequence falls out of the perfect process seen thus far.

• Once again you begin by pressing on the eight corners to produce eight triangles. Alert students will realize that if they continue in this way they will only succeed in

reversing the process back to the octahedron. You have eight triangles, but you need twenty. Where can you get twelve more? Again the mobile of mind will see the possibility of getting two triangles from each of the six squares—2 x 6 = 12 + 8 = 20. But how to get those twelve triangles?

• In a much less elegant manner than was possible to this point, you must redistribute the clay so as to build up a ridge in the middle of each square, thus bending each surface to become two surfaces. In the process, you must adjust the triangles from right-angle to equilateral. The other main factor is to get the ridges aligned in the right directions—each one should be perpendicular to the ridge on the adjoining square (Figure 4a, which is actually the same as 3b).

• Ultimate success depends on seeing as soon as possible that twelve corners are emerging, each of which is formed at the intersection of five triangles. In other words, each emerging corner should appear to be in the middle of a pentagon, in the same way you saw in earlier forms a corner in the middle of triangles or squares (Figure 4b).
• The icosahedron has twenty equilateral triangles, twelve corners, and thirty edges.

5. Transformation of an Icosahedron into a Dodecahedron

Conceptually this final transformation is straightforward. Clearly you can press on the twelve corners of the icosahedron to produce the twelve pentagonal surfaces that belong to the dodecahedron (Figure 5a). It will now also be easier to anticipate that in doing so the original twenty triangles will become twenty hexagons. Here lies the rub—to avoid a royal mess by confusing any of the twelve pentagons (five-sided) with any of the twenty hexagons (six-sided) (Figure 5b). It is purely a matter of patience and discipline.

At this point, working on a large scale is easier than on a small scale—this is actually true for the whole process. The only additional surprise and challenge is that the twelve pentagons will at the final stage become ten-sided surfaces (as the squares became eight-sided to become the cube) in order that the pentagons meet side to side instead of corner to corner. Consider yourself a Master of the Platonic Solids if you avoid muddling the twelve surfaces with the twenty triangles, and thereby arrive at the dodecahedron in the right manner!

LIST OF EXERCISES AND IDEAS

Hand Gestures

- hand conversations
- hand shadows
- curling up tight (snail in her house/ rounded head) The hand forms a living spiral !
- opening, shining and raying outwards (sun/radiant limbs)
- curving (halfway in between—feeling space)

Dialogue of two hands creating hand space:
- arching over (rainbow)
- greeting
- hugging/embracing
- receiving/holding
- giving and receiving/taking (active and passive)
- covering /protecting
- treasuring /sensing /thinking
- fitting together (doing same together)
- joining/praying
- unfolding from a bud
- sprouting (winding vine or stem)
- into blossoming
- flying (wings- bird, butterfly)

Single hands creating movement forms:
- lying or sleeping to awaking /standing upright
- bowing in reverence

Others to try:
- cower and tremble in fear
- crawl (turtle)
- run
- gallop
- slither
- creep/sneak along/stalk (cat)
- jump/hop
- snap at sniff/peck

Hand-Action Figure Stories

Hands form more figurative shapes:
- opening the doors of my steep-roofed house

Work these out for yourself:
- open the door and see all the people
- scurrying rabbit or squirrel (two fingers/ ears stick up)
- shell (listen to hole)
- hanging drop of water
- cutting scissors

Hand stories/dramas :
- talking mouths
- one hand bows/cowers before other upright (king)
- actions between tortoise and hare
- handshakes
- Traditional finger plays and games: see Emilie Poulsson's *Finger Plays for Nursery and Kindergarten* (Dover Publications)

Discovering Hand-Space Forms in the Hollow of the Hand and Imaginatively Transforming Them:

- Basic Exercise (grades one to four and up)
- Single Hand Space
- Simultaneous Forming in Two Separate Hand Spaces (age ten up)
- Forming One Piece in the Shared Space Between the Two Hands Working Together
- Hand and Finger Dexterity Exercise with Elongated Shapes
- Two-sided Double Dexterity Challenge (age ten up)
- Regularly Practising Dexterity .
- Out of the Hollow of a Single Hand Arises the Sphere , the Egg, and the Basic Human Form—Head, Trunk, Limbs— Who is Hiding in There?
- Forming the Human Figure— Smaller Format Starting in the Hollow of One Hand (recommended for children ages seven to eleven)
- A Larger New World Between Both Hands
- Forming the Human Figure Larger Format (ages ten and up)
- Forming Animals Starting in the Hollow of a Single Hand—Small Format
- Archetypal Animal Gestures
- Larger Format Animals (ages ten and up)

First Series

BEESWAX
Folk tale figures:
 Golden Ball
 Princess
 Frog in Water
 Rumpelstiltskin
Other:
 Egg, Bird, and Nest
 Acorn

 Flat, transparent forms (two dimensional)
 Leaf
 Flower petals
 Butterfly Metamorphosis
 Star
 Guardian Angel
 House of Light
 Alphabet Letters and Numbers

BEESWAX, PLASTICINE, SALT DOUGH OR SMALL PIECES OF WARM CLAY

Hand Gesture and Hand Space Exercises
 The Basic Exercise
 Simple Human and Animal Forms
 Cradled Forms
 Harmony Exercise

SAND TABLE

ADDITIONAL IDEAS
- beaded necklace
- fruits and vegetables
- passing the wax around a circle of hands so that hot hands help warm it up
- nativity scene
- candle dipping is popular in the early grades but can be done at any age

Second Series

BEESWAX
Animal Fable Figures
 Fox
 Lion and Mouse
 Grasshopper and Ants

Human and Animal—Legendary People
 Monk Francis, the Wolf and Fish
 Knight George and the Dragon

Sheltering Forms

BEESWAX, PLASTICINE, SALT DOUGH
OR SMALL PIECES OF WARM CLAY

Hand Space Experiences
 The Basic Exercise
 Grouping Hand Space Figures
 Pebbles
 Bowl and Friendly Forms
 Mirror Images

SNOW SCULPTURE

ADDITIONAL IDEAS
• opossums hanging from orange tree branches
• seasonal themes: pumpkins, etc.
• grapes

Third Series

BEESWAX
More legendary people
 Noah's Ark
 David and Giant Goliath

BEESWAX or CLAY (or Plasticine)
Spiral Tower
The Basic Exercise
Simple Human and Animal Figures
Farm Animals
Design Your Own House

CLAY
Adobe Village
Little Pots and Bowls (coil)

Form Groupings: outer and inner

SNOW House

ADDITIONAL IDEAS
• beavers, lodge and dam
• figures of mother with baby, father, child
• household objects for house models
• make an outdoor oven out of clay and use it for bread making or firing simple clay vessel

Fourth Series

BEESWAX
Mythological figures:
 Idun and Apple Tree
 Thor and Hammer
 Loki and Midgaard Serpent

CLAY (or Plasticine)
The Basic Exercise
The Human Figure
Human and Animal Compared
Animal Studies: Habitats
 Animals Arising out of Hand Forms
 Bear in Cave
 Bird in a Nest

Miscellaneous:
 Mountain Relief Map
 Bridges
 Geometric solids:
 Cube
 Cone
 Cylinder

ADDITIONAL IDEAS
• sleeping cat
• houses along a street
• pilgrims
• hand
• foot
• dig clay out of a local pit and process for use (perhaps as part of a study of local geography)
• simple solids such as prism form, cube, rectangular solids modeled in the hollow of the hand

Fifth Series

BEESWAX
Metamorphosis of a Plant
Flower
Mushroom

CLAY
Mythological figures
 Athena
 Labyrinth and Minotaur
 Prometheus Bound to the Rock
 Gilgamesh and Enkidu
 Gautama Buddha
Greek Temple
Tablet Inscribed with Cuneiform
Seated Egyptian Queen or Pharaoh
Sphinx
Pyramid: Geometric form
The Basic Exercise
Animals
 Threefold Form
 Metamorphosis
 Seal
 Bison
Human Figures
Pure Form : Convex and Concave

SALT DOUGH
Relief map: North America

ADDITIONAL IDEAS
• plant buds, fruits, other plant forms
• Greek pillars: three types (Doric, Ionic, Corinthian)
• Greek temple and tomb reliefs (see Series Six)
• Greek Vase: amphora
• Greek drama mask
• fruit (pear, apple, etc.)
• model huge honeycomb cells and bring together
• wolf

Sixth Series

CLAY
Limestone Cave
Roman Coliseum (Group Project)
Medieval Castle
Reclining Figure (Mesoamerican Geography)
Human Figures in Groups: Wrestling
Animals in Groups: Turtles
Horse
Geometry
 Sphere: A social exercise
 Cube
 Rectangular solid
 Cylinder
 Cone
Relief
 Horse and Rider
 Spiral in relief

SCULPTAMOLD
(or salt dough, clay, beeswax, plasticine)
Relief map—South America

ADDITIONAL IDEAS
- crystal forms
- characteristic forms of mountain
 ranges: granite, chalk
- waterfalls with boulders
- Roman oil lamp
- Roman head
- farmer and horse
- dig clay out of a local pit and process
 for use (as part of modeling
 lessons, study of mineralogy)
- shaping garden beds (earth sculpture)

Seventh Series

CLAY
Human Hand with Wrist
Human Foot with Ankle
Human Organs: Lung, Kidney
Masks
Puppet Heads
Human and Animal: Girl and Dog
African Animals
Candle holder
Geometry: Tetrahedron, Octahedron
Relief Forms
The Four Elements

Eighth Series

CLAY
Human Anatomical Studies
 Human Head in the Round
 Ear
 Bone (femur)
 Joint: Ball and Socket
 Skull
Human Figures in a Group
Stages of Human Development
Faces
Geometry: Transformation of the Five Platonic Solids
Reliefs
 Musical Modes
 Concave to Convex
 Coast of Maine (water-sculpted)
 Multiple Sections
Box with Lid: Slab Construction

ADDITIONAL IDEAS
- larynx
- baby from egg shape
- studies in dramatic gesture related to the temperaments and first acted out: joyful exuberance, fallen dejection, sleeping, embracing, etc.

DEVELOP YOUR OWN IDEAS AND VARIATIONS!

Record your own inspirations and variations:

-
-
-
-
-
-
-
-
-
-
-
-
-
-
-
-
-
-
-
-
-
-
-
-

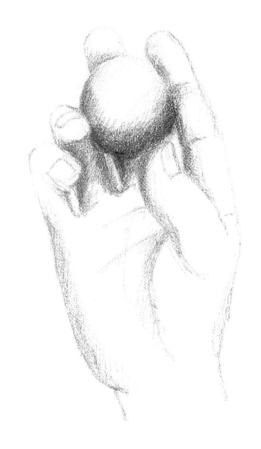

PONDERING

Form is something mobile, changing and in process.
Knowledge of form is knowledge of transformation.
Metamorphosis is the key to all the realms of Nature.

Johann Wolfgang von Goethe
Scientist, artist and poet

The Waldorf Curriculum

Reflections

Modeling activates our thinking and creativity and enhances the way we view and observe the world around us. For children in their formative years, this activity can have a significant effect on their development.

As I built up experiences as a teacher, I found it very worthwhile to continuously reflect on what I was doing. For me, a regular rhythm of practical engagement interspersed with contemplation and study became two of the most important transforming elements of lifelong learning. Talking with others about my work and sharing insights was another very productive part of this process. Attending workshops and courses on modeling and other arts was invaluable. In fact, this book developed out of an inspiring workshop I attended at a conference in Toronto with Frances Vig, a classroom and arts teacher. There are many ways to continually expand awareness and find sources of inspiration.

For me, as an elementary school class teacher in a Waldorf school for over eighteen years, it was the children who continuously inspired me to discover and create all kinds of forms and ways of doing things that I never would have anticipated or perhaps come to on my own. During my last two years of teaching, I undertook a research project on the modeling lessons I was conducting in a third and fourth grade. Through the project, I increased my understanding of the uses and value of modeling as a vehicle for learning particular subjects, as a means to know my students better, and as a remedial and therapeutic aid. In addition, I took every opportunity to consult other practising teachers and study various books and related research on how this art enhances intelligence and the learning process.

The second part of this book is devoted to resources for understanding modeling as a powerful tool in education and children's lives.

Developmental Perspectives On Modeling

Children, you have come to school to learn something . . . **You have two hands.** *These are for working, you can do all kinds of things with them. . . . Now I am* **going to do** *this. And now you can take your two hands and do it too.*

Rudolf Steiner
First Lesson of the Twelve
Grade Waldorf Curriculum

As a generalist classroom teacher, I was helped immensely in finding my way in modeling not only by my students but also by my colleagues and the wealth of insights offered by the Waldorf curriculum about child development and the critical role of the arts in education.

Rudolf Steiner, the Austrian founder of Waldorf education, gave few indications on how specifically to develop school modeling lessons. He did, however, encourage teachers to *"cultivate as much as possible"* this form of artistic activity as an important part of the educational process.

According to his research, the very young child (ages birth to seven) is an "inner sculptor." This inner sculptor's main task at the beginning of life is to form the body's organs as a natural work of art. Only after the basic plan of the physical body has been elaborated is this creative energy gradually freed. Then it becomes available for other purposes in human development.

Young children in this first stage before they are ready for school (birth to seven years old), naturally learn most of what they need to know through their wonderful capacity for free, imaginative play and imitation. In imitation they soak up and miraculously absorb what is going on around them. Often they act it out. This is essential to realize, because teachers and parents can greatly influence young children through their own exemplary behavior. Children love to see adults engaged in the arts, to work alongside them, and to imitate their actions. They can also successfully be left to their own resources. Witness the tremendous sculptural creativity in the sand box, on the beach, and in mud puddles! Give them simple materials and they create worlds and shape themselves! Helle Heckmann, innovative educator of very young children in Denmark, describes this beautifully (bold emphasis mine):

Sarah is poking in some soil and mud. Skillfully, she picks up a lump and shapes it in her hand. She finds a leaf that fits exactly as a serving dish for the *mud ball*. A hint of pebbles and a feather complete the dish. "There you go, " she says seriously. "Would you like to drink with it, Magnus?"

What makes it so important that Sarah and Magnus can sit in a puddle underneath a tree in which the wind is blowing and in deep concentration cook dinner? *What do they shape when they shape the mud balls? To me it is definitely themselves—their inner organs. Mud, soil, sand, water do not have definite shapes, they have the ability to constantly change.* This is exactly what three and four year olds need: an identification with the surrounding world. *Getting dirty is a sign of health. The four elements—earth, water, air, fire— are the basic elements which children are nourished by and grow from.* No shaped toys—be they wood or plastic—can compete with these materials. The seriousness with which children play, the deep concentration speaks for itself, and shows how important "playing" is. Nobody needs to fight about anything—*there is plenty of mud for everybody* Five and six year olds (have a) curiosity towards the surroundings—*the wish to explore, to conquer the world, but at their own level. They discover something, investigate it, use it, leave it, transform it. The process is the most important. Imagination changes reality.*

The Garden Gate: Newsletter of the Keene, NH Lifeways Project —Winter 2000

Because of their imaginative nature, young children are often best left to play informally with natural materials. They need not be pressed into any kind of formal or structured lessons. In modeling, for example, preschoolers and children in the beginning grades love to gently shape soft materials or playfully stick pieces together in very novel configurations. At this stage children are little architects and builders. They naturally see much more than meets the adult eye in their creations, which to us can have a static, rounded, and convex quality. Preschool children feeling their hands in the process of modeling can form figures, that have very large hands.

Because the creative life forces are so intensely, indeed exclusively, needed in the first seven years for growth and the articulation of the body, it is best, according to Steiner, that children not be prematurely and artificially called upon for any kind of formal learning or memorization. Youngsters instinctively know when they have had enough of an activity. They may sanguinely switch to another pursuit, perhaps take a rest, or even get cranky! Rest periods or "downtimes" are vital for the brain to dreamily digest experience and transubstantiate it into capacities and neural networking in the brain. Overtaxing memory and other abilities prematurely in the first stage of development can rob children of forces that are needed for healthy growth and body formation.

At the end of early childhood around ages six to seven, Steiner found that a certain surplus of the inner sculptural life force becomes available. It is now free for psychological and spiritual growth and to gain new capacities of memory, thinking, and imagination.

This creative life-force surplus is the result of the near completion of the physical body. Its defining structure, organs, brain, and neural pathways are now shaped. The critical foundation is now finished. This signifies school readiness and is the vehicle for school-age learning and the development of subsequent cognitive and emotional capacities. This maturational milestone is marked physically by the change of teeth, the gradual installment in new locations of thirty-two beautiful and intricately formed little sculptures containing the hardest substance in our bodies. Long before the researches of Gesell and Ilg, Steiner pointed to the change and configuration of teeth as important factors to consider in evaluating a child's readiness for school.

At the commencement of the elementary-school stage of development (ages six to seven), children awake to the realm of forms. Up to that point, they have known only concrete things and have been unconsciously and unreflectively "imbedded" in the wholeness of life. Pure forms have remained hidden to their view. To small children, a circle, for example, is not a "circle," but a "wheel" or the "sun." A triangle is a "roof."

In the first three grades, the sculptural life forces vigorously take hold of the image-forming process of the soul:

These forces tend to pass over into *plastic creation (plastisches Gestalten)*, drawing, and so forth. Those are the forces that come to an end with the change of teeth, that previously modeled the body of the child: the sculptural forces.
(Rudolf Steiner, *Balance in Teaching*, 1982, p. 17)

At this age children develop a new power of thinking that perceives pure forms, is inherently pictorial in nature, and thrives on and hungers for imagery. Abundant life forces burst forth to create colorful, albeit dreamy, images and shapes in the child's mind's eye. These pictures then want to express themselves in various artistic ways, particularly in modeling, drawing, painting, and movement.

The new forces gradually become more available for the healthy memory development using rhythm and repetition. Children no longer need a concrete object in front of them. They can remember it in the mind. Furthermore, this stage constitutes the time of school readiness when the abstract forms of the alphabet and numbers make sense. Deriving letter and number symbols hieroglyphically from pictures, as

is done in the Waldorf first-grade curriculum, is a healthy way to help the nervous system integrate writing, reading, and math.

For this stage of pictorial thinking, teachers can increasingly plan occasions when the children play with imaginative forms in soft malleable materials. These need not represent anything at first, but may be a three-dimensional counterpart to pure-color painting and form-drawing exercises. Such "pure" forms will, as a matter of course, naturally stimulate the children's own powers of imagination, and they will see something emerging. Children in the first three grades can benefit immensely by discovering and exploring all kinds of fundamental shapes—convex, concave, flat, elongated, rounded, sharp, pointed, and so forth—before they begin to represent and copy things. An acquaintance and practice with the language of such forms will build a real feeling for form, (*Formgefuhl*) and, as they mature, an inner capacity to discern and appreciate forms in nature and their environment.

More representational modeling of subjects can be imaginatively developed out of pure, nonrepresentational forms. They can be integrated with colorful stories they have heard and pictured, or experiences they have had in nature. Modeling times are not so much "instruction" as guided opportunities for children primarily to experience joy in moving their hands meaningfully and creating and transforming shapes as concrete thoughts. Secondarily, they offer the opportunity to relive a story and imbue soft materials with the dream-like images that are vividly living in their mind's eye.

A material such as colored beeswax is perfect for young children because it is warmable, melting, and malleable and has a gentle texture. Also, its aroma mildly stimulates the olfactory sense and its associative connections with memories and fantasy. Small lumps of clay that are quickly warmed can also be successfully used. (See Clausen and Riedel, *Plastisches Gestalten*, 1985, and Hella Loewe, *Plastizieren in der Unterstufe*, 2000.) Clay can be employed increasingly and in larger amounts after age nine when children are becoming more awake, "down to earth" and capable of using a more ponderous and physically challenging and demanding substance. Modeling, like other activities, should have its regular times to which the children look forward with anticipation and excitement.

With guidance, children ages seven to nine can gradually evolve the capacities and discover the skills to meet their need to make more sophisticated sculptures. And they can do so without losing the vitality of their early work. Teachers in grades one to three can help their students make the transition gradually from a younger inclination to stick parts together by giving lessons in which sculptural modeling is demonstrated and practiced. In the lessons, each child works on differentiating the surfaces of a whole figure from one piece of clay rather than assembling it out of pieces. In the beginning grades, educators can orchestrate the alternation of the different approaches to modeling. Gradually, children will replace their younger phase as they learn maturer techniques.

Artistically and developmentally, it is very valuable for children, especially at ages seven to nine, to imaginatively experience fundamental forms as a prelude to discovering and focusing on them in the world. In observing the world they will have the language of form inside to appreciate the beauty of nature outside.

Interestingly, as children mature and become more conscious, they imbue their modeled forms increasingly with more concave features. This phenomenon reflects the child's increasing awareness of a new inner world and relationship to the physical organism. Around age nine he or she is "moving into the house of the body," so to speak, and is looking out into the world differently through the windows of the senses. Children of this age particularly love to build forts and little houses in which they can be cozy and find their *selves*. Modeling exercises can show various stages of development just as children's drawings have proven to do (see Michaela Strauss, *Understanding Children's Drawings*, 1988 and Hannah Huber, *Gestalten mit Bienenwachs im verschulalter* [*Beeswax Modeling in the Preschool*, 2001]). A preschool child, for example, who is introducing too much concavity into a material may be prematurely awake in his or her senses. It is worthwhile for teachers and parents to observe such aspects.

At age nine to ten years, this new relation to the body and senses precipitates a feeling of being separate from the world and of no longer being dreamily at one with it. Participating in practical activities, using their creative hands, reassures children about the cooperative nature of human life. Modeling is an excellent hands-on way to slip into the forms of the world and feel reunited through activity.

Starting in fourth grade, sculptural modeling, particularly with clay, can increasingly play a more regular, formal, and instructional role in the curriculum (once a week). Students become much more aware of the external world, and this activity can serve as a valuable vehicle for them to recreate, in sculptural forms, what they experience in nature and then process artistically.

Modeling develops and strengthens powers of seeing, sensory discrimination, observation, memory, and imagination. It strongly connects students emotionally to their surroundings by first acquainting them with the wonders of form. Their experiences in this artistic realm prepare them for keener observation of the natural world. Modeling is especially suitable in fourth and fifth grades for an exploration of many animal forms. Steiner pointed out that strongly connecting children with the animal world strengthens their will and self-awareness. In the fifth grade, the eleven-year-old is sprouting new powers of thinking. Forming objects organically in changing stages is a wonderful analog to the process of living, mobile thinking and to the metamorphosis of plants.

During the factual stage of ages nine to twelve, as students become increasingly self-conscious, they need as positive an experience of modeling and art as possible. They need to be surrounded and supported by the right attitudes. If, however, they mistakenly think they are supposed to achieve scientific realism in their work, they can all too easily become dissatisfied and frustrated with their results, no matter how beautiful, charming, and age-appropriate these are. This is also the case in drawing.

Grades four to six are the crucial bridge years when adults especially need to encourage the efforts of and emerging abilities in all children, regardless of talent. Without praise and support, many self-conscious students may artistically shut down and give up on modeling and other arts as something they cannot do and which is only "for the artists."

At age twelve, young people stand on still another threshold of development as they look toward adolescence. Their

bodies are going into an awkward coltish stage. Modeling harmonious and interesting forms can help them reestablish their own balance and readjust to the new mechanics of their elongating limbs. They can appreciate anew the infinite possibilities of movement and form of their hands. Shaping pieces organically helps them penetrate and fathom the living world of plants, animals, and man. Trying to create flat-sided and sharp-edged geometric solids or architectural motifs challenges their capacities of thinking to imbue form with lawfulness, order, and logic. Modeling has a dynamic effect on the sense of sight and stimulates students to really observe and look at the world at a time when they are increasingly aware of cause and effect. Such artistic activity and understanding helps to balance their growing intellectuality.

From ages twelve to thirteen and on, the theme of concave space becomes especially relevant as adolescents develop their own intense inner worlds. Exploring other aspects of soul expression such as moods and polarities is invaluable. Modeling clay, carving wood, and even some soft soapstone can offer just the right challenge of resistance and working within boundaries that adolescents need to strengthen their wills. Working with such ponderous materials simulates the heaviness of their own changing bodies. At this age they have to learn to rise up anew in upright form and posture. Like the clay they can sit and slouch like "lumps" if we do not inspire them to get moving!

A still more systematic development of sculptural modeling can begin in sixth, seventh, and eighth grades. Students can conceptually and artistically explore a myriad of pure forms as well as subjects germane to their studies—minerals, anatomy, architecture, for instance. Seventh graders who study Renaissance art can experience the challenge of modeling a hand. How they appreciate Michelangelo's efforts afterward! New powers of emotion and thought enable students at this age to bring more expression and gesture into their work. New capacities of judgement are encouraged as students sharpen aesthetic discernment for proportion, beauty, mood, and movement in what they create.

Compositions can be done individually or occasionally in groups of two to three or more students. Subjects can explore the relationships between elements such as multiple human figures, herds of animals, and so forth. Older students can begin to transcend the inhibiting self-conscious urge toward naturalism and realism and learn to appreciate dramatic gesture and the metaphorical nature of forms. Physically, older children can tackle larger projects as their hands grow and are able to embrace larger lumps and spheres of clay. The world of expressiveness in their hands expands.

At a time of increasing inwardness, it is valuable for students to learn altruism and make things for younger children and other people. According to Rudolf Steiner, working with the arts helps adolescents overcome and transform the tendency toward unhealthy self-absorption, eroticism, and assertion of personal power. An aesthetic education strengthens the human senses (Greek *aesthetikos* = senses), self esteem, and moral fiber. A young person who has been deeply and regularly touched by the beauty of the world will not tend to vandalize it.

Multisensory Education

Modeling as an artistic activity provides an excellent way to practice a general aesthetic sense of form and sense of beauty. Furthermore, it can be of great benefit to children as their multiple senses are being formed and expanded. In Waldorf education, teachers take into account a dozen different kinds of senses that in-form us as whole human beings. In addition to the five physical senses, it has been found fruitful to work with those of balance, movement, temperature, and sense of life or inner well being as well as a number of psychological and spiritual senses. All of these senses interrelate and support each other's functioning. The more body-related senses of balance, movement, life, and touch can create the physical foundations for the more mental senses of hearing, language, thought, and self-awareness.

Kinesthetic Sense

Form has its origin in movement and is movement's frozen or resting state. As we move our hands over surfaces, we perceive all kinds of contours, curves, angles, and other basic geometric shapes. In modeling, children use the fine motor movements of their hands and arms and thereby exercise their kinesthetic or movement sense. Such activity of fine motor muscles builds neural pathways, keeps established ones active and prevents old ones from atrophying or dying. There are certain children whose style of learning is dependent on this sense. Motor capacities also support the development of speaking.

Haptic Sense

Movement allows us to gain knowledge of the world by touch. The sense of touch is the quintessential modeling sense. Also referred to as the haptic sense, it brings us into direct physical contact with the world and its substance. We learn to discriminate a rich variety of different forms and textures, rough, smooth, etc. We feel the border of our own skin and body geography and rub against the surface of the external. This strengthens our ego sense. The blind have exceptionally developed haptic senses and feel their hands as much bigger than they actually are (see Herbert Read, *The Art of Sculpture*, 1961). In modeling, it is valuable on occasion to strengthen our sense of touch by shutting our eyes as we work.

Sense of Self and Other Egos

The experience of touch on a physical level is important to support our sense of being self-contained individuals on both a psychological and spiritual level. About the age of two to three, children for the first time are able to touch themselves all over their bodies; at the same time they begin to have the first glimmering of ego consciousness and to call themselves "I." Our awareness and sense of our own self is intimately related to our ability to sense and recognize other egos, others of our human kind.

In modeling, we rhythmically encounter the borders between "I" and world. Modeling helps children to feel enclosed and protected within their skin. It can soothe excitable, hysterical children who are easily "out of or beside themselves" and promote a deep restfulness. Each piece tends to have a middle and center of mass and gravity with which we can identify our own inner center and security. In addition, our sense of self, inner satisfaction, and esteem is reinforced through the fact that we are imbuing and changing a substance with our own activity. We sense our selves reflected in what we make, especially when we model human faces and forms!

Visual Sense

Our eyes are not just passive receptors: they reach out actively with will and intention to "touch" the world. To grasp objects with our sight, we rely on all kinds of subtle movements of the eye that trace around the contours, shadows, and details of objects. Modeling promotes attention and active engagement in the process of sight and observation. We look at things more thoroughly and accurately. Modeling strengthens the eye-hand coordination that is so important for learning such skills as writing and reading.

Equilibrium Sense

Working with our two hands around the focal point of an object in space involves balancing movements in relation to the sides of our own body—right, left, up, down, forward, and back. Modeling entails a rich variety of upper-body positions, not just of the hands and arms. Holding a piece of material first in one hand, then in the other, and then in both at the same time is a weighing up, balancing experience. Each piece of sculpture arises from the dynamics of having a middle or center and of balancing of sides. We apply and exercise continually our own inner sense of balance in a fluctuating field of space-forming activity. Our sense of balance has been associated with our sense of hearing and bilateral listening skills. What we see reflected in changing forms helps us sense balance or imbalance. Each form calls upon us to sense its center and proportions. Vertical forms, for example, are fundamental to our sense of humanness. They give us a sense of uprightness by having a center of gravity and balance. Children need to master the sense of equilibrium and coordination in the three directions of space in order to progress to higher skills of cognitive learning.

Auditory Sense

The sense of balance is located in the inner ear within the semicircular canals and fluid. With our hearing we also orient ourselves in space. Although modeling in itself is usually a quiet, nonauditory activity, it entails verbal instructions and stimulates conversation and discussion. Some researchers have found it to promote verbalization skills in deprived children (see Smilansky, *Clay in the Classroom*, 1988).

Language Sense

Correlations have been found between children's sense of word and language and their motor coordination of limbs, legs, arms, and hands. Gestures and movements in speech seem to be neurologically connected with gestures of the physical body. In some cases children who have speech impediments also walk clumsily. Handedness is correlated with the establishment of the speech center on one side or the other of the brain. Modeling involves its own language of gesture, movement, and form, and has its own silent vocabulary of words and sounds (see chapter on Clay and Water as Vessels of Life and Instruments of the Music of Forms). Modeling stimulates conversation.

Conceptual Sense

Modeling allows children to form thoughts concretely and visibly in a physical substance. Change is a living process of mobile thinking. Children learn to recognize thoughts in the language of forms. They have to exercise their own thinking in figuring out how to shape certain forms. Formative life forces energize our thinking and, according to Schwenk,

The activity of thinking is essentially an expression of flowing movement. Only when thinking dwells on a particular content, a particular

form, does it order itself accordingly and create an idea. Every idea—like every organic form—arises in a process of flow, until the movement congeals into a form."

<div align="right">(Schwenk, 1965, p.94.)</div>

Thus, there is a very close relationship between our life of thinking and our life forces.

Life Sense

We model materials with our body's life energy as it streams in the blood into our hands. This life also energizes our thinking and helps us sculpt thoughts. According to the Swiss educator, Willi Aeppli,

All plastic art is a creating, a working in an organic way, similar to the working of the archetypal plant (Urpflanze) in the spirit of Goethe. For this reason the sense of life also participates intensely in every artistic plastic activity.

<div align="right">(Aeppli, 1955, p. 52.)</div>

Children's mental and emotional well-being depends on lively, absorbing learning situations both at home and in school. Modeling brings the world of ideas to life. It can give children deep physical and inner satisfaction to work with beeswax and clay, natural substances of the life-giving earth. These materials represent a kind of artistic and sensory nourishment for them. Working with sculptural media is not always completely comfortable and painless. Beeswax and some plasticines can be hard at first, and clay can be wet, sticky, and strenuously demanding at times. Children, however, often seek out and grow through challenges that strengthen their constitution and character. Struggling with materials such as clay and wood can encourage will power, determination, and endurance. For those who may feel unwell when they handle such materials as clay, provisions have to be made that moisture, temperature, and warm encouragement should be given. Handling the earth is a therapy for modern children who shrink from getting their hands dirty.

Temperature Sense

Modeling with malleable materials refines children's sense of the contrast of warm and cold. They feel the heat of their own hands penetrating and softening the beeswax, a lesson of elementary chemistry and physics! Working with beeswax is an expansive experience, whereas modeling clay has a more contractive quality. Cool clay, however, does warm up in the hands and offers varying temperatures cooling surprisingly when put down for a few minutes. Modeling in general warms one up through blood circulation and muscle activity.

Olfactory Sense

Beeswax, as it is warmed, exudes a pleasant scent that adds to the learning experience. The vapors of the material penetrate into the physical being through our nasal passages. Smell can work powerfully in the learning process. The olfactory nerve uniquely goes directly to the brain, which in turn strongly combines smells with vivid memories. The wonderful smell of clay connects us immediately with the earth and its soil. Watch out for the chemical smells of certain artificial plasticines: they can detract from the wholesomeness of the experience.

Sense of Taste

Children can enjoy another aspect of natural beeswax by chewing it like gum. Likewise, the taste of clean clay will not hurt the daring child who puts some on her tongue. In fact, some farmers judge good clay soil by tasting it!

Working with Different Temperaments

Children with differing personalities and temperaments have various styles and approaches to modeling substances. Teachers and parents should be aware of this when choosing appropriate activities and materials. Children with extroverted tendencies act differently than those who are more introverted. Waldorf educators subdivide these two basic directions or gestures of personality into four types of temperaments: choleric, sanguine, phlegmatic, and melancholic.

Choleric children are extroverted, for example, and typically will seize a lump of clay with vigor. They quickly shape its main dramatic gestures. Some may need to be reminded not to pound clay noisily or furiously. Others need to be encouraged to work further on more balanced proportions or detailing. In making a human figure, one short, redheaded "arch-choleric" quickly did the assignment and then proceeded to make a whole family of other figures plus a soccer ball! Good-sized chunks of clay can be just the match a choleric needs to bring his or her forces into balance.

Sanguine children are also very extroverted, lively, and active in modeling. They particularly love working with bits of colored beeswax. One very sanguine girl took the time to manufacture and stick dozens of minute yellow polka dots on a dress. Sanguine personalities may need encouragement to bring more form and order into their figures.

The phlegmatic temperament is more introverted and self-absorbed. It actually can be ideally suited for the gradual, patient process needed for modeling. Although phlegmatics can be slow, they like the peaceful, engaging activity and often keep working at it with considerable stamina. They particularly enjoy the sensualness of creating smooth, rounded surfaces in moist and even wet clay. One dreamy, phlegmatic child in my class even made a pyramid with soft rounded edges. It is often helpful for such a child to be encouraged to refine or add a little more detailing to their pieces.

The melancholic child introvertedly and seriously contemplates what he or she is going to do with a heavy material such as clay. This child is tentative about really "getting into" the encounter with substance. Once engaged, however, he or she can become very involved and thorough, expressing interesting and thought-provoking detailed work. Melancholics can be hypersenitive and easily hurt by certain comments about their efforts. Teachers may work on the child's form to help it along. One delicate and very melancholic girl with exceptionally dry skin and asthma was at a loss as to what to do with a "messy, icky" piece of clay. It is helpful to such a child to have clay at just the right moisture, never too wet, cold, or sticky and to be offered warm sympathy, encouragement, and advice.

All children can knead clay in preparation for use. This activity enables the different temperaments to first become involved with the material in a general way and to express their different styles of action. Regularly making a ball at the beginning of exercises can help tentative children such as melancholics take up the assignment more readily.

Temperaments in the Dynamics of the Artistic-Creative Process

Magda Lissau, in her book *The Temperaments and the Arts*, insightfully characterizes how all four temperaments are included in the modeling process. The following is an excerpt from her valuable work, which also helpfully sheds light on the role of the teacher in inspiring students:

The temperament activity in the artistic process is most closely related to the dynamics of the creative flow, to the correlation, transformation and metamorphosis of one stage of the process into the next. We bring to bear, as it were, each characteristic temperament element essence in sequence upon the medium. As the process itself becomes dynamically alive, the various form elements of an art may converse with each other in their imponderable language.

We have the greatest clarity of characterization of the fourfold dynamics of a process in the musical arts. Indeed, I am convinced that only an imbuing with musicality will enable the teacher to infuse life into the artistic process. Thus I shall have to make use of musical concepts here in order to describe the dynamics of the artistic process.

1. theme
2. variations on a theme
3. conflict, polarization and dissonance
4. balancing, harmonizing
5. resolution

There is a dramatic sequence in the parts of a symphony, for instance, that indicates the dynamic flow of artistic creation. For we have, first of all—returning to sculpture—the basic substance: the lump of clay or the piece of stone. Then we have to bring some kind of force to bear on it, change it and transform it. As we work towards some kind of climax, the tension mounts. At last we find the harmonious resolution. A new form has arisen.

1. substance at rest: that which is given
2. directed attention: application of energy
3. playful activity: pendulum swings between polar opposites
4. balancing the details, smoothing over, correlating details with whole
5. dynamic equilibrium: a new form has arisen

When working with these stages of a process, we work with time. The exact point at which the leverage of the temperament is necessary in order to bring the process into flux, to transform the static into dynamic, is at the beginning of stage two—with our very first impression of our fingers upon the clay. With our fingers we can work in an earthy, watery, airy, and fiery manner.

Clay makes it easier to employ an earthy or watery manner of treatment. Beeswax makes it possible also to work in an airy or a fiery manner. Wood again has its very own characteristics, and invites a great deal of watery forms respectively.

As we reflect upon the two polarities active in man and in world, we may describe the artistic process once more thus:

STEP ONE: There is a static and fixed object, medium, or substance. It may have a definite shape, or may be amorphous.

STEP TWO: This static material needs to be brought into motion. In order to enthuse his students, a great effort needs to be exerted upon them by the teacher. He has to inspire and challenge them with thought, story, question, description, and so forth, so that through the stirring of the imagination a fiery spark may kindle action and the creative process be enjoined.

STEP THREE: How we push and pull and shape the clay in all six directions of space. Constantly polarizing, balancing, intensifying, playing, as the music of the process unfolds.

STEP FOUR: We begin to have an inkling of the final outcome. Amid often traumatic birth pangs, the balancing and harmonizing takes place.

STEP FIVE: A new wholeness of form has come into being.

The first step—the stasis before creative action begins—is fundamentally of an earthy-contractive-melancholic nature. We have something that is tangible and material as a seed point, be it a piece of clay, wax, wood, or stone.

The second step—in high contrast—is the point at which the greatest effort needs to be made, at which the greatest energy needs to expended, it is the choleric activity, the aggressiveness which attacks this passive material and aims to change it in every way. The choleric's ability to envision the future arouses his inner fire, so that the transmuting process can begin. The teacher will find that a fiery mood will help him release the dynamic potentialities which slumber in the souls of children, so that

they can indeed begin to work on the material. He needs to stimulate the fiery enthusiasm in each child.

Then, in the third step, the joys of playfulness abound as one tests the polarities, tastes one or the other pose and form, and gives full range to the "Spieltrieb," the instinct and drive to play. How all avenues are open, are tried out, all possibilities are considered, everything is attempted in the course of the airy-sanguine third stage.

In the fourth step we balance out and harmonize. This requires a mercurially fluid and phlegmatic rhythm to help us finish off and round out all corners, as it were, satisfying the senses and putting the final touches to the work of balancing detailed facets with our concept of the whole.

In the fifth step we ensure that the finished result is a living image of the concept that has worked its way through to tangible form. That which has lived in our soul as the thought of the new form has now received—through the application of all four temperament/element stages—its new being and body. The creator—I—stands face to face with the creation—my work.

Melancholics tend to remain longer with the first step—that is where they are most comfortable. Cholerics tend to bring their ego force to bear so powerfully that they shatter the material and transmute it only too well in dramatic action. Sanguines tend to remain with the playfulness; therefore they have difficulties in finishing, but instead they delight in the polarization without being able to finally resolve their work.

Phlegmatics like to avoid the middle stages and go from the first to the last in a straight line—rounding off the given instead of effecting any actual transformation. A balanced person will go through all five stages, employing their dynamics in the act of creation. Thus any one temperament prefers its respective stage of the creative process.

The pathway of the creative process leads from a melancholic beginning over a choleric transformation and sanguine playful experimentation and phlegmatic harmonization to the new balanced whole. A given whole is pulled apart cholerically, mixed up sanguinely, fitted together again phlegmatically. For this reason all artistic-creative activity will help balance out one-sided temperament tendencies.

I . . . want to show that the spirit needed in schools can be magically engendered through art. If done properly, this light-filled art can produce a radiance in children that allows the soul to integrate into the physical body , and thus into the world, for the person's entire future life.

Rudolf Steiner

Piaget, Multiple Intelligences
and the Modeling Process

In my work as a Waldorf class teacher, I conducted a research project entitled "Sculptural Modeling: Its Value and Uses in the Classroom." This gave me the opportunity to do research on various perspectives on the subject from the point of view of developmental psychology and art education.

Piaget

In his classic study, *The Child's Conception of Space* (1956), Jean Piaget hardly refers to modeling at all, but where he does, he describes it as "exhibiting a multisensory character . . . at once tactile, kinesthetic, and visual, quite apart from haptic perception." (Piaget and Inhelder,1956, p.30.) Indirectly, however, Piaget is very helpful in shedding light on the activity of modeling, because he explores the fundamental question of how the human being comes to know spatial reality. Interestingly, he does this by first examining what experimental psychology calls "haptic perception," the tactile recognition of solids. Haptics, Piaget cautions, however, has a "mixed character" because

These so-called perceptions go far beyond the limits of the purely perceptual and usually presuppose the translation of tactile perceptions and movements into visual images.
(Piaget and Inhelder, 1956, p. 4)

Piaget applies a great deal of study to the complex relationship of tactile-kinesthetic perception to the visual image, and of perceptual to conceptual space. From his careful observations and investigations, he derives many remarkable insights about how a child achieves various levels of spatial awareness, evolving from general topological perceptions in his or her preschool years to a conceptual grasp of Euclidean geometry and perspective during primary school years and adolescence:

For it is not until *after seven to eight years of age* that measurement, conceptual coordination of perspective, understanding of proportions, etc., result in the construction of conceptual space, marking a real advance on perceptual space, *(italic emphasis by the author).*
(Piaget and Inhelder, 1956, p. 13)

The key and common factor in understanding the development of a child's sense from perceptual space to one of conceptual space, visual image, and geometric abstraction, according to Piaget, is movement, or motor activity. Healthy children, he says,

Are able to recognize, and especially to represent, only those shapes that they can actually reconstruct through their own actions. The "intuition" of space is not a "reading" or apprehension of the properties of objects, but, from the very beginning, *an action performed*. It is precisely because it enriches physical reality instead of merely extracting from it a set of ready-made structures, that action is eventually able to transcend physical limitations and create operational schemata that can be formalized

and made to function in a purely abstract, deductive fashion.

(Piaget and Inhelder, 1956, p. 449)

Action itself . . . plays a far more fundamental role than does the image. Geometrical intuition is essentially *active* in character. It consist primarily of virtual actions.

(Piaget and Inhelder, 1956, p.452)

Manipulation of and interaction with changing non-Euclidean, non-regular topologies, as experienced in modeling, are viewed as a fundamental basis on which a mature geometric imagination and spatial thinking later develops. Piaget even refers to Euclidean geometry and perspective as subareas of an all-encompassing topological geometry.

Howard Gardner

Inspired by Piaget, Howard Gardner of Harvard has continued to investigate the development of human intelligence and has proposed and amassed evidence for "a theory of multiple intelligences." Included in the seven (or more) basic types are three "object-related" types that appear readily applicable to an understanding of what modeling might contribute to education and human development. They are:

1) Spatial intelligence, which "focuses on the individual's ability to transform objects within his environment and to make his way amid a world of objects in space."

2) Bodily intelligence, which "focusing outward entails physical actions on objects in the world."

3) Logical-mathematical intelligence, which "grows out of the patterning of objects in numerical arrays. "

(Gardner, 1985, p. 235)

According to Gardner, sculpture (which includes modeling) involves "an exquisite sensitivity to the visual and spatial world as well as the ability to re-create it in fashioning a work of art." (Gardner, 1985 p. 196). The "fashioning" and "re-creating" process is not only visual/spatial but also bodily/kinesthetic. It is an exciting part of the theory that "intelligences usually work together in complex ways." (Armstrong, 1994, p.12). It is also revealing to examine modeling in the light of the other types of intelligences. Mathematical intelligence and geometric topologies have been mentioned previously. Modeling can also help to develop language (linguistic intelligence), social skills (intrapersonal intelligence), and self-esteem (interpersonal intelligence).

To the seven, Gardner later added an eighth called natural or nature intelligence. This is the capacity to observe, comprehend, and organize patterns in the natural environment. Such an ability is supported by modeling organic forms. The theory of multiple intelligences offers many very fruitful and applicable insights into the act of modeling.

Herbert Read

In his classic study, *The Art of Sculpture*, art researcher and educator Herbert Read, like Piaget, examines how a human being gradually learns the size, shape, and position of things in space. He points out that visual perception and memory alone do not give us the notion of volume and three-dimensional mass. We are helped by the memory of other sensations such as touch and weight. Above all, Read says, it takes *"imagination"* to synthesize and construct a three-dimensional image out of a multiplicity of perceptions.

Read relates the development of our ability to perceive the three dimensional character of objects to our developing self-awareness of the tri-dimensionality of our own human bodies. He points out that our body image is constructed not solely by sight, but also through many other factors, including internal sensation and touching. In fact, he states, the body image does not necessarily have to be a visual image. Read cites work with congenitally blind children who, it was thought, would not be capable of coherently modeling the human figure. It was found, however, that they were not only able to do this, but they did it with a *high degree of realism.* Furthermore, in the work of these children there were certain revealing exaggerations, which Read attributes to the fact that

> The general form of the sculpture is built up from a multitude of tactile impressions; the features that seem to our normal vision to be exaggerated or distorted proceed from inner bodily sensations, *an awareness of muscular tensions and reflexive movements.* This kind of sensibility has been called haptic.
>
> (Read, 1961, pp. 27-30)

In a moving example, Read includes in his book a description and a photograph of a human figure made out of clay that had enormous hands. The blind sculptor modeled his enhanced experience of his primary sense organs, his hands, with their "extraordinary seeing touch." Preschool children feeling their hands intensively in the modeling process may also create figures with very large hands.

Related to these insights about the haptic sense, physicist Arthur Zajonc begins his facinating book, *Catching the Light: The Entwined History of Light and Mind* (1993) with a fascinating story about human perception:

> In 1910, the surgeons Moreau and LePrince wrote about their successful operation on an eight-year-old boy who had been blind since birth because of cataracts. Following the operation, they were anxious to discover how well the child could see. When the boy's eyes were healed, they removed the bandages. Waving a hand in front of the child's physically perfect eyes, they asked him what he saw. He replied weakly, "I don't know." "Don't you see it moving?" they asked. "I don't know" was his only reply. The boy's eyes were clearly not following the slowly moving hand. What he saw was only a varying brightness in front of him. *He was then allowed to touch the hand as it began to move; he cried out in a voice of triumph: "It's moving!" He could feel it move, and even, as he said, "hear it move,"* but still needed laboriously to learn to see it move. Light and eyes were not enough to grant him eyesight.
>
> (Zajonc, 1993, pp. 1-2)

The boy's sense of movement was neurologically supported by those of touch and hearing, but needed to be integrated with the sense of sight and other senses in order to sort out visual images that do not automatically make sense after an operation.

Claire Golomb

Research on children's modeling is limited and has been hampered by the fact that samples tend to fall apart and are not easy to manage or store. There has been much more study of children's drawings and graphic creations.

In 1974 Claire Golomb published *Young Children's Sculpture and Drawing: A Study in Representational Development.* She is an investigator who finally got down to the messy, awkward work of collecting, storing, scrutinizing, and photographing many, many pieces of children's modeling. By combining this research and showing parallels with drawing, she balances out the predominant "drawing-based bias" of a lot of research on art. (Howard Gardner's perspectives, for example, have evolved strongly out of his experiences of children's drawings.)

In her study, Golomb describes many aspects of the development of modeling from the young child to the older. I include some excerpts and insights here and encourage the reader to study the full book (italic emphasis mine):

The young child is under no compulsion to conform to a 'realistic' standard of representation and to include all the object's details. He *has no desire to copy reality;* his lines and circles are his own inventions.

Symbolic play is an important source of creative activity, and the young child's attempts to eliminate contradictions and inconsistencies by renaming, redefining, and by playful and narrative procedures illustrate this well.

The older child, who has acquired representational concepts, models, and skills, can now adequately express his intention in drawing and modeling without relying on verbal transformations of the figure. Symbolic representation takes new forms.

Perhaps the child is always caught between two opposing attitudes, between the inherent need for ordered, simple and meaningful representation and the *playfulness and fluidity* typical of what Piaget calls "symbolic activity." Representation moves between these extremes: the trend toward imitation and the trend toward symbolization in art.

(Golomb, 1974, p. 187)

Golomb's description of a creative tension between imitative reproduction and expressive symbolization caused me to reflect on the question of how much a teacher should help and guide a child's particular effort.

More recently, in 1995, Golomb, with Maureen McCormick, published a new study called "Sculpture: The Development of Three-Dimensional Representation in Clay." The modeling of eight different figures (cup, table, man, woman, person bending, dog, cow, and turtle) by 109 children (ages four to thirteen), including twenty third and fourth graders, and eighteen college students, was assessed in terms of dimensionality, figure differentiation, construction style, and type of representational model. The findings were very interesting in that they pointed to "an unsuspected competence" in young children in their conceptions of uprightness and multiple sides. The results ran counter to the "One Dimensional Stick Hypothesis" of Rudolf Arnheim, also called the Linear-Graphic Hypothesis (one- to two- to three-dimensional progression from primitive to complex!) and supported a so-called "Global-Modeling Hypothesis." This study offered many valuable insights into the development of the modeling process and how it compares with drawing:

The global-modeling hypothesis states that development begins w i t h an early albeit primitive three-dimensional conception of uprightness and attention to multiple sides.
(Golomb and McCormick, 1995, p. 36)

The previously held notion that the singular attention to frontal aspects of the human being represent the child's conceptual limitation regarding dimensionality seems no longer tenable.
(Golomb and McCormick, p. 47)

When children develop graphic and plastic representational concepts, three-dimensional representation in clay appears not to follow the hypothesized progression from one- to two- and then three-dimensional representation. Instead they seem to begin with an incipiently three-dimensional conception that becomes gradually refined and differentiated, providing the child is exposed to the medium and experiments with various tasks and possibilities.
(Golomb and McCormick, p. 47)

One-dimensional models were extremely rare.
(Golomb and McCormick, p. 46)

The majority of humans were constructed in a top-to-bottom sequence ... In terms of animal figures, the majority selected the body as the first part to be modeled.
(Golomb and McCormick, p. 47)

The older children differed in persistence with which they make repeated attempts to revise the figure, three or four times.
(Golomb and McCormick, p. 43)

Flattened, horizontally placed hu-

man figures appear to be a somewhat later development, a function of experience with this difficult medium and the ambition to create more complex and differentiated figures ... they reflect the impact of drawing. . . .
(Golomb and McCormick, pp. 47-48)

The analysis of representational processes in drawing can benefit from an understanding of its development in modeling.
(Golomb and McCormick, p. 47)

The study of the development of three-dimensional representation presents a paradox in that drawing rather than a three-dimensional medium has been the major focus of research Drawing ... lacks a third dimension and requires special tricks of the trade to create the illusion of volume and of multiple sides Children's drawings are based. . . on two-dimensional strategies ... these graphic styles have been interpreted as symptoms of cognitive immaturity.
(Golomb and McCormick, p. 35)

This juxtaposition of different views (in drawing), most commonly interpreted as a sign of conceptual immaturity, is an exceedingly rare occurrence in our modeling tasks and calls into question its interpretation in drawing.
(Golomb and McCormick, p. 48-49)

The Golomb and McCormick study points to modeling clay as a medium that connects children more immediately and directly with reality than does drawing.

Sara Smilansky

By far the richest and most well-developed experiential study to affect my perspectives on modeling's value and usage is entitled *Clay in the Classroom: Helping Children Develop Cognitive and Affective Skills for Learning* (1988). This work is an outgrowth of the pioneering efforts of Sara Smilansky, a professor of Education and Clinical Psychology at the University of Tel Aviv, Israel, who is also known for her research on socio-dramatic play and drawing in education. She collaborated with Judith Hagan and Helen Lewis and was consultant to an international effort involving twenty-seven schools with fifty-three classrooms and approximately 1,600 children. The Clay Project, as it came to be called, took three years to complete and produced cross-cultural findings, involving children in Israel and in a collaborative school system in Columbus, Ohio. The project trained dozens of classroom teachers to do the research and collect data. The results and techniques learned from this effort then came to be implemented further in programs that introduced students to clay as a learning tool in the classroom environment from the Midwest of the United States to Hong Kong!

Although I cannot go into the many details of how that study was conducted, I will summarize some of the essential points. According to the Project's findings, modeling clay was an activity which was found to wholistically promote both intellectual and emotional growth and "allowed children to *actually think through the medium*." Three aspects of clay were deemed to be of particular value for the educational process: its three dimensionality, flexibility, and manipulation.

Three basic features of clay, its three dimensionality, flexibility, and manipulative qualities, allow children to actually think through the medium. . . . Clay facilitates "trying out" ideas, allows for continuous change, and provides children with a sense of freedom of action and choice. Manipulation (is) recognized by most educators and researchers, particularly by Piagetians, as basic to the development of logical thinking and language. Without manipulative activities, children have difficulty or cannot progress to higher levels of thinking.

(Smilansky, Hagan, Lewis,1988, pp. 24-25)

In terms of the characteristic of three-dimensionality, the study pointed out that clay challenged a student to take into account a number of dimensions of spatial reality simultaneously. This, according to the authors, meant that observation and perception are broadened. One-sided judgments are made more difficult, and children are encouraged to try to *integrate varying observations.*

(Smilansky, Hagan, Lewis,1988, p. 25)

The study saw a second valuable feature in clay's quality of flexibility. The plasticity of this particular medium was seen to naturally reflect and encourage a corresponding plasticity of thinking and expression. In comparison with other media, the authors described how

Clay allows for flexibility without penalties associated with paper/pencil or crayon activities. With clay, erasing is done by smoothing out the clay or reshaping parts; changing ideas is possible and encouraged

(Smilansky, Hagan, Lewis,1988, p. 18)

Ideas emerge and reemerge easily, with no penalties for change and exploration: Whether ideas come from observation of reality or are from imagination, clay

adapts to a wide range of concepts in many different ways.

(Smilansky, Hagan, Lewis, 1988, p. 22)

The importance of the third characteristic of manipulation was emphasized strongly by the study. What children do with their hands was considered to be a formative force in shaping their intelligence and learning abilities in remarkable ways that are being increasingly recognized by educators and researchers. The authors related their own findings to the work of Piaget cited earlier and characterized manipulation as

Basic to the development of logical thinking and language. Without manipulative activities, children have difficulty or cannot progress to high levels of thinking (p.25). They also cited recent research on brain-hemisphere functions that has revealed that many children do learn more easily and with deeper understanding if given the opportunity to use the *right-brain function involving spatial skills as well as the ability to see wholes.*

(Smilansky, Hagan, Lewis,1988, p. 30)

The study showed that clay's fundamental characteristics lent themselves readily to a full learning experience for children. Modeling was found to help them in the process not only of expressing concepts but also in evolving and "owning" them in a deep and fundamental way.

The foregoing are a few of the rich insights offered by the Smilansky, Hagan, and Lewis study. It also included a great amount of practical advice. A review of this extensive, in-depth project served as a valuable backdrop for my own research. With so much ground so thoroughly covered, I could then develop and affirm my own experiences and insights, and in a sense carry further the much-needed research on what Smilansky and her collaborators called a *"medium. . . . often overlooked, frequently dismissed as too messy for the classroom setting."*

(Smilansky, Hagan, Lewis, 1988, p. 19)

Hand Movements Sculpt Intelligence

Every action of the hand and the eye sculpts the soul. Piaget called the process accommodation, the development of new cognitive structures.

Arthur Zajonc
Professor of physics

I let my teacher training students discover that their hands can intuitively figure out how to do classroom projects.

Ron Labrusciano
Professor of education

The human hand is a very special organ. A long-time Waldorf teacher, Arvia MacKaye Ege, who taught handwork for many years, characterized beautifully its special role and significance for human existence and education:

Through the fact that man is an upright being and his hands are thus freed from resting on the earth, they have become, down through the ages, the most marvellous instruments. The shape of the hand with its five delicate, mobile fingers surrounding the quiet center of the palm, intimates its connection with the rays and impulses of the five-pointed star, the pentagram—that special creative form found, for instance, in the rose family and also basic to man himself! An organ of the sense of touch, it can be used to feel, to grasp, to move, mold, intertwine, or to relate other objects to one another, but also to make free gestures expressive of the inner dictates of the soul. Through infinite variations of all these, it has become one of man's most creative and, at the same time, selfless organs. Rudolf Steiner has spoken of the hands as the eyes of the rhythmic system. And one who works much with his hands may well feel how an essential part of his being would be blind without them. [The rhythmical use of the hands] works in a mobile, living way upon the development of brain cells, so that [the child's] physical brain will become a far more pliant and sensitive instrument for "living thought" and for clear, strong, mobile knitting of thoughts when he has grown to full adulthood.
(Arvia MacKaye-Ege, *The Human Hand*, p. 47)

La neurologie cherche a comprendre l'homme lui-meme.

It is the task of neurology to understand man himself.

Wilder Penfield
Pioneer of neurology

The Tapestry of Our Mind and Soul

Neurophysiological research increasingly confirms the wisdom and efficacy of what has been called "hands-on learning." Correlations have been found between dexterity and mobility in the fine motor muscles of our hands and cellular development in our brain, which supports our cognitive capacities.

According to the Swedish neuro-physiologist Matti Bergstrom:

The density of nerve endings in our fingertips is enormous. Their discrimination is almost as good as that of our eyes. If we don't use our fingers, if in childhood and youth we become "finger-blind," this rich network of nerves is impoverished—which represents a huge loss to the brain and thwarts the individual's all-around development. Such damage may be likened to blindness itself. Perhaps worse, while a blind person may simply not be able to find this or that object, the finger-blind cannot understand its inner meaning and value.

If we neglect to develop and train our children's fingers and the creative formbuilding capacity of their hand muscles, then we neglect to develop their understanding of the unity of things; we thwart their aesthetic and creative powers.

Those who shaped our age-old traditions always understood this. But today, Western civilization, an information-obsessed society that overvalues science and undervalues true worth, has forgotten it all. We are "value-damaged."

The philosophy of our upbringing is science-centered, and our schools are programmed toward that end....These schools have no time for the creative potential of the nimble fingers and hand, and that arrests the all-round development of our children — and of the whole community.

(Mitchell, *Will-Developed Intelligence,* 1999, p. 9)

Our brain is an intricate loom of billions of neural pathways with a huge potential for weaving internal interconnections and connections out to the world. The name for a brain cell is "neuron" which derives from ancient Greek roots for "fiber," "thread," or "cord." When our hands interact with the world, they are not only actively sensing and transforming what is "out there" but are also simultaneously acting back upon the human soul and its instrument, the brain. They are weaving the branching, thread-like dendritic connections and patterns into our nervous system that correspond to our cumulative experience.

As our hands touch and play upon surfaces of outer reality, we internalize and inwardly fabricate a personalized tapestry upon the multidimensional loom of our mind. The richer and deeper these experiences are, the more *meaningful* the world can potentially be for us. The word "meaningful" is derived from the Old English root "maenen" = "to have in mind or memory." We come to have the world in our minds, but first, we often must have it actively in our hands. Furthermore, we become "interested" in things. The Latin "interesse" literally means "between to be"; between child and world is established a linkage, a bridge, a template, an inner patterning that corresponds to the world.

The ancient Greeks had an intuitive sense of this relationship of thinking to weaving and handwork that was reflected in their myths and legends. The inspiring feminine spirit of their entire culture, for example, was Athena, who was born from the head of Zeus. It was she who became the goddess of wisdom and knowledge, weaving, and handwork! In the great epic of the Odyssey she acts as the inspirer and mentor to clever Odysseus, whispering

thoughts into his ear. His wife Penelope did weaving on a loom in the great hall of Ithaka and craftily outwitted her unwanted suitors by unraveling her work each night. Odysseus himself was the archetype of the new Greek intellectual thinker. It was he who tricked the Trojans through the device of a wooden horse. (The horse as a symbol has been associated with intellectual thinking).

The superiority of the human being is owing to his hand.

Anaxagoras
Early Greek philosopher

Grasping Objects, Words, and Thoughts

A primary vehicle for weaving the world "into our minds" is the active engagement of our hands. The newborn and very young child has billions of active neurons and passageways eagerly ready to meet reality with incredible openness and selfless imitation. Even before the first smile comes the active movement of the hands immediately grasping at the mother's breast and soon after stretching out into the world. By the age of two weeks, newborns already will reach out to things put in front of them!

To start the wonderful process of neurophysiological weaving, the hands first need to grasp and manipulate objects physically. The baby grips the new world with incredible will and intensity. At around age one, when the child achieves uprightness and begins to walk on its legs, a development of similar significance is happening in the hands. They become manipulative organs with fingers that are increasingly able to move independently. This also marks the onset of the next stage of attaining speech in the second year of life. In the

first three years of life the child is also intensively "grasping" and manipulating sounds and words, and miraculously absorbing language and complex grammars. And out of his or her grasp of language arises the grasp of thoughts and the first glimmerings of consciousness of self and ego.

Physical grasp and manipulation thus set the stage for emotional and mental grasp of experiences and ideas. The nouns "concept" and "percept" and their related verbs "conceive" and "perceive" are derived from the basic Latin root "capere" meaning "to grasp, to take into one's hands, to seize." To conceive an idea is to grasp it. To perceive an object is to take hold of it with our active senses. The grasp of our hands is thus an external protoactivity related to other modes of grasping and sensing reality with an active will. The eyes need to reach out actively and intentionally to "grasp" reality, to really see, observe, connect with something rather than just passively receive impressions.

Hand activity and grasping not only initially help establish the awe-inspiring neural network of the mind in our very early years, but also contribute to keeping it vibrant, flexible and active throughout our most formative learning years (ages birth to twenty-one) and into adulthood. Without regular, rhythmic, and active engagement of our hands, many neural pathways would remain unused, underused, or would fail to receive the permanent myelin sheathing they need around them for remembered and repeated action. They would remain disordered and chaotic, atrophy, and wither away. Our minds would be reduced to underdeveloped reflections of their true potential.

Joint Evolution of Hand and Brain

While I was writing this sourcebook, I came across a newly released study by a leading neurologist, Frank Wilson, called *The Hand: How It Shapes the Brain, Language and Culture(1998)*. In it and a related lecture ("The Real Meaning of Hands-On Education" (1999), I discovered a wealth of insights into the latest research on the human hand, its evolution and role in human development. Wilson called his work "a meditation on the human hand, born of nearly two decades of personal and professional experiences." (I highly recommend this well-written and accessible book to teachers, parents, artists, and anyone concerned with the education of children. I include here several excerpts and summarized parts as they relate to my theme, in hopes that people will go on to read and study this thought-provoking work.)

Wilson's explorations caused him to be highly dissatisfied with what he termed the "cephalocentric" (head-centered) view of intelligence, in which the head receives all the credit for knowledge. For him the human being is a wholeness in which brain and hand and other aspects of our being collaborate and participate in each other's development. From Wilson's book and lecture (italic emphasis added by author):

The interaction of brain and hand, and the growth of their collaborative relationship throughout a life of successive relationships with all manner of other selves—musical, building, playing, hiking, cooking, juggling, riding, artistic selves—not only signifies but proves that what we call learning is a quintessential mystery of human life It marks the fusion of what is physical, cognitive, emotional, and spiritual in us.

(Wilson, *Hand*, 1998, p. 295)

The desire to learn is reshaped continuously as *brain and hand vitalize one another* and the capacity to learn grows continuously as we fashion our own personal laboratory for making things.

(Wilson, *Hand*, 1998, p. 59)

There is growing evidence that H. sapiens acquired in its *new hand* not only the mechanical capacity for refined manipulative and tool-using skills but, as time passed and events unfolded, an *impetus to the redesign, or reallocation, of the brain's circuitry.*

(Wilson, *Hand*, 1998, p. 59)

It . . . seems most likely that the brain elevated the skill of the hand as the hand was writing its burgeoning sensory and motor complexities, and its novel possibilities, into the brain . . . The brain keeps giving the hand new things to do and new ways of doing what it already knows how to do. In turn, *the hand affords the brain new ways of approaching old tasks and the possibility of undertaking and mastering new tasks.* That means the brain, for its part, can acquire new ways of representing and defining the world.

(Wilson, *Hand*, 1998, p. 290)

In "The Real Meaning of Hands-On Education," (1999) Wilson gave a summary of the fascinating evolution of the hand and its imagined emancipation from arboreal gymnastics and limiting specialization:

Somewhere between 200,000 and 100,000 years ago, *the hand had reached its present anatomic configuration, the brain had tripled in size*, tools were more elaborate, there was a complex society based on the organization of relationships,

alliances, ideas, and work, and we started calling ourselves Homo sapiens. . . . [The modern human hand acquired] *the ability to move the ring and small fingers across the hand toward the thumb*—a movement which is called ulnar opposition. Ulnar opposition is a prime example of *a small anatomic change with monumental consequences*, because it *greatly increased the grasping potential and manipulative capacity of the hand*. Ulnar opposition made it possible for the thumb to powerfully hold an object obliquely against the palm, as we hold a hammer, a tennis racquet, or a golf club, or as a violinist holds the neck of the violin. This new grip has been called the oblique squeeze grip, and it would have been a major advantage in close combat because in this hand a club could be held tightly and swung on an extended arm axis through a huge arc.

(*Hands-On Education*, p. 6)

But ulnar opposition also meant that *the hand could conform itself to a nearly infinite range of object shapes* and could orient and control them, precisely, delicately, or powerfully if need be. Small objects could be taken apart and put back together again, or made into entirely new objects that could themselves be connected, taken apart, revised, reconnected, and so on.

(Wilson, *Hand*, 1998, p.6)

The trick of ulnar opposition is unique to modern humans. . . an effect . . . can be seen in an improved precision grip, in which *small objects are manipulated between the fingers without contacting the palm*.

(Wilson, *Hand*, 1998, p. 28)

The ability of the hand to *conform to large spherical objects* is due in part to the action of small but powerful intrinsic muscles . . . that help to maintain its arch.

(Wilson, *Hand*, 1998, p. 120)

Since it does not seem likely that the brain's remarkable capacity to control refined movements of the hand would have predated the hand's biomechanical capacity to carry out those movements, we are left with a rather startling but inescapable conclusion: it was *the biomechanics of the modern hand that set the stage for the creation of neurologic machinery* needed to support a host of behaviors centered on the skilled use of the hand. *If the hand did not literally build the brain, it almost certainly provided the structural template around which an ancient brain built both a new system for hand control and a new bodily domain of experience, cognition, and imaginative life.*

(Wilson, *Hands-On Education*, 1999, p. 6)

The brain does not live inside the head, even though that is its formal habitat. It reaches out to the body, and with the body it reaches out to the world. *Brain is hand and hand is brain.*

(Wilson, *Hand*, 1998, p. 307)

These last two excerpts reflect an agreement with the philosopher Kant, who said that *the hand was our outer brain.*

In this remarkable relationship and interdependence of hand and brain function, Wilson discerns other profound ramifications for understanding the development of intelligence and learning, speech and language, self-awareness, ego development, and even our health and inner sense of freedom:

Self-generated movement is the foundation of thought and willed action, the underlying mechanism by which the physical and psychological *coordinates of the self come into being.* For humans, the hand has a special role and status in the organization of movement and in the evolution of human cognition.

(Wilson, *Hand,* 1998, p. 291)

As far as we know, or can imagine, *thought and intellect are the sum total of the organizing tendency of the child's entire, rapidly expanding collection of passive and active interactions with the world via touch, smell, sight, hearing and kinesthesis.* It is probably not possible to be more specific than this. . . .

(Wilson, *Hand,* 1998, p. 195)

Whatever precise sequence (children) follow discloses the influence of an abstract, *hierachically organized (learning) process . . . The seven-year-old, manifesting maturational changes in her brain, approaches the problem* (of forming stick patterns) *as an architectural one.* [In comparison, *the eleven-year-old's*] performance is not orderly. She *has become an improviser.* Her use of hierarchical pattern thinking is now so secure, so integral to her technique, that she has been set free . . . She is now unequivocally behaving with *intelligence!*

(Wilson, *Hand,* 1998, p. 167)

I think working with children has given me this idea, which isn't often discussed in medicine: a lot of disease— medical disease and emotional "dis-ease"—is an outcome of a lack of full development. It's not something we can get to just by removing a psychological block. There actually are no blocks in that respect, but there is the block caused by lack of learning and development. In that sense, *healing is a process of continuing development and learning.* It's not the single, miraculous event that people imagine, a catharsis or something like that. So when I look at people with problems, more and more I ask: "What have they not learned? *What in their development have they missed?"*

(Wilson, *Hand,* 1998, p. 252)

If the hand and brain learn to speak to each other intimately and harmoniously, something that humans seem to prize greatly, which we call *autonomy,* begins to take shape.

(Wilson, *Hands-On Education,* 1999, p. 9)

In comparison with animal appendages, our hands have remained curiously unspecialized and almost embryonic. Yet therein lies their great flexibility and freedom of movement. They are able to learn to execute an infinite number of tasks. The human hands have emancipated themselves from being environmentally fixed for specific purposes and become primary organs of freedom and the basis for mobile, creative thinking and communicating.

Speech and Language

Wilson devotes considerable attention to the intimate relationship between what he calls the articulate hand, its gestures, and the development of speech. He explores the possibility that the hand may very well have been the instigator of human language *(Hand,* p. 59). To this end, he brings into his study the insights and conclusions of several other researchers.

For (Russian psychologist) Vygotsky, "well-developed thought"

arises as the verbal behavior of the child undergoes a long metamorphosis during which words that were originally object attributes come increasingly to be *manipulated* and combined, just as *real* objects are manipulated and combined by the child.

(Wilson, *Hand*, 1998, *p. 193*)

(Linguists Armstrong, Stokoe, and Wilcox, in their 1995 book *The Nature of Language*:) conclude:*"With their hands* and developed brain and greatly increased eye-brain-hand neural circuitry, hominids may well have invented language—not just expanding the naming function that some animals possess but finding true language, with syntax as well as vocabulary, *gestural activity.*

(Wilson, *Hand*, 1998, p. 204)

We can now say with considerable confidence that almost the entire set of distinctive human motor and cognitive skills, including language and our remarkable ability to design, build, and use tools, began as nothing more than an enhanced capacity to control the timing of sequential arm and hand movements used in throwing.

(Wilson, *Hands-On Education* ,1999, p. 6)

Such research correlates in part with the language investigations of Johannes Kiersch: "[Early language] achieves its individual form not through participatory imitation, but through the type of motor activity peculiar to early infancy. In several lectures of 1923 and 1924, Rudolf Steiner describes in what subtle ways *the human capacity for speech is predisposed by the occurrence of certain leg, arm and finger movements.* Thus he maintains that the structuring of language in sentences is anticipated through vigorous, regular movements of

the legs, good pronunciation through harmonious arm movements, and the sense for the modulation of speech through the child's experiencing the life in its fingers." (Kiersch, *Language Teaching in Steiner Waldorf Schools*, 1997, pp. 34-35)

Education of Head, Heart and Hands

The implications of recent brain research and Wilson's work for education and basic educational arts such as modeling are immense. In his book *The Hand*, and in his lecture on "The Real Meaning of Hands-On Education," Wilson explores the necessary role of real hands-on, experiential learning in human life and believes that we ignore it at great risk:

The young of our species will respond to their environment and will advance their own skills and understanding according to the same basic plan provided to every new Homo Sapiens for at least 100,000 years.

(Wilson, *Hands-On Education*, 1999, p. 4)

The hand enjoys a privileged status in the learning process, being not only a catalyst but an experiential focal point for the young child's perceptual, motor cognitive, and creative world.

(Wilson, *Hands-On Education*, 1999, p. 14)

In the formative years of each human being, *the hands need to recapitulate and play their crucial evolutionary role designing and building significant elements of our neural circuitry and capacities.*

It may be that the most powerful tactic available to any parent or teacher who hopes to awaken the curiosity of a child, and who seeks to

join the child who is ready to learn, is simply to *head for the hands.*

(Wilson, *Hand,* 1998, p. 296)

Wilson ultimately includes the role of feeling and the heart with those of hand and head. A delightful part of his research involves qualitative case studies of individuals who use their hands in a variety of special ways: jugglers, surgeons, musicians, puppeteers, car mechanics, engineers, rock climbers, and so on. Through interviews he encounters successful lives and minds that have been incredibly enriched and enhanced by hand creativity. In connection with his study of a surgeon's hands, for example, Wilson experiences that there is knowledge that can "be obtained only by acting on the object being *held in the hands* and then written in the brain in the tactile and kinesthetic language of manipulation."

(Wilson, *Hand,* 1998, p. 276)

In evaluating this more personalized aspect of his research, Wilson comes to one of the most striking observations of his entire book:

When personal discovery and desire prompt anyone to learn to do something well with the hands, an extremely complicated process is initiated that endows work with a *powerful emotional charge. People are changed,* significantly and irreversibly it seems, *when movement, thought, and feeling fuse* during the active, long-term pursuit of goals . . .

(Wilson, *Hand,* 1998, pp. 5-6)

For me as a teacher, this special fusion of willed movement, thinking, and feeling is also very applicable to the quality and level of experiential learning we should be aiming for in the education of children. Such fusion means that the whole child and human being is addressed and engaged. It integrates head, heart, and hands in full, unified experiences.

In the Prologue to his book, Wilson posed a provocative question to society and educators: *"How does, or should the education system accommodate the fact that the hand is not merely a metaphor or icon for our humanness, but often the real life focal point—the lever or launching pad—of a successful and fulfilling life?"*

(Wilson, *Hand,* 1998, p.14)

To this, I would respond as a teacher and say that I have found education is profoundly enhanced when it uses an artistic-experiential method to achieve lasting and integrated capacities of intelligence—intellectual, emotional and volitional (will). Such an education is not intended to train or produce artists, but uses the experiential methodology of the arts to gain knowledge, values in life, and a healthy practical sense among other things. Herbert Read called this *"Education as an Art,"* an expression also used by Waldorf schools. The arts are not frills but rather the great, largely untapped fountain of educational renewal. This was recognized in a issue of *Educational Leadership* magazine (November 1998) devoted to "How the Brain Works":

Because our visual, auditory and motor systems are essential to cognition, it's probable that the arts emerged to help develop and maintain them Evidence from the brain sciences and evolutionary psychology increasingly suggests that the *arts* (along with such functions as language and math) *play an important role in brain development and maintenance*—so it's a serious matter for

schools to deny children direct curricular access to the arts. The arts are highly integrative, involving many elements of human life . . . (especially) on two key elements: (1) heightened motor skills that we call performance, (2) the heightened appreciation of our sensory-motor capabilities that we call aesthetics. Movement is central to life and to the arts. Why do we have a brain? Plants seems to do fine without one; many trees far outlive us. *We have a brain because we have muscle systems* that allow us to move toward opportunities and away from dangers. (*Educational Leadership*, November 1998, pp. 31-32)

For me, the very form and function of the instrument of the human hand and its fine motor muscle systems is a key to education. It curiously holds within its configuration an imaginative miniature of our human wholeness and nature. The tips of our fingers are like little sensing heads with their incredible concentration of nerves and "seeing" ability. The interior hollow is an inner heart space of feeling in which we can hold, weigh, and judge things. The lower part of the hand and the strong opposing thumb have the most developed musculature and embody the hand's will power. Let our children work with their hands and imbue life with creative form, beauty and wisdom!

Thinking through Modeling

The activity of thinking is essentially an expression of flowing movement. Only when thinking dwells on a particular content, a particular form, does it order itself accordingly and create an idea. Every idea—like every organic form—arises in a process of flow, until the movement congeals into a form.

Theodore Schwenk
Water researcher

Sculptural modeling, as described and illustrated in this book, is one artistic mode of fusing thought, sensitivity, and action in free exploration and learning about the world and ourselves. Previously, I used the metaphor of the woven tapestry to describe the intricate dendritic networking of our brain. Interestingly, this "fabric," if you will, is all wrapped up in multiple folds and layers and sits like a soggy, fissured lump in a vessel of cerebro-spinal water. Indeed, it looks more like a modeled lump of grayish/whitish clay than anything else. The organ-forming forces of the body have done their special work in sculpting the brain's two symmetrical halves, corpus callosum, and brain stem. Furthermore, the brain continues to maintain a certain remarkable degree of "plasticity" of learning modes and styles throughout life even into old age. In certain cases it has proven it can malleably compensate and adjust after injury.

In light of its plastic nature and plasticity, one might thus just as easily speak of a "modeling" of the structures of our nervous system as of an internal weaving of them. Similarly, we can refer to the forming or shaping of thinking as well as to weaving threads of thought or knitting them together.

Weaving, knitting, and forming/shaping are expressions that also interestingly characterize the work of the hand. I submit that this is more than coincidence and metaphor.

Artistic modeling with the hands externalizes the thinking process in a powerful, experiential way. When we shape or form a piece of clay we are actually moving it through a mobile process of thinking and series of thought stages.

Our brain is being greatly activated and exercised and is itself changing and being sculpted internally. Like the surgeon who has a special knowledge as she holds actual tissues or organs in her hand, we also have an immediate tangible experience of a complexity of forms that we could not have if we were only looking at it. This primary tactile, haptic experience is intimately and closely connected with how we plastically built up the initial foundations of our cognition in the first place. Wilson describes this early learning in this way:

The curious, exploratory, improvisational interaction of the hand with objects in the real world gives rise to what we call "ideas." This process begins quite early in the child, and is usually described in somewhat mechanical terms, usually as an essential stage in sensorimotor development or in hand-eye coordination. Not many people think of the preverbal child as having ideas as such, but that is because most people think of ideas as being constrained by the operations of formal language. *Ideas, in, fact are more intimately related in development with the interaction of the body with the world.*

("Wilson, *Hands -On Education*, 1999, p.10)

Modeling mobile, changing, and often complex topologies of form brings us back to these nonverbal roots of interaction and learning that absorb us in a deeper, silent language of movement and the intuitive will. It can be likened to comparably powerful, nonverbal experiences in music. (Modeling is a kind of musical progression, in fact, and its forms become "frozen music" in the end). Such prototypical activity enhances and resonates with the very heart and foundations of our intelligence. We feel refreshed because we have made contact with the world in a very direct, immediate way. We have the world in our hands. We thereby tap into the original sources of knowledge and learning that we knew through grasping when we were very young.

> The beauty of the hands is that they speak a universal primary language. It is the language of newborns. That's the language before words. Everybody had that language or we would not be alive.
>
> (Wilson, *Hand*, 1998, p. 253)

There is nothing like working with primal substance of clay and imbuing a piece of earth with the gestures and movements of universal forms. We are exhilarated at the freedom we have in exploring and discovering various concrete thoughts and using the deepest intuitions of our articulate, intelligent hands. Infinite variations are possible as we learn to freely practice a liberating kind of improvisation. The process involves us in a transformation of matter in time and space as creatively shaped by the movements and energy of our hands. Energy, mass, space, time—all that is needed to complete the Einsteinian fundamentals of the universe is light, or enlightenment! And that we receive by engaging ourselves with living, metamorphosing forms and patterns in a direct, primary way. For in the process we are also actively building and exercising the patterning, the geometries and topologies, the organizing principles and processing of higher cortical functions. Plastic forms are ideas, and ideas are plastic forms. Modeling is a mode of thinking, and thinking is modeling.

Modeling ultimately changes our brains and consciousness and educates us to perceive whole, living, evolving organisms and systems, a capacity which is sorely needed for today's ecological challenges. Sculptural and manual intelligence, I believe, can help us develop the new awareness and organic paradigms we urgently need in the next pivotal century. With new modes of a flexible morphological thinking and consciousness, we will be able to truly make new steps in coexisting on the living organism of our precious earth, whose fate is in our hands.

I . . . want to show that the spirit needed in schools can be magically engendered through art. If done properly, this light-filled art can produce a radiance in children that allows the soul to integrate into the physical body, and thus into the world, for the person's entire future life.

Rudolf Steiner

Doing Revisited: Head Back to the Hands with Heart

Most of us are probably like Frank Wilson, neurologist and author of *The Hand*, who admits that "I have spent the better part of my life oblivious to the workings of my own hands." One does not overcome this lack of awareness, however, by merely reading or even writing books, no matter how interesting. Wilson himself not only studied the hand but also, as part of his research, took up piano playing. Through it, he says, he directly experienced that "inside me, it seems, there was already a plan."

(Wilson, *Hand*, 1998, p. 4)

At the beginning of this book I introduced a number of imaginative exercises for getting to know one's hands and their versatility, expressiveness and space-creating possibilities. These, I pointed out, could be adapted for children. One of them was called "raying out" (expansion) in contrast to another designated "curling up" (contraction). In light of what Wilson has said about the special significance of ulnar opposition, I would like to introduce you to two further exercises to help you become more aware of the miracle of your hands. They are called:

Finger Waves

• Curl one hand up tight into a little spiral of life (fist). Contemplate its inward curving fingers and form. Feel the living warmth of its inner layers and heart of the hand's space.

• Ray out your fingers and make a flat hand.

• In ulnar opposition, move the sensitive head-like tips of your small and ring finger and then each of your others to touch the big tip of your thumb, one at a time slowly and several times.

• Now without touching your thumb, rhythmically move your fingers towards your thumb in a wavelike pattern much like playing a harp. As your fingers move towards it, your thumb will also move in and out rhythmically. Increase the vigor with which you do this so that your whole palm and larger muscles at its base move with a concerted will.

• Repeat the above with the other hand singly.

• Try the entire exercise with both hands moving at once.

• Bring both moving hands opposite each other and move their radiating curves rhythmically in and out of each other.

• Observe, follow and marvel at the myriad of spatial forms and graceful movements created by the hands singly and together.

Finger Grips

• Using the palm and fingers of only one hand, model a walnut-sized lump of clay into a sphere.

• Move it away from your palm and up between all five finger tips (a circle in a pentagon!).

• Next hold the ball between the thumb and each of the other fingers: little, ring, middle, and index.

• Find all the possible grip combinations of two, three, and four fingers.

• Pass the sphere down the row between different adjacent pairs: from thumb-index to index-middle to middle-ring to ring-little.

• In both of the preceding exercises, contemplate the role of the hands' infinite movement and form possibilities in the development of our humanness.

When we do not merely grasp with our hand but think with it, then, thinking with our hand, we follow our destiny . . .

Rudolf Steiner

Beeswax, Gift of the Hive Community
How The Bees Make Wax and Sculpt Honeycomb Homes

Grades One and Two

Before the children start to work with beeswax , make up a colorful, moving, and imaginative story about the marvelous life and work of honey bees.

Once there was a great swarming family of thousands of little creatures, golden, furry honey bees, lifted through the air by short gleaming clear wings (which weave in figure eights). They were all filled with joy and excitement, for something momentous was happening in their lives. Their happy buzz in the sunshine was a great song of celebration on this summer day. Mother Nature had woodpeckers working hard for many weeks on a new home for the bees, pecking out a hole in a great rotting tree. . . .

Adapt whatever you choose from the following descriptions to suit your children:

The bee family lands and hangs on the tree like one moving, humming curtain, and then swarms into the cozy hollow to make a new golden palace of rooms.

The new home inside the tree is built by the young bees who are less than seventeen days old, not yet old enough to fly off and fill their honey sacs with flower nectar or their pollen baskets with golden pollen. The bees hang from the roof of the hollow. As one hooks its claws to the ceiling, an-other hooks onto the hind legs that dangle down. More and more bees hang onto each other and form a chain of bees growing longer and longer downward.

On both sides of each bee's belly are four wax pockets. After hanging for a day, flakes of wax appear out of these pockets. When a bee knows its flakes are ready to come all the way out, it climbs over the other bees, takes the flakes out of its pockets, chews them into a soft, warm, creamy mass, and pats and models the wax into the right place where the golden palace walls are rising. At times there are so many bees hanging and making wax that the scales slip out and onto the floor. The bees at the bottom of the chain let go, drop down, pick up the little slabs and buzz over with them to build the walls.

Bees start a hive by first piling up wax and pushing holes into it. These holes are like rough cups that fit the bee's body. Many bee bodies keep pushing on the cells so that they push against each other. They use their heads, feet, and bodies — ramming, scraping, and smoothing the wax. Miraculously, six-sided rooms form from all this pushing and modeling of the honeycomb. And all of these hundreds of spaces are warmed by the busy, hardworking bodies of the bees.

Soon the hollow of the tree is filled with row upon row of little rooms all the same size and shape. The six-legged bees make each room with six sides in the form-ing hexagons just like a sparkling quartz crystal. Three pairs of strong, beautifully

and exactly shaped walls face each other. While the wax is still soft, the bees draw special threads of tree resin through the thin walls of wax to strengthen them. The bees spend most of their time running around the top of the honeycomb so that its top edges are thickened. Extra wax is dabbed above to soften the sharp edges.

The little hexagonal rooms, or cells, are used to store honey and pollen and to raise babies. They are sealed off with a little wax cap. In the winter when food is scarce, the caps are chewed off and all the bees feed off of the stored treasure. The bee that takes out the honey shares it with all the bees in the hive. It is passed around to every bee. Nectar starts forming into honey in the honey sacs of the bee's stomach and is stored for ripening in the cells of the hives.

Bees live for the sake of the whole hive and family. They love to huddle together and keep each other as warm as we human beings are. What work they do for the good of the family depends on how many days old they are. The youngest bees bring food to the babies for only a few days before they have to move on to modeling the wax walls of the honeycomb. Several days later, they change jobs and becomes guards to the entrance of the hive. Finally, they fly out as food collectors.

Humans have befriended bees and made tree-like hollows for them in basket hives or wooden box hives. Beekeepers know how to take honey and honeycomb wax for human use without the bees becoming angry and stinging. Beeswax candles glow so beautifully. Beeswax softens in our hands and can become all kinds of shapes. Whenever a bee becomes trapped in your house, gently help it escape and come to no harm. We are so grateful for the gifts of the bees.

Grade Three

Retell the foregoing on a more sophisticated level, add new aspects and facts such as those listed below, and relate them to studies of farming, gardening, and orchard cultivation. Visit a beekeeper and hear his or her stories.

Dance of the Scouts

After spending a night in the hive, the bees stir the next day but do not fly out until they receive exact directions from a dozen or so scout bees. The scout bees are out early, winging their way around to see what flowers are available. They fly out around the hive in larger and larger circles. If flowers have blossomed nearby in fields, gardens, or orchards, reports come back quickly to the hive, which buzzes with excitement. A scout comes back loaded with a sample of what can be found. If she dances in a weaving pattern to the left and then to the right, the others know there is plenty to be fetched. The others crowd around and touch the dancer with their antennae to taste the scent of the flowers to be found. If the flowers are far away, the scout takes longer to announce the location and distance in a more complicated dance. The scout runs an inch in a straight line, turns left, goes back, runs the same line, turns right and repeats this several times, all the time wagging its rear end. The straight line points exactly in the direction of the treasure in relation to the sun. The slower the bee moves, the further off are the flowers. Making ten circles in fifteen seconds means the blossoms are three-hundred feet away. Very slow movement, such as two circles in fifteen seconds, indicates they are four miles away. The vigorousness of wagging tells the eager audience how much honey or pollen to expect. Bees also make sounds with their wings that tell the others details about the find.

Gathering Nectar, Pollen, Water, and Resin

When bees go out to gather food, they first take along a tiny bit of honey to give them strength to travel. Bees dive down into the blossom and extend their tongues to quickly suck up the nectar, the precious flower juice. If there is abundant juice, their sacs can be filled in a minute. It can take about three minutes to fill their pollen baskets with the golden dust. When they are rolling around in the flower, hairs all over their bodies pick up pollen. They then have to scrape and comb it off their bodies, wet it into balls and fill their pollen baskets evenly on their legs. As soon as they are loaded with nectar and pollen, they fly directly—that is, they make a beeline—to the hive to deliver what they have gathered. If the hive is thirsty, they can also bring water in their honey sacs, or they might bring sticky resin for strengthening and lining the hive and patching cracks.

Honey

As it is transported, nectar starts to become honey in the stomach of the bee as water is recovered and the sugars are transformed in the nectar. Honey is nectar that has been changed within the bee and regurgitated for storage and ripening in the little capped rooms or cells of the hive.

The Queen

Most bees busy themselves in collecting and storing nectar and pollen from flowers, building their home of wax, and sharing honey. There is one very special bee at the center of the hive, however, who is doing none of this. She is the queen of the family of thousands of bees. She spends most of her time walking across the face of the comb and laying an egg into each open cell—sometimes 20,000 eggs in a single day.

Where does she get so much strength to lay so many eggs? Around her are twenty special children only six to twelve days old, who take pollen out of the storage rooms, chew it with their special kind of spit or saliva, and make the most nourishing of all foods: the royal jelly for the Queen. (Every day, three of them become twelve days old and have to be replaced by three six-day-old bees.) The young bees surround her and take turns feeding her the magic jelly every twenty minutes while she rests. Imagine, the queen is nourished by pollen, and the magic dust that sparkles on the seeds of flowers also helps the bee eggs to grow.

Grade Five

It is wonderful to discuss the whole life cycle of the bees once again in connection with the study of plants and other insects. A curriculum should become a living spiral of understanding.

Further aspects to be elaborated about the life the honeybee:
- the anatomy of the bee
- four stages of development (egg, larva, pupa, winged adult)
- interior structure of the hive
- the chemistry of honey and wax making
- how different tasks are assigned to different ages
- more descriptions of scout motions and signaling
- the intricate steps involved in removing pollen from the bee's body
- the role of drones
- stinging and dying
- birth of a queen
- swarming patterns and new colonies
- the sources of forest resin to fortify the hive

- the relationship of the bee to particular flowers
- endless topics depending on your research

(See the work of Dr. Karl Frisch on the fascinating behavior of bees, and Steiner's lectures on *Bees.*)

Clay and Water
Vessels of Life and Instruments of the Music of Forms

Khnum the Moulder, the ram-headed God, shaped human beings and all flesh, modeled the gods and fashioned the world egg on his potter's wheel.

Egyptian Mythology

And God formed the human being of the clay of the ground and breathed into his nostrils the breath of life . . .

Genesis

Remember thou hast made me of clay . . .

Job

Wise Prometheus modeled human beings out of river clay and in the shape of the gods. He desired fire for his creations.

Greek Mythology

Grade Three

Narrate the Hebrew story of how human beings were created from the clay of the earth. In studying farming and gardening, students can be told about the value of clay soil for holding moisture and fostering the life of plants. A balanced soil loam has humus (life-filled compost), clay (moisture holder), and sand (light silica) in it. Third graders can participate in making an outside oven from clay and use it for making bread and firing simple clay objects.

Grade Four

When students start to use clay more to model such subjects as animals, they may have the opportunity to visit a clay pit as part of local geography studies. If possible, allow them to bring some back to school to model. In the fourth and higher grades their teacher can discuss appropriate aspects about this remarkable material called clay.

Grade Five and up

Tell the myths of the Greek Titan Prometheus modeling the first human beings out of moist clay and of the Egyptian god Khnum shaping humans on the potter's wheel. In geography lessons, the relationship between clay, landscape, vegetation, and human activity can be vividly portrayed.

Grade Six

In geology, clay's relationship to other minerals such as feldspar can be characterized. Feldspar is a binding constituent in granite, which also contains quartz and mica.

Grade Seven

Chemistry reveals clay as aluminum silicate. Aluminum oscillates continually between the poles of base and acid, linking and balancing them.

Skin of the Earth

Wet clay uncannily has the consistency of wet skin, naturally and pliably lending itself to the forming of life-like shapes. As a soil material and mineral, it exists in a variety of forms that support the life of plants, animals, and human culture. According to Rudolf Haushka, chemist and medical doctor, clay plays a interesting "bridging" and balancing role in the life of the earth:

Valleys and basins between mountain ranges delight us with their luxuriant vegetation. Here we find still another type of landscape. Everyone knows the type of soils native to such regions—its brownish-yellow clay sticks to one's shoes in rainy weather and one's feet sink into it. Chemically speaking, this loam is an aluminum silicate. In its pure form it is known as potter's earth or china clay. This is the type of soil deposited in river valleys or in mountain basins. It is a heavy, fertile soil, such as favors the growth of lush foliage. Geologists call it alluvial because it is formed by the weathering and washing down of disintegrated mountain rock. Thus we may call clay a bridge between ranges. Since it has been found to constitute about 20% of the earth's crust, it is—like lime and silica—one of the building materials of which the earth's body is composed.

Lime and silica (can be) shown to be polarities. Aluminum seems designed to bridge the two. We can see this in rock where clay is present. Feldspar is a good example. It plays a harmonizing role between quartz and mica . . . (Chemically) aluminum oscillates continually between the poles of base and acid, linking them in a constantly re-created balance. We even find the plant's two poles, root and blossom, brought into harmony by the aluminum element. It is not, however, the substance aluminum, but the aluminum process that carries the earth forces upwards from the root, and the sun and stellar forces of the blossom region downwards to the root. Aluminum's material presence in the soil stimulates the plant to this activity. Silica is responsible for color, scent, and finely articulated form, while lime sees to the material filling out of vegetation from below. Aluminum keeps these earthly and heavenly forces in a living balance. That is why we called luxuriance of foliage, the green middle zone of the plant kingdom, a sure indication of clayey soil. Aluminum's material presence in the soil stimulates the plant to this activity.

(Hauschka, 1950, pp. 132-33)

Mineralogist Friedrich Benesch concurs with Haushka about clay's intermediary role in the environment and also examines its functions in the human organism:

The silica process turns the human being toward the surrounding sensory experience, most notably through the sense of vision. Conversely, the calcium process calls one inward, making one listen. Between looking out and listening into, the process of clay—the basis for the sense of touch—mediates and brings into proper relation what has been sensed outside and found by touch inside. It almost has the function of a diaphragm, insofar as upper man is more inclined toward the surroundings and lower man toward the inner world. Between this lives the multitude of sensations. always relating an outer to an inner experience.

When we observe a potter creating beautifully formed vessels at his potter's wheel, we sense some of the divine creative force. We can feel how the human soul exhales the creative power that was breathed into the soul. The creative idea and the goal indwelling in the soul, via the creative hands, completely melt with the clay as it is moved on the potter's wheel. The hands must touch it thoroughly, the human soul has to identify completely with the form imagined in order to bring it to manifestation. Do we not experience an accomplished form as ringing "inaudibly," sounding, awakening something musical in ourselves?

(Benesch, 1995 , p. 57)

It is interesting that the word for clay in German is "Ton" which is etymologically related to the Greek "tonos" = "act of stretching", or the Latin "tonus" = "tension." Tone is most frequently applied to the pitch of a sound in music or word, the voice, and to color and shade. According to Webster's Dictionary, it also denotes the functioning of a living body which can have healthy, vigorous tone (muscle tone and skin tone), and normal tension and responsiveness to stimuli. Furthermore, tone can characterize general character and quality, healthy elasticity, resiliency, frame of mind, and mood. As a verb, it can mean to blend or to harmonize; to tone up means to strengthen; to tone down, soften.

Educator and artist Michael Martin asks,

How has it come about that in the German language the word for malleable earth ("Ton," clay) is the same word as that for a musical "tone?" Perhaps, an explanation lies in what Steiner says about musical tones:

The evolution of form in matter can be properly compared with the formation of form through tones (Chladny figures). Archetypal processes are revealed here. All form is frozen music. The sounding tones must first battle their way through primeval fires, and the mineral and the animal kingdoms—actually everything is music which has fought its way through fire.

(Martin, *Educating Through Arts and Crafts*, 1999, p. 97)

The fascinating relation between musical tone and clay tone, plasticity, and responsiveness is also cited by Haushka:

Wet clay ("Tonerde") is plastic and responsive to formative forces acting and working on it from outside. Just as a musical instrument responds to a musician, so plastic clay ("plastische Ton") is the instrument for the music of forms composed by the sculptor.

(Hauschka, 1950, p. 134)

In this connection, studies have been made using musical principles to understand the sculpture-like formation of the human body.

(See Armin Husemann's *The Harmony of the Human Body: Musical Principles in Human Physiology*, 1989.)

Properties of Clay for Artistic Use

The chemical and physical composition of clay is expressed in a remarkable plasticity, malleability, and capacity to create smooth contours and surfaces. Examination under an electron microscope shows a microcosm of leaf-like or plate-shaped particles, elongated in two dimensions, and thin in the other dimension. Each very flat particle can be thought of as a clay crystal.

Potter Gerd von Steitencron describes in detail the properties of clay for pottery and modeling from an educator's and artist's perspective:

Clay is an ideal raw material for sculpture, pottery, and the modern ceramics industry. Like wood, it offers extraordinary creative potential and also possesses qualities which must be felt to be disadvantageous, especially if we have not taken them into account sufficiently in our work. Wood warps, shrinks, and splits while drying. It is primarily active across the yearly rings. Clay shrinks approximately equally in all directions as long as it was previously properly kneaded or pugged, and it can also dry out evenly. Good-quality clay is a prerequisite for successful work and strongly influences the overall character of the finished product. Its most important and unique quality is its plasticity, its capacity to take the impress of the slightest pressure of hand or finger and then to maintain the finished form throughout the processes of drying and firing and beyond.

Now, all clays are not equal. There is coarse brick-makers' clay and the finest porcelain clay, as well as a great variety of naturally occurring types in between. Of these, the best and most easily accessible are used industrially: they are dug up, processed, and marketed commercially. Much of their natural character is unfortunately lost in modern processing. A completely different relationship to clay can be found by going in search of it ourselves. Even a fine loam is often very usable for modeling if first crumbled and put through a sieve through which the finest sand just passes. Mole heaps, river banks, and flood plains of streams and rivers, defiles, building pits, and large gravel pits all offer possibilities of discovering clay beds. Attention must be paid that there are no particles or bits of chalk in the clay and that no plaster bits are absorbed while the clay is drying on plaster boards. Clay or loam that can be picked up from brickyards is usually quite usable for sculpture and for modeling clay pots.

Rural potters used to dig for a single clean, usable clay located near their ovens. These early potters still sensed the whole elemental connection to nature that bears unseen within it the primeval process by which clay arose. They were usually content with their direct experience of the clay, not seeking out a geological, mineralogical, or particularly a chemical understanding of their raw material. In any case, there was little to be known, for science began to interest itself in this specialized field quite late. Even today there are only uncertain insights into it; huge questions remain. If a deeper interest develops for what is passing through our hands almost daily in the way of clays and glazes, then the following may be discovered, broadly speaking:

Almost all clays arise from a transformation, crumbling, and erosion of feldspar-bearing primary rock (granite and related stone); the causes are many and various. In the process of breaking up, quartz, feldspar, and mica or hornblende separate out and disintegrate further. From the feldspar, only the mica-bearing kaolin remains behind at the original location, close to the mother lode. This pure and almost white "primary clay" withstands high temperatures, but

is in itself unusable, having too little plasticity. The actual malleable clay used as a raw material by both potters and ourselves is termed "secondary clay" and is generally found far from the mother rock. It is also called sedimentary clay. This has usually been washed away and carried quite far by the force of water. Further fine mineral and organic material became mixed in—partly at intermediate points of settlement—until the clay was deposited in its final location. Its characteristics are extremely dependent on the various possible processes involved in its origin and formation. Most common is iron-bearing clay, which fires yellow to red, or at higher temperatures brown (brick and clinker clay). All colors, including those of the glazes, are produced by various metals and metal-oxides present. South of approximately forty-nine degrees of latitude almost all clay contains lime and cannot withstand high temperatures. Above 1100 degrees celsius, it suddenly melts. The principal components of clay are:

Quartz (siliceous acid) ca. 50–70%
Aluminum-oxide ca. 20–30%

The remainder consists of minute quantities of oxides of iron, lime, titanium, magnesium and alkalies.

Generally, a "richer" clay contains comparatively more aluminum-oxide and correspondingly less quartz; a lean clay has the reverse, more quartz and less aluminum-oxide. Potter's clays are generally moderately rich and can absorb a considerable amount of water, giving them plasticity and malleability. A good clay takes time to mature; this is connected with its plasticity. It must lie wet and become saturated with water—this is called maturing—preferably out in the open where it can freeze in the winter and be rained upon in the summer. Before being shaped it must be thoroughly kneaded or pugged; this also applies to the moist, ready-to-use "de-aired" clay marketed in plastic sacks.

Kneading must be learned as well; the most effective technique is spiral kneading. It is much more difficult than commonly supposed, for no air may be allowed into the clay. Should there be air bubbles in clay, they must be eliminated through kneading. The following is a guaranteed method of pugging the clay and eliminating any air: Take a block of clay and cut it with a thin wire into two approximately equal parts. Slam the one half down onto the other so that edge meets edge or curved surface meets curved surface. Repeat about twenty times.

In the course of drying, a substantial reduction in volume occurs through evaporation; the richer the clay is, the more it will shrink. It can easily happen that it warps or even cracks. To prevent this, the clay can be made leaner by adding ground shards, grog, sand, or chalk. Clay shrinks as a result of losing its water content, becoming stable and hard, but not yet durable. Sufficient water will dissolve it completely again, breaking it up and softening it, thus reconstituting it for reuse in modeling

Let us look more carefully at our malleable clay . . . Primeval rock crumbles and erodes down to fine mineral particles. Water converts these particles from a crystalline into a colloidal state; the latter is highly unstable,

however, and can easily revert to its original condition (primary clay or kaolin). Colloid solutions play a role primarily in living organisms, e.g., in protein combinations.

In secondary clay formations (malleable clay), a process begins under particular conditions enabling completely new minerals with a very finely layered mica structure to arise out of the colloidal particles mentioned above. (Humus arises in a similar way.) These extremely fine, leaf-like layers are not in crystalline form (which mica is); they are thus capable of binding large quantities of water. This water is what makes the clay malleable. This is, in contrast to unyielding rock, a new development, a life process of the earth not following the usual chemical laws. Inherent in it is something of the natural laws of the primeval mineral-plant world that preceded the formation of primary rock in earth's evolution.

Recall that this formative process does not end with the settlement of the clay, that clay through maturing in the open air—through a rhythmic process of getting wet, drying out, freezing, and thawing, of summer and winter and day and night—is becoming ever more malleable. We can also see this as a preparation for new life processes: it is as if the clay would speak: Come, shape me, work with me!
(Martin, *Educating through Arts and Crafts*, 1999, p. 95-97)

With its unique properties and applications, clay has played a significant, practical role in the life of mankind. According to the *Encyclopedia Britannica*,

The use of clay in pottery making antedates recorded human history, and pottery remains are a major human record . . . As building materials, bricks have been used in construction since earliest times . . . The finer grades of ceramic materials have made use of white clay or kaolin . . . To this are usually added ground quartz, ground feldspar, and ball clay to increase plasticity.

Many other human uses are impressively listed including refractory materials for chemical ware and melting pots for glass, wool scouring, refining of mineral oils, paper fillers for gloss and opacity, rubber compounding for durability, portland cement for setting, earth dams, water softeners, cosmetics, crayons, pencils, insulating materials, medicine, paints, soap and detergents, toothpaste and at one time phonograph records. . . .

. . . not to mention its healing properties and mud packs on the skin!

Customs, Myths, and Legends

The finest porcelain or "China" once came from ancient China. It was customary for the grandfather in a family of potters to prepare the revered clay for long aging and eventual use by a grandson. It is not surprising that this amazing mineral substance also played a role in mythology, religion, and philosophy. As indicated by the short quotations at the beginning of this section, many civilizations such as those in ancient Egypt and Israel thought of clay as a basic element in the creation of the human being. In Greek culture, it was the Titan Prometheus who formed humanity out of moist clay and also gave it the element of fire and a freedom-loving spirit. Ancient peoples sensed a mysterious analogy

between the formation of man and the making of clay vessels. All the four Greek elements came together wondrously and alchemically in the pottery process. The clay *earth* was made malleable by *water* and was shaped into a form. It was then dried in the *air* and *fired.* Tall Greek amphorae remind us of the human form.

Water: Do Not Forget It!

Clay without water is dust. Clay's true nature is the result of a marriage of the earth and liquid elements. Water in the right proportions is what enables clay to realize its structural potential for malleability and flexibility. The life-bearing qualities of water join with those of clay. Clay's organic plasticity lends itself to the embodiment of living thoughts.

Theodore Schwenk researched the wondrous properties of water and its movements. Here are some insights from his book *Sensitive Chaos* (1965) as they relate to the process of sculptural formation (italic emphasis mine):

Water is Nature's *sense organ.*
(p. 65)

Water endeavors to round itself off into an *image of the whole cosmos.*
(p. 13)

Falling *as a drop, water oscillates about a sphere*; or as dew on a clear and starry night it transforms an inconspicuous field into a starry heaven of sparking drops. Wherever water occurs it *tends to take on a spherical form.* It envelops the whole sphere of the earth, enclosing every object in a thin film. We see moving water always seeking a lower level, following the pull of gravity. In the first instance it is earthly laws that

cause it to flow, draw it away from its spherical form, and make it follow a more or less linear and determined course. Yet water continually strives to return to its spherical form. It finds many ways of maintaining a rhythmical balance between the spherical form natural to it and the pull of earthly gravity, resulting in a play of movement with its rich variety of forms . . .

A sphere is a totality, a whole, and *water will always attempt to form an organic whole* by joining what is divided and uniting it in circulation.
(p. 13)

Every living creature, in the act of bringing forth its visible form out of its archetypal idea, passes through a liquid phase.
(p. 20)

The child before birth is in a protective envelope of water.
(p. 24)

The *spiraling forms of muscles and bones bear witness to the living world of water* and also to the powerful aim towards mastery of the solid and are reminiscent of the way water flows in meanders and twisting surfaces in the interplay between resting in spheres and being drawn in an earthly direction.
(p. 24)

When a wave appears and remains stationary behind a stone in a stream, a form is all the time being created simply out of the movement, with new substance constantly flowing through it. This is an archetypal principle of all living creation—an *organic form*, in spite of continuous chemical change, remains intact.
(p. 33)

At every single point, where (water) wave trains from different directions meet, *spatial forms arise* such, for instance, as pyramid-shaped structures or interweaving organic-looking surfaces and the like. It is *possible for water to create forms out of the interplay of various forces or directions of movement.* This is a principle that plays a great part, for instance, in all embryonic processes. In all things great and small the whole of nature is interwoven with interpenetrating rhythms and movements, and forms are created in the interplay between them. Form patterns such as those appearing in waves, with new water constantly flowing through them, picture on the one hand the creation of form and on the other the constant change of substance in the organic world.

(p. 33)

*Thus we see that right from the first, the fluid element contains moving, formative processes akin to those that living beings use to form their bodies. The creation of form in living substance is only thinkable if at one and the same place in space manifold movements can flow into, over, and through one another. *The fluid element is thus a most suitable medium for the form-creating process,* which would be impossible in the three-dimensional world of solids, where there is only exclusiveness and no interpenetration. Nature here reveals one of her secrets, showing how movements are indeed by their very nature "super-spatial"; they do not exclude one another at one and the same point in space, but interpenetrate and move over and under one another. They appear in the spatial world as though from higher realms and in so doing create law and order. *The fluid element is therefore the ideal bearer of movements, by which it allows itself to be moulded and plasticised.*

(p. 34)

But Nature does reveal her secrets at particular moments; some of her archetypal movements she reveals separately by densifying them to clothe a living creature. And if Nature creates creatures in which she reveals *one* of her creative movements, she also creates *one* living creature in whom all archetypal movements stream together: the human being. "The human being as we see him is a completed form. But this form has been created out of movement. It has arisen from those primeval forms that were continually taking shape and passing away again. *Movement does not proceed from quiescence; on the contrary, that which is in a state of rest originates in movement."* (From a lecture given by Rudolf Steiner on 24th June, 1924.)

(p. 64)

The bodily instrument of thinking, the brain, in its spherical form . . . rests in the waters of the world . . . Its undulations are the movements of the life element of "water" which have become *organ*; they have been laid down in flowing lines. We have here, in a play of repetition, the basic theme of the meander. Is it surprising if this formative life, once it has been freed from actually forming the organ, should reappear in the flow of thought? Does not this life force, forever multiplying, reappear in the ability of thinking to be able always to repeat what has once been thought? Constant repetition is characteristic of water and formative life forces, so also of thinking. Inherent in memory is the capacity of being able to rethink any number of times what has been thought before.

In the world of living creatures this principle of repetition appears in great variety, e.g., in the formation of segments, vertebrae, metameric organs, for instance in the primitive kidney, and in many other examples. Reproduction, repetition in propagation, appears in the organic world as well as in the flowing of water and in the spiritual life of the human being. When learning something by heart, the more often we repeat it rhythmically, again and again, the better it impresses itself upon us and becomes a permanent memory and ability. But also it is all the easier to understand something the more it is examined, felt, and grasped from all sides. This spiritual activity too has its expression in the liquid element, which envelops objects from all sides, grasps and feels and goes thoroughly into every detail of a form.

The activity of thinking is essentially an expression of flowing movement. Only when thinking dwells on a particular content, a particular form, does it order itself accordingly and create an idea. Every idea—like every organic form—arises in a process of flow, until the *movement congeals into a form.* Therefore we speak of a capacity to think fluently when someone is skillfully able to carry out this creation of form in thought, harmoniously coordinating the stream of thoughts, and progressing from one idea to another without digression—without creating "whirlpools." We say of someone who is less successful in this that his thinking is languid and sluggish. An exercise suggested by Rudolf Steiner to help thinking to become fluent and mobile is to recreate and transform in thought, for instance, *cloud formations.* With this ability to enter thoughtfully into everything and to picture all things in the form of ideas, the process of thinking partakes in the laws of the formative processes of the universe. These are the same laws that work in the fluid element, which renounces a form of its own and is prepared to enter into all things, to unite all things, to absorb all things.

Thinking that cannot enter deeply enough into every detail becomes a flight of ideas, torn along as though by an invisible torrent in which it can create no permanent forms. On the other hand, thinking that becomes solidified in fixed ideas remains a captive of form, without being able to develop towards further possibilities. *Like water, thought can create forms, can unite and relate the forms to one another as ideas; it can unite, but also separate and analyze. The capacity of water in the realm of substance to dissolve and bind together reappears in thinking as a spiritual activity.*

Water and this spiritual activity of the human being belong together; the nature of the one is a picture of the other. Both can unite with the earth, while at the same time receiving the ideas of the universe, uniting and coordinating them. In thinking there prevails the formative life of the water forces; through water flows the wisdom of the universe. Is it not this wisdom itself which has created the element of water, a tool for its own activity?

(p. 95-96)

Panta rhei—everything flows.
Heraklitus

Rudolf Steiner's Advice

Waldorf curriculum researcher Karl Stockmeyer very briefly summarized Steiner's statements on the subject of modeling (italic emphasis added by the author to highlight aspects):

Only very few hints and indications exist for modeling. The children should begin modeling in the ninth or tenth years. They should be guided to *make plastic forms out of the hollows of their hands, and forms for form's sake can be made out of the previous results. A similarity to outer objects should be discovered only when the form is completed.* We have been told that a real knowledge of the forms of human organs awakens a desire for modeling in the child, which however, will *not result in his copying outer forms*
(Stockmeyer, *Rudolf Steiner's Curriculum for Waldorf Schools*, 1965, p. 210)

Stockmeyer, however, does not systematically collect all the available quotes and sources on modeling into one place and in context as he does with other subjects. Some are scattered in his chapter on "Painting, Modeling, Drawing," but other valuable insights remain hidden in various lecture cycles such as Steiner's fundamental *Three Curriculum Lectures*. The following is an attempt to summarize and bring together some of the main indications that are related to modeling and the arts. *Readers are strongly encouraged to consult the full texts and lectures and study the quotations in their fullest context.*

Summary of Suggestions

- Let children do things with their two hands to learn about the world.
- Model plastic forms out of the hollows of the hands.
- Model forms for form's sake. Work entirely out of the forms. Discover a similarity to outer objects when the form is completed.
- Develop form modeling: Start modeling fundamental forms like spheres with younger children.
- Modeling's tremendous educational value is well worth the mess and trouble.
- Use whatever modeling material you can find—even mud off the streets— it doesn't matter.
- Through modeling develop the ability to see, feel and sense forms (Formanschauen, Formgefuhl, Formensinn).
- Follow plastic forms with the hands and with the will emerging in the eyes.
- Awaken in children the feeling for form (Formgeuhl) before the urge to imitate outer objects awakens.
- Grow together and become one with the forms.
- Allow the children to follow their own sense of discovery and to freely struggle with the material.
- Render forms freely rather than copy them.
- Let modeling vitalize sight, observation and imagination.
- Educate nimble fingers to promote flexible and penetrating thinking and healthy judgement.

- Derive the alphabet out of modeled forms.
- Study the human form and organs through modeling.
- Let modeling enhance the understanding of organic processes, such as plant growth.
- Teachers should model forms to understand growth and development.
- Let modeling develop the will.

Plastisches Gestalten

Already in the first two-week "crash course" in 1919 for the original twelve teachers of the first Waldorf school, Steiner indicated the importance of modeling, *plastisches Gestalten"* (literally, *"plastic forming"* and *das Bildnerische* (*the sculptural element*) in education. At that time he recommended that modeling start with basic archetypal forms:

Sculptural modeling (*Plastisches*) should begin *before the ninth year, first spheres* (*Kugeln*), then other forms, and so on. Also with modeling one should *work entirely out of the forms. (ganz aus den Formen herausarbeiten).*
(*Discussions with Teachers*, Lecture XV, p. 178)

Later, in many other lectures, he spoke about how arts such as modeling were to become powerful educational tools to help children make the transition from play through artistic activity to work. They were to help connect children experientially and practically with the world and prepare them for life and adult work:

. . . Whatever subject is being taught, the child's inherent impulse to play,

which is an intrinsic part of its makeup, can be guided into artistic activities. And when children enter the *first and second grade,* they are perfectly able to make this transition. However clumsy children of six or seven may be when *modeling,* painting, or finding their way into music and poetry, if teachers know how to permeate their lessons with artistry, *even small children, as miniature sculptors* or painters, *can begin to have the experience that human nature does not end at the fingertips,* that is, at the periphery of the skin, *but flows out into the world.* The adult being is growing in children whenever they put their being into *handling clay (Ton),* wood, or paints. In these very interactions with materials, children grow, learning to perceive how closely the human being is interwoven with the fabric of the world.

These (artistic channels) permit a freedom of inner activity while at the same time forcing the children to *struggle with outer materials,* as we have to do in adult work.
("Education and Art," in *Waldorf Education and Anthroposophy*, vol. 2, p. 58-59)

On another occasion in connection with the introduction of writing he recommended early modeling and that

We bring the child as much as possible into the artistic element and *the modeling of small plastic works, without wanting anything other than what the child naturally wants to make out of the form from an inner creativity.*
(*Human Values in Education*, Lecture III)

In spite of its critical importance, Steiner acknowledged and anticipated the practical challenges classroom teachers

might encounter in working in this essential, albeit wonderfully messy, medium:

However inconvenient it may be for the teacher, he or she should always encourage the young pupils to form shapes of all kinds out of any material he can lay hands on. True, one should avoid letting the children get unduly dirty and messy, for this can be a real nuisance. But what children gain in these creative activities is worth far more than that they should remain clean and tidy. And if artistic activities are introduced in the way indicated, other subjects will become easier. Foreign languages, for example, will be learned with far greater ease if pupils have done artistic work beforehand.
(*Soul Economy and Waldorf Education*, Lecture XII, p. 211)

Pure Form Modeling : Form Feeling Before Copying

Just as as there was to be in the first four grades an education in the fundamentals of the dynamics of pure colors (out of which forms may *secondarily* arise) and the drawing exercises of pure linear geometric forms (formdrawing), so, too, Steiner wanted young children to practice the universal language of three-dimensional forms in modeling material:

We continue this(fundamental artistic work in grades one to four) by moving on to three-dimensional, plastic forms, *using plasticine if it is available and whatever else you can get if it isn't—even if it's mud from the street, it doesn't matter.* The point is to *develop the ability to see (Forman-schauen) and sense forms (Formgefuhl = Form-Feeling)*
(*Second Curriculum Lecture in Discussions with Teachers, p.198*)

Such "form modeling" was to be an excellent way to foster higher intelligence in younger children through an age-appropriate means that was not unduly or overly intellectual. It could have the same energizing effect on a child's life forces and health that he later specifically attributed to formdrawing:

During sleep . . . our body of formative life forces continues supersensibly (in the unconscious) to calculate, continues (to perfect) all that its has received as arithmetic, (geometry) and the like . . . If we are aware of this fact and plan our teaching accordingly, *great vitality* can be generated in the child.
(*A Modern Art of Education, Lecture IX*, p. 154)

In the first training course Steiner described how the teacher can guide the child to *feel* modeled forms, using the hollow of the hand as a unique organ of will, and to intuitively experience form with his or her whole being:

By means of music or by means of drawing or modeling (*Zeichnerisch-Plastischen*), we lift the realm of feeling into the intellectual sphere. This must happen in the right way. Today everything is mixed and blurred, especially when the artistic is cultivated. We draw with our hands and we model (*plastizieren*) with our hands, yet the two activities are totally different. When we guide children into the reality of what can be modeled, we must as far as is possible see to it that they *follow the plastic forms with their hands*. By feeling the way he makes his own forms, by moving his hands and making a drawing, *the*

child can be brought to following the forms with his eyes but also with his will emerging through his eyes. It is no violation of the child's naivete if we teach him to follow the forms of the body with the hollow of his hand.

(*Practical Advice to Teachers*, Lecture 1, p. 21)

Elementary school children (ages seven to fourteen) in particular have the optimal formative potential and abilities to develop this unique *Formanschauen*, Form-Seeing) and *Formgefuhl*, Form-Feeling or Sensing. After this primary time and window of opportunity, if such capacities have not been learned, possibilities fade as the human organism becomes older, harder, and more fixed. In the artistic process in the early grades, Steiner recommended that teachers

Awaken in the children the feeling for form (Formgefuhl) *before the urge to imitate outer objects awakens. Wait until later before allowing them to* apply what they have practiced in drawing forms to imitating actual objects. First have them draw angles so that they understand what an angle is through its shape . . . do not let children imitate anything until they have *cultivated their feeling for independent forms* (Formen in ihrer Selbstandigkeit) which can be imitated later. Stick to this principle even when you move on to a more independent and creative treatment of drawing, painting *and modeling (Bildnerischen).*

("Second Curriculum Lecture, in *Discussions with Teachers*, p. 198)

(*English readers Note: The word "modeling" is left out of the official 1997 translation.* We are grateful to the publisher, however, for the "Three Curriculum" Lectures in *Discussions with Teachers*. They contain vital indications about Steiner's true intentions in

modeling for young children and were unfortunately not widely and readily available until recently).

As students grew older, Steiner wanted them then to learn to freely render and re-create forms out of a dynamic inner process and not copy and reproduce figures with pedantic intellectual exactitude:

It is totally irrelevant to judge whether something is copied properly and so on. A resemblance to something external should only appear as something secondary. *What should live in the human being is his inner closeness to the forms themselves* (innere Verwachsensein mit den Formen selbst, *literally, "to grow together and become one with the forms").*

(*Practical Advice to Teachers*, Lecture 1, p. 19)

This principle was specifically demonstrated in Steiner's response to a teacher's question about a modeling assignment in an older grade:

You could use a column (pillar) seen from a particular perspective as an example, but *you should not make the children slavishly imitate it.* You need to get the children to observe, but *allow them to change their work.*

(*Faculty Meetings with Rudolf Steiner*, p. 62-63)

Steiner deemed certain forms to be very meaningful for human experience. For example, he said that

To feel a sphere (ball) in space is to feel one's selfhood, *to feel the ego* . . . When the human being sees a little piece of a sphere's curvature (*Kugelschale*) and feels that it points to a sense of oneself as an independent being, he *thereby learns to live in forms.*

(*Ways to a New Style in Architecture*, 1927)

Education Toward Freedom

Waldorf pedagogy seeks, above all, to educate human beings in responsibly directing their own lives. Essential to the development of this self-direction is the creative freedom to discover new ideas and not get stuck in copying fixed forms and intellectual concepts inherited from the past. Modeling affords children and adults a way to develop flexible, imaginative thinking and to freely discover an infinite changing diversity of ideas in concrete form. Concepts are allowed to grow and expand through this medium.

To lead play gradually over to the creation of artistic forms and then to the practical work . . . is to act in complete harmony with the demands of man's nature. And it is absorbingly interesting to find that the *children's plastic, artistic activity turns quite naturally (wie von selbst = as by itself,* ie., through the children's own creative initiative with the right kind of teacher support and guidance) *to the making of playthings and toys* . . . Our children are *allowed the greatest freedom* even in their practical work and are *allowed to follow their own sense of discovery.* Their souls create the most wonderful forms when they have learned to observe certain things in the human being or the animal with a truly artistic feeling for nature . . . At the Waldorf School, the children *do not merely "have an idea" in their heads; they feel the idea, for it flows into their whole life of feeling. Their being of soul lives in the sense of the idea, which is not merely a concept. The idea is a plastic form.* The whole complex of ideas at last becomes a human form and figure and in the last resort all this *passes over into the will.* The child learns to transform what he or she thinks into

actual deed. (*Das Kind lernt eigentlich alles dasjenige auch machen, was es denken lernt.*)

(*A Modern Art of Education*, Lecture XII p. 197-198)

Powers of Imagination And Observation

In 1906, thirteen years before Steiner founded the first Waldorf School for the children of the Waldorf Astoria Factory, he recommended bringing children activities and toys that would strengthen their own creative powers of imagination and will:

If before their seventh year, children see only foolish actions in their surroundings, the brain will assume the forms that adapt it to foolishness in later life . . . As the muscles of the hands grow firm and strong through doing the work for which they are suited, so the brain and other organs of the physical body of human beings are guided into correct course of development if they receive the proper impressions from their environment . . . If the children have (a simple doll made from a) folded napkin before them, *they have to fill in from their own imagination* what is necessary to make it real and human. *This work of the imagination shapes and builds the forms of the brain. The brain unfolds as the muscles of the hands unfold* when they do the work for which they are suited. By giving the child the so-called "pretty," elaborate, realistic doll the brain has nothing more to do. Instead of unfolding it becomes stunted and dried up.

(*The Education of the Child,* p. 19-20)

Soft dolls formed simply out of tied napkins are examples of what might be called cloth sculpture or modeling. What Steiner says about them can be applied to

materials such as wax and clay that, having even more flexibility to change, call upon and strengthen a child's forces of imagination.

Steiner wanted people to appreciate how modeling engages the whole child. He pointed to the mutual benefits of the hand working in artistic harmony with the eye, enlivening sight and powers of observation and allowing the world to flow into the heart and soul:

> Modeling, too, is cultivated as much as possible, albeit only from the ninth or tenth year, and in a primitive way. It has a wonderfully *vitalizing effect on the child's physical sight* and on the inner quality of soul in his sight, if, at the right age, he begins to model plastic forms and figures. So many people go through life without even noticing what is most significant in the objects and events of their environment. As a matter of fact, we have to learn how to do it before we can see and observe in the way that gives us our true position in the world. And *if the child is to learn to observe aright, it is a very good thing for him to begin, as early as possible, to occupy himself with modeling, to guide what he has seen from his head and eyes into the movements of fingers and hand.* In this way we shall not only awaken the child's taste for the artistic around him—in the arrangement of a room, perhaps—and distaste for the inartistic, but *he will begin to observe those things in the world which ought to flow into the heart and soul of man.*
>
> (*A Modern Art of Education*, Lecture XI, p. 192)

Enhancement of sight and observation through modeling and other sculptural endeavors such as wood carving can play an increasingly important role as children around ages eleven to twelve become more conscious of cause-and-effect connections in the world. Such artistic activity and the development of an aesthetic sense and understanding helps to balance a growing intellectuality.

Hands and Thinking

Steiner conceived of Waldorf Education as a pedagogy in which:

> *Manual dexterity . . . stands at the beginning of our teaching.*
> (*Human Values in Education*, Lecture VIII, p. 148)

He recommended that in the first lesson of the entire twelve grade curriculum, a first-grade class teacher calls attention to the fact that each child has *two hands* and is going to *do* something with them and learn new things.

(*Practical Advice to Teachers*, Lecture IV, pp.59-60)

Waldorf Education was thus created to elevate the vital role and intuitive capacities of the human hands and will to an equal and balanced status with those of the heart and head, with emotional intelligence and intellectual cognition. It is a form of education that strives to engage the whole child, the child who not only thinks, but also feels and has the will to act upon his or her thoughts and emotions. Working with the hands, or "handwork," as it is called, is thus an integral part of the curriculum, not only to bring about good manual skills and a confident heart connection with the world, but also a clear and healthy thinking capacity.

Long before the discoveries of brain research at the end of the twentieth century, Steiner at its beginning was pointing out the intimate connection between nimble fingers and nimble thinking. In his words:

A person who uses his fingers clumsily also suffers from a "clumsy" intellect. Someone who knows how to move his fingers properly (*derjenige, der seine Finger ordentlich bewegen weiss*) also has flexible ideas and thoughts and is better able to *penetrate the essence of things with his thinking.*

(*The Renewal of Education*, Lecture V, p. 67)

For Steiner,

The movements of the fingers are to a great extent the teachers of the elasticity of our thinking.

(*Man: Hieroglyph of the Universe*, p. 128)

The hands are also important in the development of speech and even judgment:

A child (who becomes) sensitive in its fingertips . . . will develop . . . the right sense for *modulation in speech.*

(*The Child's Changing Consciousness*, Lecture II, p. 33)

The speech center is on the left side of the brain in right-handed human beings because the *gestures of the right hand powerfully executed by the will mysteriously continue into the brain and bring about functions which bring a human being to speak.*

(*Human Being, Destiny and World Evolution*)

The *faculty of judgment* is indeed essentially enhanced by the activity of the hands.

(*Education for Adolescence*, Lecture II, p. 53)

Our activity and interaction with the world, in part with our sensitive hands, work back upon us, stimulate our imagination, thinking, and speech, and result in what Steiner referred to as a "sculptural formation of our brain."(*plastische Ausbildung unseres Gehirns*)

(*Soul Economy and Waldorf Education*)

Enlivening Curriculum Subjects

In the Waldorf Curriculum modeling is utilized as an invaluable means to explore the universal language of form and all sorts of themes and subjects. For example, Steiner recommended that it be utilized in learning the alphabet (an approach championed recently by Ronald Davis in *The Gift of Dyslexia*, 1997).

This is an inner urge, an inner longing of the life body, to be at work in modeling or painting. So you can very easily turn this impulse and longing to account by *deriving the letters of the alphabet out of the forms that the child paints or models*, for then you will be really molding your teaching out of a knowledge of the human being.

(*The Kingdom of Childhood*, Lecture VI, p. 94)

He also saw in this activity a remarkable tool for children to experience the geometry of human form, first imaginatively in grade four and then more scientifically in anatomy lessons in higher grades.

It would be good to make a round ball out of wax or kneaded dough and then cut off . . . part so that you got the shape of the human trunk as a fragment of a sphere.

(*Practical Advice to Teachers*, Lecture VII, p. 102)

Steiner described to teachers in Torquay, England, how invaluable it was for both pupil and teacher to model organs of the body, such as the lungs, and gain a real knowledge of anatomy and physiology through the living process of art. His researches revealed that the formative life forces of the human being act in an organized field that he called a life body, or body of formative forces. This life body, he found:

Is preeminently an inward artist in the child in the first seven years; it is a modeler, a sculptor. And this modeling force, applied to the physical body by the life body, becomes free, emancipates itself with the change of teeth at the seventh year. It can then work as an activity of soul.

This is why the child has *an impulse to model forms* or to paint them. For the first seven years of life the life body has been carrying out modeling and painting within the physical body. Now that it has nothing further to do regarding the physical body, or at least not as much as before, it wants to carry its activity outside. If therefore you as teachers have a wide knowledge of the forms that occur in the human organism, and consequently know what kind of forms children like to mold out of plastic material or to paint in color, then you will be able to give them the right guidance. But you yourselves must have a kind of artistic conception of the human organism. It is therefore of real importance for the teacher to try and do some modeling as well, for the teachers' training today includes nothing of this sort. You will see that however much you have learned about the lung or the liver, or let us say the complicated ramifications of the vascular system, you will not know as much as if you were to copy the whole thing in wax or plasticine. For then you suddenly begin to have quite a different kind of knowledge of the organs, of the lung, for instance. For, as you know, you must form one half of the lung differently from the other half; the lung is not symmetrical. One half is clearly divided into two segments, the other into three. Before you learn this, you are constantly forgetting which is left and which is right. But when you work out these curious asymmetrical forms in wax or plasticine, then you get the feeling that you could not change round left and right any more than you could put the heart on the right-hand side of the body. You also get the feeling that the lung has its right place in the organism with its own particular form, and if you mold it rightly, you will feel that it is inevitable for the human lung to come gradually into an upright position in standing and walking. If you model the lung forms of animals, you will see or feel from the touch that the lung of an animal lies horizontally. And so it is with other organs.

You yourselves therefore should really try to learn anatomy by modeling the organs, so that you can then get the children to model or to paint something that is in no way an imitation of the human body but only expresses certain forms. For you will find that *the child has an impulse to make forms that are related to the inner human organism.* You may have some quite extraordinary experiences in this respect in the course of your lessons.

We have introduced lessons on simple physiology in the school, and especially in the fourth, fifth, sixth, and seventh grades, as this is obviously an integral part of the Waldorf School method. Our children paint from the very beginning, and from a certain age they also do carving. Now if you simply let the children work freely, it is very interesting to see that when you have explained about the human being to them, the lung for instance, then out of themselves they begin to model such

forms as the lung or something similar. *It is really interesting to see how the child forms things out of its own being.* That is why *it is essential for you to take up this plastic method, and to find ways and means of making faithful reproductions of the forms of human organs exactly in wax or plasticine—even, if you like, as our children often do, in mud, for if you have nothing else, that is a very good material to work with.*

(*The Kingdom of Childhood*, Lecture VI, p. 92-94)

Steiner recommended using modeling in fourth and fifth grades to study the bones:

At a comparatively early age, that is to say, for children between ten and eleven years old, we take as a subject in our curriculum the "Study of Man." At this age the children learn to know how the bones are formed and built up, how they support each other, and so on. They learn this in an artistic way, not intellectually. After a few such lessons the child has acquired some perception of the structure of the human bones, the dynamic of the bones and their interdependence. Then we go over to the craftroom, where the children *model plastic forms,* and we observe what they are making. We see that they have learned something from these lessons about the bones. *Not that the child imitates the forms of the bones, but from the way in which he now models his forms we perceive the outer expression of an inner mobility of soul.* Before this he has already got so far as to be able to make little receptacles of various kinds; children discover how to make *bowls* and similar things *quite by themselves,* but *what they make out of the spontaneity of*

childhood before they have received such lessons is quite different from what they model afterwards, provided they have really experienced what was intended. In order to achieve this result, however, these lessons on the "Knowledge of Man" must be given in such a way that their content *enters right into the whole human being.*

(*Human Values in Education*, Lecture III, p. 66)

We must try to model these varying forms of (the muscle and the bone of the upper thigh) and we will find that in the one particular form, cosmic forces act to produce length; in another the form is rounded off more quickly. Examples of the latter are the round bones, and the former are the more tubular bones. Like sculptors, therefore, we must develop a feeling for the world. . . .

(*The Roots of Education*, Lecture III, p. 40)

Although Steiner stressed the significant limitations involved in the modeling and sculpting of actual plant forms, he pointed out the special value and relationship that this artistic process in itself had with plant growth and metamorphosis:

Any plastic skill that we develop in the child helps him to *understand the formations contained in the plants.*

(*Modern Art of Education*, Lecture XI, p. 193)

Above all, modeling whole pieces from stage to stage helps us to understand living processes of growth. In a lecture on "Actions, Feelings, and Thoughts," Steiner pointed out that

Everything that is merely combined out of separate physical components

does not have a body of formative life forces, but everything that organically grows has life to it.

Teacher Training

Indeed, Steiner saw modeling and a basic knowledge of morphology as indispensable means for learning how to behold and truly grasp child development itself and the working of life and growth forces in the human being and nature in general. He emphasized the role it could play in teacher training and the professional practice of teachers:

We understand the body of formative forces when we enter the shaping process, *when we know how a curve or an angle grows from inner forces.* We cannot understand the life body in terms of ordinary laws, but *through the experience of the hand—the spirit permeated hand.* Thus there should be no teacher training without activities in the areas of modeling or sculpture, an *activity which arises from the inner human being.*
(*The Essentials of Education*, Lecture III, p. 45)

Modeling should take a foremost place in the curriculum of a (teachers') training college, for it provides the means whereby the teacher may learn to understand the body of formative forces. The following may be taken as a fundamental principle: a teacher who has never studied modeling really understands nothing about the development of the child.
(*Human Values in Education*, Lecture VIII, p. 148)

(As teachers), we should learn to sculpt and work with clay, as a sculptor works, *modeling forms from within outwards, creating forms out of their own*

inner principles, and guided by the unfolding of our own human nature. The form of a muscle or bone can never be comprehended by the methods of contemporary anatomy and physiology. Only a genuine *sense of form (Formensinn)* reveals the true forms of the body
(*The Roots of Education*, Lecture III, p. 38)

He also pointed out that children's modeling helps teachers know their students better because

When you ask children to model something or other, their work will always display distinctly *individual features.*
(*The Child's Changing Consciousness*, Lecture V, p.120)

Strengthening the Will And Balance

Steiner strenuously emphasized that modeling and other arts have a crucial role in education because they not only educate the senses through direct experience but also

Work particularly strongly on the will nature of the human being.
(*Practical Advice to Teachers*, Lecture I, p. 12)

Because of the artistic handling of the lessons, the children have been *inwardly gripped by what they were doing. It entered their will*, not only their thoughts and heads. And we can therefore see, as they concentrate on their work, that this continues to live in their hands. The forms change according to the content in our lessons. It lives itself out in forms. We can see in the forms the children produce what they experienced in the previous main lesson, because their lesson ought to enter and *grasp the whole of the human being.*
(*Spiritual Ground of Education*, Lecture VIII, p. 98)

It is through the will that we connect with the world in creative activity and effectively transform it. The artistic element helps children develop the capacity to act in life and to "learn how to learn!" In addition, Steiner perceived the arts as an ideal means for a healthy education of the senses and for meeting the individual needs of differing temperaments.

Steiner recognized that nature and spirit had charted out an order in human development that needed to be respected. His entire method is based on a natural progression from an initially more unconscious mode of will activity through a sensitive feeling cognition to the awakening intellect; in other words, from doing and experiencing to reflecting. The gradual waking up of thinking expresses itself first in the hands and the early urge to move. What the hand grasps and touches is emotionally absorbed by the heart, and the head wakes up by itself without being artificially prodded from outside:

> The more we take into account . . . *that the intellect develops from the movements of the limbs*, from dexterity and skills, the better it will be!
>
> *(The Renewal of Education*, 1989)

Such an approach is crucial to the child up to age twelve when thinking then reaches a new level and becomes more intellectual (the transition of Piaget's stages from "concrete operations" to "formal operations"). The extreme opposite of this organic, artistic methodology is to cater first to the head and nervous system of the child prematurely and present it with all kinds of intellectual facts and information to memorize. Doing then is limited to work sheets and test taking. This disregards the human being's need for a balance in education.

Waldorf Education, above all, strives to bring about a balance of the human capacities of thinking, feeling, and willing and harmonize them with the help of the arts:

> Having brought the children into close contact with the *plastic*, poetic, and musical arts, and having brought eurythmic movements into their bodies, having awakened to life through eurythmy what would otherwise be the abstract element of language, we create in the human being an inner harmony between the spirit-winged musical and poetic elements, and the spirit-permeated material elements of *modeling* and painting.
>
> ("Education and Art" in *Waldorf Education and Anthroposophy*, p. 61)

Speaking out of Practical Experience

Steiner held that the arts were an essential part of human activity and could be taken up by anybody with a willingness. He especially wanted teachers to become practicing artists and creative models to children.

In addition to being a philosopher and educator, Steiner made contributions to numerous other fields and was himself a practicing artist, architect, and sculptor. He executed numerous pieces in soft modeling material as prototypes for larger works of sculpture and architecture. His great masterpiece, The Representative of Humanity, was carved in wood by him with the assistance of the English sculptor, Edith Maryon. For it he developed several interesting models in plasticine. Steiner lectured at length about the sculpting of organic forms and their placement in a renewed style of architecture. On one occasion, he spoke of how adults truly become involved and immersed in the sculptural process:

One's head suddenly becomes empty. Thoughts leave you and something begins to stir in other parts of your being. Namely, one's arms and fingers begin to become tools of thoughts, but the thoughts now live in forms. And one has become a modeler, sculptor.

(The Arts and their Mission, 1964)

Children have the ability to become fully absorbed in modeling. Their natural enthusiasm can teach us much.

Modeling as the Expression of the Child's Inner Being

by

Dr. Elisabeth Klein

After the change of teeth, formative forces loosen themselves from the body of the child, in which they have worked until now, and press on to new activities. Knowledge of the transformation of these forces, as observed and described by Dr. Rudolf Steiner, is fundamental for pedagogical work. These liberated forces not only enable the child to learn writing, painting, and drawing, but they also help him to build concepts and to keep impressions in his memory.

As these sculpturing forces long for an outlet in work, it is good to let the children, in their first school years, do some modeling from time to time. The desire to knead something into shape streams out of their very finger-tips. For this reason modeling presents a particularly good opportunity to study how these formative forces work in the child.

When we started modeling in the first grade, our subject was the figure of a little child. To begin with, each child took a ball of beeswax, of a color chosen by himself, and held it in his hand. Just then I was called away from the class and was forced to leave the children alone.

I was greatly surprised when I returned. One boy had formed a figure in red wax with two giant arms spread out in the air and two long legs and nothing else! I asked him, "Have you finished? Isn't there something lacking in your man? Just look at yourself and see!" But the boy did not notice that his figure had no head.

He was a strange child. I will describe him briefly. From the first day he was a disturbing element in the class. Fundamentally he had a good heart, but before he himself was aware of it, he would kick someone. His actions lacked consciousness, as if his will acted of itself without being directed by thought or reason. He was really headless, like his figure, which actually presented a picture of the forces that especially dominated him. In temperament he was choleric. His ungovernable will caused much disturbance in his environment. And yet, in the gestures of the figure he made was contained such splendid activity. At my suggestion this boy was allowed to beat the rugs at home.

In the work of another boy the opposite pole was shown. The head of his figure was over large, and the arms and legs were mere stumps. This child lived in an inner world of his own; he was a dreamer. He moved like a snail, but his soul was filled with the most beautiful pictures. As he had narrow, flat feet, he often fell, but if you asked him what he would like to be he would beam and say, "An astronomer."

The following incident in this boy's school life was very characteristic. On one occasion, when his class was to act out the fairy tale of the shepherd boy, we were looking for someone who would be good in the

part of the king. After class, this boy said to me in a low voice, "You must make me the king for, first, I know how a king speaks, and, secondly, how he walks." And though he had formerly had certain difficulties in speaking, he played the part of the king successfully through the living quality of his imagination. When the golden crown was given to him, after the play, he experienced his greatest thrill.

Thus this child lived strongly in his imagination, in the forces of his head. He had, in fact, a huge head; so, in this case too, the figure he made was a true reflection of the distribution of forces in the child. The two examples are polarities.

One remembers the description Rudolf Steiner gave of the arrangement of the human organization. He described the head organization with the nerve-sense system as the seat of thinking; the breast organization with the rhythmic functions as the physical basis for feeling; and the limb and metabolic system as the bearer of the will. He showed graphically how the preponderance of one or the other pole might bring about one-sided types.

Thus the small creations of two children bore witness to a fundamental law and in them the two poles of the threefold human organization were convincingly manifested.

A third example lies between the two which we have already considered. It again was the work of a very vigorous boy, but the child had a phlegmatic streak in his choleric temperament. His outbursts were not quite so chaotic as those of the first boy, and though he also struck out around him, he was on the whole more considerate. One could say "To the extent that the small cone-shaped head rose above the huge form of his wax figure, to that extent was he more considerate."

A plump, easy-going little girl of phlegmatic temperament gave me her work with a beaming look. She had produced the amusing form of a little child with a small stomach like a ball, emphasized by a row of carefully placed buttons. The similarity between the little girl and the plastic figure is, in this case, so striking that no further comment is needed.

A fifth figure, bent-over and contracted into itself, was the work of a melancholic child. Here, too, a definite connection seemed to exist between the temperament of the child and his work.

The temperament is closely bound up with the distribution of forces within, and, as these latter function in the child, so they pour themselves into his work, making it a small reproduction of himself, which can reveal much and be of great help to the teacher. In these first lessons, with seven-year-old children, the connection between the inner nature and outer expression can be seen clearly.

Not only are the finished figures characteristically differentiated, but also the methods of working show characteristic differences. Once, when the fairy tale of the White Snake was told, the children were supposed to form the shell with the ring inside, which the three fishes bring to land. As the children were grouped according to their temperaments, one could observe their characteristic ways more easily than otherwise. One whole group, after having formed the shell, tried to give it a richly decorated edge, working diligently with the very tips of their fingers. This was the group of *sanguine children*, children who move their heads as quickly as birds, who discover everything at once, but who have no perseverance. Most of them had slender bodies, delicately shaped limbs, and wide-awake senses. Such children live, for

the most part, in their nerve and sense system. Their experiences touch only the surface, the periphery of their bodies. It was very evident in this lesson how consciously they lived in their sense of touch, how their vitality extended to their very fingertips.

Opposite to them sat some children who dug and bored into the wax with their thumbs, even with their fists. They worked hard, with red and earnest faces. They found satisfaction in modeling deeply hollowed—out forms with thick, clumsy margins. One child, in his zeal, had even bored right through the bottom of his wax. The work of hollowing out was the chief interest of this group. For the sanguine children, that was too difficult. As the wind ruffles the water, so they liked to mold only the surface.

The second group consisted of the cholerics. They live more within their bodies. They are connected less with their senses than with their blood. These are the children who, at the beginning of the lesson, enjoy warming up the cold, hard wax with their hands. They like to help with their warm fists when some other child cries: "My wax does not feel soft!"

From a pedagogical point of view one can accomplish a great deal in these lessons. For instance, a girl from the sanguine group said she had finished. The margin was beautifully decorated, but in the middle the wax was thick and unformed, the shell was flat. This child, then, had to accustom herself to dig down more vigorously into the wax. Or I showed a boy, who had made a deep, heavy shape, the beautiful margin of another child's form, saying, "You should decorate yours just as nicely." And so the clumsy boy had to try to make his fingers delicate and mobile.

Most of the children had formed an open shell boat. A melancholic girl gave me her work, of white wax, the shell of which was closed. Only through a narrow slit could one see the ring. She was told: "When the shell is closed, the ring cannot shine out over the water." The little girl understood this and opened her shell.

To the boy who had made a headless figure, it was a great shock when, at last, he saw that his figure had no head. To the other children it was merely amusing. They just cried: "He has forgotten the head!" But to the boy himself it was a shock—and wholesome.

Help given in this way penetrates more deeply into the being of a child than many words. And it is possible, in the modeling class, to make something clear through the shaping of the forms, through the action itself. This works back upon the child, perhaps even into his physical body. Not only do children in their modeling reveal the formative forces working in them, but also it is possible through modeling to work back upon these forces in a healing and transforming way, and to build up, in the course of the lessons, a picture of the living, harmonious human being.

—Translated by Christiane Sorge from "Erziehungskunst," published by the Stuttgart Waldorf School, December 1931.

Sculpture in the Waldorf Curriculum

by
Patrick Stolfo

The sculptural arts are an integral part of the Waldorf curriculum. They represent in a practical, artistic form all those activities that bring a formative, structuring, "Apollonian" element into education. Although the finished product is often pleasing to look at, the importance of the activity lies in its effect on the child. Through giving shape to a plastic, malleable medium, the child gains an enlivened, feeling-filled relationship with her own imagination, with the world around, and perhaps with the very life-forces behind phenomena. At each "age plateau"—early childhood, the middle years, and adolescence—a different approach and medium is called for.

Parents and teachers are most familiar with the lively, yet somewhat amorphous, clay models done by the fourth through seventh graders in conjunction with main lessons or in special classes. In the fourth grade, there is a main lesson block called "Human and Animal." In this block, the child takes the first steps toward a scientific observation of the world. The content, though, is still interwoven with a strong imaginative element. Through stories, pictures, and lively descriptive comparisons, the child is given an overview of the animal kingdom and how its forms can be seen as specializations of the human form. During this block, the children are usually introduced to clay modeling. Their intuition for inner dynamic is ready to interact with images born from the awakening capacity for outward observation. The shaping process proceeds from spherical mass, to movement, to expressive gesture.

Here the teacher can help resolve the outer-inner conflict that the child is experiencing. In the modeling sessions the students watch and imitate the teacher's working with the clay. They are encouraged to work so that the animal's characteristic gesture residing in their enlivened memory pictures, shapes and forms the clay. Outer form is shaped by movement originating from within.

The clay medium and the approach used are appropriate to the children at this age. Clay is a highly changeable substance, ideal for holding a form born of movement. Its nature is to absorb water, as demonstrated by its ability to dry out the hands. When we model clay, our "life forces" stream out into it, and some people become fatigued while working in this medium.

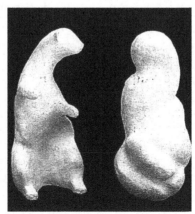

The shaping process proceeds from spherical mass, to movement, to expresive gesture.

The shaping activity demonstrated by the teacher and practiced by the children is also new. The laws of sculpture first come into effect with clay modeling in the fourth grade. The development of the child, as reflected in the whole Waldorf curriculum, proceeds from the general to the particular. So in clay modeling, as well,

the single lump of clay is modeled into an overall gesture, and then to its more detailed parts. For example, the child begins with a large piece of clay, forms it into a sphere, and then gives it a horizontal direction or orientation. Then the head of a cat, cow, horse, or other mammal is "coaxed" and "pulled out" of the clay. While the movement or gesture comes from within, the form takes its shape through the planes and the more detailed surfaces as they are created by the hands. The intuitive sense for form in movement is expressed by the child in a kind of recapitulation of classical Greek art.

In a Waldorf school, children in kindergarten through third grade work with beeswax. Holding this hard, colored substance in their hands, they first give it warmth and malleability. Then they playfully shape it into a figure or object suggested by the fairy tale or story told by the teacher—an angel, princess, sword, bird, or tree, for example. The question arises: What is the nature of this handwork with beeswax in the early years? One has to maintain, given our discussion here, that it is not in any way a "sculptural" process. The young child's art work is not an imitation of an observed outer world as is the clay modeling of the fourth grader. It is mainly a representation of an inner imaginative realm, which is both rich and real. With the magic of childhood, a cardboard box can be a house and, in the next moment, an elevator. The art work of the young child similarly takes on symbolic meaning. (Cf. Strauss, Michaela, *Understanding Children's Drawings*, Rudolf Steiner Press, London, 1988.) Each creation is a representation of an inner and complete imaginative realm. The relationship between the young child and her art corresponds to that between the so-called primitive or prehistoric human beings and their artifacts.

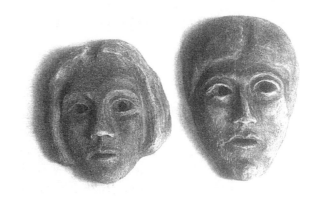

Seventh-grade face masks.

Also, the different developmental stages of the first grader and the fourth grader are reflected in the materials that they use. Beeswax is a "heavenly" substance. The bee is a creature born out of warmth, the beehive maintaining a temperature about that of human blood. Once warmed, beeswax has great plasticity and is easily stretched and molded. The young child in his purity and innocence has much in common with this translucent, yielding substance. There is no reason he should be coaxed into creating something naturalistic or "real-looking." The shapes should emerge out of a playful interplay between the fingers and the imagination; they should never be critically evaluated as works of art. Clay, in contrast to beeswax, is earthy, cool, and heavy. It is appropriate for the nine-year-old, who has just experienced, for the first time, a sense of separation from the world and thus is able to observe and replicate things in the environment.

Plasticine, though not "light-filled" like beeswax, also holds warmth and does not absorb moisture because it is oil-based. It is an acceptable, though not ideal, alternative to beeswax or clay.

Rudolf Steiner indicated yet another mystery of human development in describing how early modeling and other handwork exercises lead to a dexterity in finger

activity. This dexterity metamorphoses in later life to a capacity for mobile, lucid thinking. (Steiner, *R., Balance in Teaching,* Mercury Press, Spring Valley, NY, 1982.)

In the fifth grade, the children study ancient cultures. They learn how the early cultures began to cultivate the earth, to build massive structures, such as the pyramids, and to bring the beauty of movement to expression in Greek sculpture. Now the "subtractive" process in sculpture introduced. The children are ready to penetrate hard yet organic material—wood—which is less yielding than clay and must be approached "from he outside." The forms must be "revealed" through the carving and rasping away of material. Woods of various degrees of hardness are explored, from cedar to mahogany to oak. Knives, rasps, gouges, and draw-knives are introduced in gradual succession from fifth grade on. They challenge the student to work safely and with control and accuracy. The students carve animal forms (beginning with simple archetypal shapes of birds and mammals), bowls, spoons, stools, etc., always with the assignment to combine practicality and aesthetics.

Through the eighth grade, sculpture has been embedded in the broad, integrated, Waldorf elementary school curriculum. In the Waldorf high school, though, sculpture, like the various academic disciplines, becomes an independent subject. In their clay work, the students explore the "additive" process, building up whole forms from small pieces. Also, they undertake challenging projects in wood and stone carving. With a studied, objective attitude, they observe and render natural objects, the human figure, and sometimes a full-scale human head. The students also explore "pure form," working, for example, with convex and concave surfaces, the spiral, and the double-bent plane. In each project, they are encouraged to be exact and thorough in bringing it to completion

Eighth-grade study of human anatomy.

In the high school, the three-dimensional work of art can now be fully judged according to aesthetic laws. We can speak to the student about what is beautiful and what is not in a way that would have been superfluous, if not harmful, in the earlier years. I often find the students create forms and figures that are reminiscent of the Renaissance and Romantic periods. The students, like the artists of those times, combine the discovery of the hard and fixed natural world with a longing for classical beauty and idealism.

The great art of all cultures expresses the striving for more than what meets the physical senses. The sculpture curriculum in the Waldorf school seeks to inspire the child to that same aspiration.

An upright human figure, done by a twelfth grader.

The Idea of Metamorphosis in Connection With the Modeling Lessons of the Waldorf School

by

Anna-Sophia Gross

When the onslaught of destructive forces in our time constitutes a real threat, it is especially important to have recourse to the forces that revitalize nature. Destructive forces must be confronted with an increased understanding of the mysterious laws of formative forces in nature and in the human being. This alone will make it possible for us to influence the dying life forces in a positive way. This task is well begun with a study of natural science as shown by Goethe. Exact observation of the plants led him to a knowledge of the fundamental principles of plant growth: his idea of the archetypal plant. His descriptions of the single stages in plant life allow us to recognize the metamorphoses and sense the active being of the plant in its continuous transformations.[1]

Rudolf Steiner extended the idea of metamorphosis to all living nature processes, including the human soul in her step-by-step transformation. He described the development of the child, with changes occurring not only in the body but also in the soul. Body and soul are closely linked during childhood. Educational measures that affect the child's soul via the body (food, daily rhythm, meaningful activities, and medical treatment) and those that affect the body via soul and spirit (preoccupation with mental images, thoughts appropriate to the age and artistic activities) all contribute to the child's harmonious development. It is only the adult who is able to

educate himself through the strength of his ego, in which case he will continue to transform his inner life in old age, not, however, by virtue of natural conditions, but through the strength of his own spiritual striving.

Art connects these two sides of human development, nature and soul/spirit. Rudolf Steiner applied the idea of metamorphosis to the arts as a new impulse. He graphically demonstrated in the first Goetheanum the way this can be done in the sphere of sculpture. Even today, through studying the models of the large auditorium, we can see how the motifs of the pedestals transformed step-by-step from the first to the second pillar, intensified and connected by the mighty architrave. And so on, every one of the seven pillars, with its characteristic form, being an intrinsic part of the whole.

Thus, during the second decade of the century, when art, through the advent of abstraction and realism, was under threat of losing its original life, Rudolf Steiner gave us the opportunity to develop an art of sculpture that connects again to active life forces in nature and the human being. An organic sculpture is, according to him, neither a copy nor a simplification of outer nature but is developed out of the experience of formative forces in the world. Rudolf Steiner put Goethe's words as a motto for a future aesthetics: "Beauty as manifestation of mysterious natural laws

that would, without it, remain hidden." According to Goethe, the artist's task is to make the hidden spiritual tendencies in nature perceptible to the senses, allowing the totality to emerge from the formative possibilities of a single part. He or she must try to break the spell of what is mysteriously enchanted in nature, unable to unfold in it. "Only that will be experienced as beautiful which appears to be more perfect than nature, where the object grows beyond itself on the basis of what is hidden behind it." [2]

Rudolf Steiner gave us an example of this: he described the form tendencies to be discovered in the human being that can be developed in an artistic process—where asymmetry could come to the fore to a greater degree than is made visible by nature. The ossifying form of the head could, in accordance with its tendencies, develop a head with strong, mobile elements. The form-creating forces, active in human nature either as hardening, rigidifying or as mobile, volatile elements, are to be brought out as "spiritual forms." Rudolf Steiner attempted this in his wooden sculpture for the Dornach Goetheanum building.

We may dimly sense the creative possibilities of this artistic impulse. We stand at a new beginning. What Rudolf Steiner wrote in connection with the plastic forms of the Goetheanum applies to this new approach to the art of sculpture: "The natural wherever it unfolds in a living way, works in forms that grow from each other. In artistic work one may get close to the work of nature if one devotedly and emphatically grasps the way nature lives in metamorphoses." [3]

This artistic impulse gives us the opportunity to develop a series of exercises that culminate in the study of metamorphosis. I shall show, by using a number of examples, the basic experiences in modeling that seem important to me. These experiences will always need to be encompassed, albeit more or less consciously.

Modeling in the lower primary school is mostly connected with the main lessons. The so-called Man and Animal block (class four) is a prime example: When penguins have been discussed, the children will joyfully shape these birds, even if several weeks later. The experience will still live in them, becoming the motivation for shaping the animals. We see the most diverse shapes of penguins formed—fat ones, skinny ones, large and small headed. Some of them seem to look about with curiosity, others appear to be quite calm and phlegmatic. We see a wealth of possibilities of movements and expressions. Exceptionally quick workers might add one or two chicks—the given subject is differently and individually addressed.

Every child is still, in her mind, in the workshop, even though she may have gone to do something else.

In one class, the question was repeatedly asked: "When can we make swans?" I did not initially respond, because of the difficulty for the beginners to succeed in shaping the thin necks. But they insisted. When I found out that swans had been the subject of a lesson the previous year, I at last gave in, and they were satisfied. I clearly experienced the children's need to actually shape what had been learnt and seen, and this at a definite time after the event.

Vice versa, modeling has a tremendously enlivening and ensouling effect on physical sight—through watching the hands' activities. By perceiving the forms produced, the eyes awaken for the perception of the environment; the children take a greater interest in the things around them if they were introduced at the right age and in the right way to the forming of three-dimensional objects!

If we wish to put this effect on physical sight to the test, we could try to model a form with closed eyes, or feel an unknown object with the fingers. We will discover a strong wish to visualize what the hands are doing. In this experiment, the will impulses we can feel in the eyes allow us, afterwards, to look at the world with greater wakefulness. Our interest in everything we do increases.

He or she who has experienced the connection between seeing and modeling can, out of true understanding, motivate children to model. The only question is whether we notice and support the events that are important for our children's development. A happy incident gave me an example furnished by daily life.

We were in the mountains; a heavy downpour kept us indoors. As soon as the rain stopped, we went outside and looked at the black mud that had washed down from the pine wood further up. As soon as the seven-year-old boy saw it, to his mother's horror, he knelt down in the wet grass and put both his hands in the mud. "Look!" he cried jubilantly, "You can make things with it. All you have to do is to mix it with some dry earth!" The fact that the mud would crack when dry did not bother him. The joy in shaping was the decisive factor.

Building sand castles at the beach or in the sand box is an important experience for young children. They have to get the sand moist enough for their castles, mountains, roads, tunnels, caves, and lakes. The children's formative forces wish to be used and, if nothing else is available, they will make do with the mud in puddles. The result is of secondary importance—the doing is all.

Water plays an essential part in getting the consistency right. Be it in nature or in the modeling room, it makes it possible for the living formative forces to enter the otherwise lifeless substance. Unformed matter, clay, is given shape through water: it lets itself be kneaded, is enclosed in a skin. Yet it is only the human being who can give it a "taut" surface; it never just happens by itself. The formative penetration of matter engenders the children's growing into the world.

Rudolf Steiner suggested that clay modeling should begin at about the ninth or tenth year. Before that, beeswax is preferable. The child's inner relation to the environment changes considerably during this time. Up to now he did not experience himself strongly as being separated from the world; whereas now it is possible for him to feel apart from it, and he must find new ways to relate to his family, home, and nature.

The new subjects of nature study and history are a great help for this, as well as artistic and practical activities.

Woodcarving is introduced in the middle school and complemented by formative exercises. The work with wood should not exhaust itself in the practical doing, but appeal to the children's sense of form. They should be brought to the point where they only like useful articles if they are beautifully shaped. While we need tools for the work we do, the uniqueness in modeling lies in the fact that we can shape the material directly and exclusively with our hands. During the work, the faculties of these most human of all organs are unfolded in differentiated ways. It does not make any sense, therefore, to use modeling sticks in this subject.

The children gradually learn to appreciate the truly wonderful structure of their hands. Arched forms are shaped with the palms; with the pronounced arched and muscular balls of our hands, we transform the shapes, are able to produce slightly

hollowed surfaces. The wealth of angular forms is already there in the bony structure of the fingers. Just as the complementary copy of the colorful environment arises in our eyes, so do form and hands complement each other to a unity during modeling. With our concave palms we experience the convex form, feel its wish to expand, and we retreat from it. With the balls of our hands and with our fingers we enter actively into the material, force it back. Through this, the form assumes a receptive character. Out of the reciprocal interplay of polar active forces, the apparently living plastic form arises.

Our first exercises in the practical and artistic lessons in classes five and six are animals and people, just big enough to be enclosed by the hands. Within this space of our warm hands, from the enclosed ball of clay, roundish animals emerge: sitting birds, frogs, hedgehogs, rabbits, baby sheep are all suitable subjects, their simplified shapes especially allowing the expression of convex forms. During the transforming process the beautifully stretched surface of the ball of clay should not be destroyed. If the surface is roughly handled by inserting the fingernails in it, there will be problems in restoring the broken "skin" afterwards. Less haste, more speed is a sound principle. We can already see in this exercise how a form differentiates itself as it develops. A little help will encourage the children to test themselves again. Without concentration, without being engrossed in the hands' activities, an enclosed surface will not come about. Any hectic state must be avoided. A pleasant and calm working mood is produced when the children immerse themselves into the process of feeling by touch.

Not all children find modeling easy. And it is the more important to see to it that their joy does not wane, that they do not despair in the all too common "I can't do it!" The essential thing is not what they can do, but what they can develop through practice.

We progress from the roundish animal forms to the stretched ones. The fish has always proved itself as a transition. The fish is formed through the wavy movements of its surrounding; it speeds ahead through the beat of its lateral fins. We get a clear picture of the archetypal movements of the fish, a horizontally forward-striving right/left movement. And the children can directly see how the movements we give to our animals also express their very soul. A little bird may look sadly downwards, or cheekily upwards, can look to the front as it greedily reaches for food, or have a critical, sideways expression. Every child shapes his or her very own little bird.

The children learn much by comparing their work at the end of the session that closes with the attempt to make a small upright human figure.

This initial theme can be further developed during the next block by making small groups of animals. If we decide on turtles, we begin with the shaping of a generous Mediterranean-like landscape. From this the turtles will emerge quite naturally—they look like walking hills. Their armor-like backs are convex and have to be lovingly sensed by the fingers during the work. When making cats, we start with the semispherical backs that gradually develop into playing kittens. Their movements must be carefully harmonized if a cohesive group is to be the result. In a fox or bear emerging from a cave, the forms complement each other in an ideal way; as the cave is modeled, the animal's body almost happens to arise from it. It is not only the plastic forms that meet in a harmonious unison, but animal and surroundings can also be experienced in their close connection.

Developing our work further to include human figures—simple at first—we may suggest the modeling of a shepherd with a few sheep, or a man or woman and dog. This allows the children to give individual expression to their relation to animals. We get shepherds who caringly bend down to their sheep, shepherds who hold a sheep in their arms, or shepherds standing upright, watching over their flock. A phlegmatic child might insist on his shepherd having a rest.

As soon as we model upright standing figures we must find the balance within the form that corresponds to the balance in walking or standing. In modeling we intensively use those senses Rudolf Steiner called the "unconscious night senses" or "will senses"—the senses of touch, movement, and balance. We are hardly ever conscious of them, and yet we could not take a step without their continuous presence. As we touch an object or exert pressure on it from within our bodies, the sense of touch lets us perceive the surface of the skin. We knock, as it were, against the world outside. Our sense of movement tells us of the movements carried out by our body, our limbs, of changes in the space around us. The sense of balance provides us with the possibility of relating to the directions in space, especially to the vertical. These experiences of the energy relationships are a precondition for the ability to perceive them also in sculpting and architecture. Fluctuating movements within us are brought to a static condition in a sculpture.

When the main lesson in class eight deals with the study of anatomy, it is appropriate and stimulating to model bones. We try to shape the flat top of the skull, a vertebra, and a tubular bone. We shall easily discover the formative forces in the chest vertebrae, finding the balance between these opposite tendencies. One of our students once brought a vertebra bone to school to keep us from making a mistake. It proved to be a bonus, as we were able to study exactly how the small bones beautifully interlock.

In order to avoid mere copying, I tried to lead to the natural forms by a gradual, developing process. We began with the basic form of a lemniscate, densifying it towards the inner part of the body, resulting in supporting vertebrae. At the same time, the protecting cavity of the hole in the vertebra formed itself. Added to this arrangement in the horizontal are the vertical connections of the bordering vertebrae and the right/left transitions to the ribs through the appendices of the vertebrae. The polar opposites of form, most clearly manifested in the enclosed concave shape of the head and the tubular bones of the legs as vertical props, are only brought together in the vertebrae—and at the same time are connected with the three spatial directions.

This experience will not be forgotten. How a part adapts to the whole, how, not immediately, but in its form it is in tune with and related to all the other parts, are questions the students in the high school carry with them also as inner problems: How can I adapt, with my individual possibilities, to the social life in a harmonious way? Can I learn to control the polar soul forces in myself, the rising sympathies and antipathies?

The soul's experiences are reflected in the form processes. The subject of metamorphosis of bones is thus not only an essential basis for free, formative exercises in the high school, but is also of assistance in mastering life.

At the beginning of puberty the students ask for more concrete projects. The free forces of imagination give way to the forces of reasoning and intelligence that now develop as independent entities. It is our task during this time, when thinking is

assuming a realistic and analytical character, when the video culture either threatens to extinguish the remnants of the forces of imagination or turns them into an unhealthy, fantastic world of pictures, to develop the appropriate forces of imagination through the arts. With few exceptions, the students are unable to respond to a free, individual theme. Past experiences are of no use; we must begin anew. But this offers a great opportunity. The individual students now show us quite new aspects of their personality During the course of the high school, the teacher is continuously surprised by them. Very slowly, new formative forces keep emerging from the chrysalis of formlessness. I would now like to show, with the help of some illustrations, what I attempted to achieve with my high school students with the exercises in the plastic arts. Every teacher will, of course, find his or her individual methods, depending on the point of departure. Experience with students, study of the human being, and personal artistic formative abilities will provide the basis on which lessons will he founded and sustained.

The previous exercises of "feeling by touch" in the earlier classes are now raised to a higher level in class ten—to a free shaping of forms arising from a number of transformations of the sphere. The shaping of surfaces, their stretching to create edges, are exactly observed and practiced. Art, too, is based on craftsmanship. Rounded forms with their qualities of growth and expansion radiate strength and life. Hollow, concave forms with their enveloping and receptive qualities "breathe" definite soul moods. Both of them through a wealth of reciprocal interplay, shape the plastic forms. We begin to pay attention to the transitions joining the single forms. What kind of curve are we dealing with here? Is it convex? Is it concave? It is both: doubly curved. Convex and concave curves lead, through their working together, to a heightening of the polar formation of surfaces. The moving element, the process of becoming in a form, is most clearly visible in the doubly curved surface.

Everywhere where forms are continuously passing into each other, be it in organic nature or in a sculpture, this is happening through the doubly curved lines (as, for example, in the surface of a saddle).

If you have not yet observed such a surface accurately, you should take a look at your outstretched arms, at the transition at elbow and wrist, and you will discover many such places. Contraction, connected with stretching and turning, allows the development of living, active formations of surfaces in the world of organic forms. Movement here is flowing; rhythmical balance is established. The eyes do not here come to rest, cannot be fixed. They are compelled to move from concave to convex forms. We are, as it were, asked to see through the sense of touch. We feel changes taking place, with the pulse of life in them. The simpler the basic exercises, the stronger will be the faculty to observe. A more difficult exercise would be counterproductive to the learning of the basic phenomena in the formative arts.

During the second half of the block I work in the opposite way. After the main lesson on the history of art, we practice observing and experiencing proportions.

We derive the sitting figure of an Egyptian scribe from the totality of the form of a pyramid. Afterwards we model a standing figure, allowing ourselves to be stimulated by ancient Greek culture. In the process, the geometrical rigidity of the sitting Egyptian figure with its clearly perceptible forces of gravity must give way to a harmoniously living uprightness. A truly wonderful levity is present in the Greek Korea.

As present-day students have problems with the attempt at rising to the vertical, at lifting the heaviness and penetrating it with formative strength, the making of an upright figure is therapeutic for them.

In class ten, I ask the students to model animals once again, shapes in which soul forces come to expression. What are the movements by which the animal's soul expresses itself? We refer to Franz Marc's art. In our first free exercise we show the forward movement. We usually get the most amazing variety of quite ancient primal animal gestures. It is now interesting to discover the specific animals that can be developed from them. What we get, to begin with, are animals that are more closely connected to the ground: a fish, a whale, a beaver, a weasel: imagination is kindled. Later, during the modeling of a wild animal, much will become clear. Looking from above, we can see the symmetrical-rhythmical arrangements. Expanding and contracting parts of the body alternate with each other. In the play of forms, the organization of each part of the body becomes visible, shared by all animals, but different in their proportions. The rhythm of the spatial animal body (seen from the side) is intensified by the line along its back. It clearly expresses the way the animal moves. Think of a squirrel, a deer, or hippopotamus. A third element is added by the right/left movement, still rhythmically, harmoniously swinging during a peaceful walk, but changing to an arhythmical and asymmetrical movement at the slightest inner disturbance; all it needs is a sideways glance, or coming to a halt. During a fight, vehement, passionate movements can take place in space. It is a most difficult task to show an animal in a typical movement, most of all the harmonizing of all the possible different movements in a group of horses.

Our last exercise is the modeling of a large, bulky animal of the students' choice—a hippopotamus, rhinoceros, or elephant, animals where we do not experience movement as much as their massive form impressed on them by strong, vital processes.

The wishes of the students should be responded to. At this time when our inner connection to nature is almost nonexistent, where animals have been reduced to mere economic units, it seems to me ever more important in the context of artistic subjects in the high school to occupy ourselves with the animal as a living and ensouled being.

Our class ten students are working with the two aspects of the human head. The quite wonderfully rounded head of a little child expresses most strongly the growth forces active in building the physical body. Future formative faculties lie hidden in the faces of young children. We must proceed caringly and cautiously when modeling them. Indications are sufficient.

As foundation for the head of an adult we begin with a concave form. The very first steps already indicate the temperament, giving direction towards the next stage. We always work with one hand from within and the other from without. Only then can the reciprocal interaction of forces be grasped. The enclosed and protective inner space is felt by the hand's touch, and gradually surges beyond the arched skull to the outside. The effect of the form is as though filled with life, but as yet asleep. Effective energies from outside now intervene, pressing the curved forehead back, flattening it a little, working into the sphere of the eyes, differentiating the shape of the nose, awakening a definite physiognomy.

The physiognomy reflects the ego's confrontation with the world. The emphasis of curves and clear transitions between

forms will result in an expression of youthfulness and liveliness. In restrained and reserved forms, we get increasing individual, and aging features.

During the process of becoming, of developing, the artist's own formative forces in the head are gently vibrating along as he works; there is experienced a delicacy to the feeling of touch, be it consciously or subconsciously. No wonder, then, when the first freely shaped head turns out to be almost a self portrait.

In most cases, we shall perceive in the sculptures the inner mood corresponding to their creators. For me, it is important that the students learn to see, in their first attempt, the proportions, the two asymmetrical halves of the face, without trying to express soul conditions, such as joy and pain, that show themselves not so much in the physiognomy but in gestures and mimicry. There will, of course, always be an expression, but it is of secondary importance; it would tax the students too much. If, as a result of the work, the students tell me that they had observed the faces of fellow travelers on the bus more attentively, a healthy basis has been established for independent work. The students experience this block as the culmination of their modeling lessons.

The project in class twelve consists in the forming of a threefold series of metamorphoses. Taking a number of examples from nature or from lessons during previous years, we try to understand what this means. Before actually starting, the whole of the process must be known and understood. Not the single steps of the work—they will only develop during the creative process itself, from the basic idea. You can get quite excited about the way a single form arises, as this will usually be very different from what you had expected.

The student who remains faithful to the basic idea will recognize it again and

perceive it as the moving, driving force capable of developing a wealth of forms from itself.

A number of possibilities were considered and put to the test: movement leading from weight to lightness. A pronouncedly voluminous, seed-like round form develops into a bud-like one, grows upwards and unfolds into its surroundings. This we connect to the plant world. A round form can then be gradually changed into a concave one; this will lead to forms that allow us to think of the development of inner human organs.

Another example: a pronounced voluminous form stretches in a horizontal movement. The freely formed shape will express the animal nature. Depending on the degree of mobility in mental picturing, the single parts may be lying close together, or the transformation may be so strong that the onlooker himself is asked to bring movement into his imagination.

And it is just this that makes the work so valuable, because it is here that you begin to feel what nature is accomplishing when, for example, it metamorphoses the petals of the poppy blossoms into the seed capsules.

I consider the exercises in metamorphosis to be a good preparation for stone sculpting. During stone sculpting—if done with the pointed chisel in the classical Greek tradition—you will experience in a truly wonderful way the closing of the circle of our exercises: an undifferentiated round or upright figure, depending on the shape of the stone, gradually transforms, becomes open to a variety of forms and yet retains its organic wholeness.

Again we experience growth forces. The work at a surface, point after point with a pointed chisel, so that one can no longer see any arbitrariness, demands the greatest attention of the students. If, during the

previous years, he had not noticed what constitutes a stretched, formed surface—and this can happen in spite of the teacher's efforts—he certainly will now. The weaving softness given to the form by the "pointed" surface produces the semblance of life, and this more intensively than you would expect.

Modeling in clay is, on the one hand, practice and stimulation for the life-building forces of the child and, on the other hand, preparation for the work in durable materials. A world of form, closely connected with human nature, is opened up. The need may, perhaps, arise from this to harmonize the things around us in our homes with the human being. They should, in future, not only radiate a geometrical objectivity that excludes us or leaves us cold, but have a vitalizing effect on human beings of all ages, especially children. If our children do not get the opportunity of relating their souls to the things around them, later in life they will lack social faculties: insufficient soul development during childhood leads to isolation, to an inability to relate, to connect to the world. In this sense we can see in the modeling lessons of the Waldorf school more than just a balancing of the predominating intellectual demands made on the students.

1. v. Goethe, J. W. *The Metamorphosis of the Plant.*

2. Steiner, R., *Kunst und Kunsterkenntnis*, November 9, 1888 and February 17, 1918, *A Modern Art of Education*, August 8, 1923.

3. Aeppli. W. *The Care and Development of the Senses.* Steiner Schools Fellowship, 1989.

Some Thoughts Concerning the Methods in the Formative Lessons

by

Michael Martin

A look into the world of plants will open our eyes to the inexhaustible wealth of form structures. We can observe the continuous metamorphoses of plant forms, starting from the shoot, via the unfolding of leaves and blossoms, to the mature seed. First are simple, spherical shapes: buds, seeds, tubers, bulbs. Comparative processes take place in animals and human beings, All organic forms emanate often from very tiny, yet undifferentiated and more or less rounded forms, very similar to each other.

The basic forms modeled in class four and five also look similar, due to their being true to the organic formative processes. From the pressure of the ball of the hands, the fingers, the palm, the lump of clay gradually differentiates itself into an archetypal animal shape. There the back compresses into the shoulders, the head inclines threateningly, at the ready; here it slinks away, soundlessly and cautiously; in yet another work, the archetypal form of a fox, bull, or dog emerges from the greedy, scenting instincts leading to a pointed, scenting mouth. Such forms emerge through the teacher's guidance. The qualities of movement in crawling of slinking away, or the alert poise in the region of the sense organs are brought to the children's attention, who experience and then model them. The shape and form of the animal is already hidden in the human hand, and it is, therefore, not at all difficult to discover that it presses and forms at the right places, produces protuberances and indentations, in order to find the characteristic form of an animal.

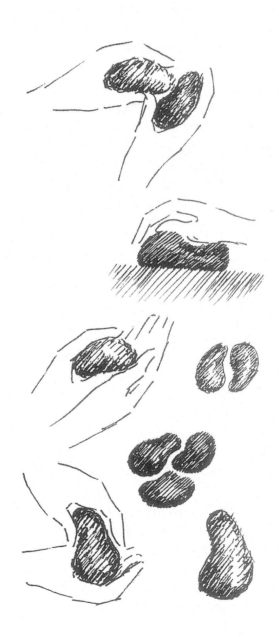

Guided by their teacher, the children set to work out of the movements of the basic gestures (jumping, slinking, lurking, swimming, etc.) and not from the memory of a particular animal. In the process it gradually becomes clear to which animal the activity will lead. It is the inner experience of the way the form develops that leads to the shape, and not the conceptual idea or picture of a specific animal. From the creative variety of the moving (and moved) world of form, the different animals arise, umediated, as it were, through the universal formative forces of the hands. In the process, each child also spontaneously expresses his or her temperament and individuality.

In his lectures on the curriculum, Rudolf Steiner encouraged this approach for the drawing lessons, extending it immediately afterwards to painting and crafts.[2]

All imaginable form elements should be practiced "out of the form itself" in order to give the children the immediate experience of round, concave, pointed, straight and sharp forms. Since round, convex forms come from different formative forces, they have a different effect than pointed ones.

This the children should learn to feel before discovering the corresponding forms in the environment. They are first to draw an angle, to be told afterwards that such an angle can be found in a chair. "Don't ask the children to copy before having cultivated in them, out of inner experience and feeling, the form as such, independent of where it may be found. Afterwards it is okay to copy . . . "[3]

We have here a manifest mystery of the greatest importance for the children's healthy growing into the world. From a creative enlivening of their own formative forces, a feeling for form within the children is stimulated and made visible in their drawings, paintings, and modeling. Awakening step by step to their surroundings (at age nine and eleven and during puberty), they will rediscover these forms, carried within their inner sphere of experiences, in their environment.

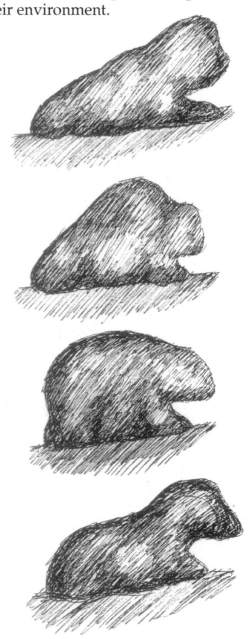

In their discovery of forms and lines, they salute their environment as something with which they are familiar, something they already know. They experience the world around them, not as strange, but as

familiar, intimate one, insofar as it is already present within themselves, albeit in an unconscious way. The objects outside have merely assumed another substantiality, another reality.

Once aware of this motif, we teachers can see our educational tasks having this aspect. The children's individuality is to be led into the objectively visible world of space; personality and world are then no longer polar opposites, but the human being experiences himself in many ways interwoven into the world. Both physical and inner (soul) life have their foundation in whatever the world presents. The opposites of subject and object are conditioned by our modern materialistic consciousness that makes it difficult for our children to relate to their environment. The adolescent especially runs the danger of looking for an understanding of himself only, and not for the connections with the world into which he must grow. A dangerous retreating into himself can be the result, or he might lose himself in the materialistic temptations of the environment.

On the other hand, a thirteen year-old-boy described his feelings of complete oneness between himself and the world, causing him the greatest happiness. "The fact that a boy was lying on his back amongst heather or somewhere, this interesting situation that enriches the life of every young person would not have remained in my memory if it had not served as framework for one of the greatest pleasures I have ever experienced."

"My ordinary and meaningless dreams gradually transformed into an exceptional experience that I can only imagine to be comparable to clairvoyance. It was as though a veil was removed and my eyes began to penetrate the objects in my environment. The blue sky above me with its summer clouds, the trees, bushes, grass, the birds on the branches, the tiny bugs, ants and spiders—all seemed to me endowed with a new and until then unthought-of value. The whole of nature had become transparent, had thrown off its mask.

Everything that had been dark, dead, and material had vanished, and things revealed their eternal nature, as living light and life and, indeed, as the very same light and life that was also within myself—it was the one and the same consciousness, the one and same substance in myself and in them. The one and the same band connected me with them and them with me; there was no longer anything hostile, anything foreign in the whole, large creation. My heart glowed, and I experienced something of the joy of someone who suddenly recognizes in strangers whom he had learnt to love his very own brothers and sisters . . . "[5]

I must emphasize that this description is of an exceptional change of consciousness. But it does clearly demonstrate that the duality of the world and the I, necessary for the development of the personality, can, at a higher stage, pass into a state of concord and harmony. Can artistic exercises contribute to the bridging of this necessary distance between subject and object, and establish a balance between inner and outer world as condition for every real "interest?"

The theme of the simple animal sculptures made in the hollow space of the children's hands in class four or five, is taken up again in the high school leading to differentiated projects in which the students can express their individual feelings of forms and show their individual creative ability. As before, they begin with the archetype, the characteristic form—this is brought into movements in which the instinctive life of the animal lives. The students must try to experience this movement in order to find the corresponding form that will be convincing to anyone seeing the sculpture. It is quite easy to distinguish whether the form is just the animal's physical appearance, or one in which the gestures have arisen from its inner instinctive urges.

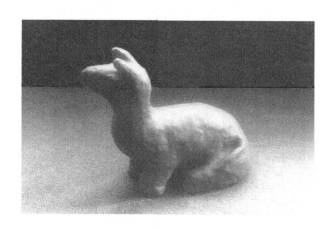

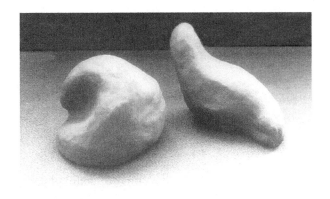

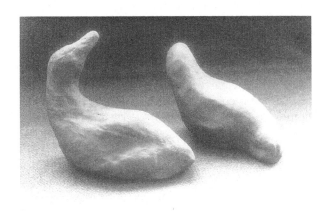

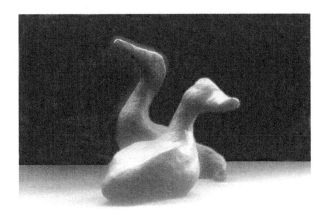

The consciousness of the sculptor directs his flexibility, it submits to every pressure of the hand until the creator has found the final form before relinquishing any further work from his or her hands.

Method, material and hands as the only tools give the work a certain style one finds again and again in Waldorf schools, as distinct from that elsewhere. Looking more closely, however, one will discover the individuality of the students' work. It is only the superficial observer, not familiar with the material, who can assert that the individuality of our students is not sufficiently expressed there. True, our schools do not offer the scope of techniques and materials in the art subjects as do other schools. We do not seek the individuation of our students so much in the choice of different techniques, but rather provide the individuality itself free scope within a given theme and a given technique—as we also do in written work. It is the structuring of form that individualizes, and not the technique.

The present contributions may have shown the importance of the described methods and materials for the training and maturing of our students. We chose them according to the principle: how may the developmental stages of the students be meaningfully supported? Tackling too many techniques will be at the expense of thoroughness and may easily lead to the illusion of having mastered something that one has only superficially dabbled in. An intensive connection seems to be more important today than rapid changes, and this conditions the selection of a few basic techniques. Lack of time does not allow for more.

A similar case to that made out here for modeling would apply also to painting and shaded drawing. In all of them, methods are used that allow for changes during

the work. As it develops, a process of maturing can take place in the students' imagination that manifests outwardly in the continuing transformations.

A superficial glance at an exhibition of students' work will see similarites, even the "unmistakable style," already referred to. What is missing are collages or the popular copies of modern schools of art. Everything assembled from single parts, artificial materials, waste products of our culture, and so forth, comes from a world of form derived from technological products. Technological articles must indeed be "synthesized" from a variety of materials and forms. We meet such methods in the area of handwork, such as: basket weaving, metal work, joinery, and tailoring that are practiced in the high school. It is here that the preparatory stages for methods used in technological productions, can be found.

The organic principle develops its living formation actively from oneness to differentiated forms, without renouncing its inner totality. It does not synthesize from single parts, but forms from the whole. This organic quality in our students' artistic work radiates something of a living harmony and inner calm that the onlooker experiences as beneficial. There are critics who maintain that this does not correspond to the tensions of our technological age! We respond: because of this, our understanding of the reality of the organic-living world is in danger of being lost. Our environment and our social life today are largely determined by human beings. Is it not time to work on a new picture of the human being that understands not only the technology around us, but also—and largely through artistic activities—the organic laws in the world?

1. Clausen and Riedel, *Plastisches Gestalten*, J. Ch. Mellinger Verlag, Stuttgart: 1968.

2. Steiner, R., *Practical Advice to Teachers*, Rudolf Steiner Press, London: 1976.

3. Ibid.

4. In this connection the following statement by Jaques Lusseyran might be interesting: "Everything happened as though the light were no longer an object of the outer world, no longer this strange shedding of light, no longer this natural phenomenon that may or may not be there. over which we have such little power, but as though this light from now on was enveloping both the outer world and myself with just one grasp. Having no physical sight, I was not able to say whether the light I perceived came from without. Neither could I say whether it came from within. Indeed, inside and out-side had become inadequate .concepts. When, much later during my studies, I was told of the difference between objective and subjective facts, this did not satisfy me: I saw only too clearly that such a difference rested on an erroneous conception of the way we perceive . . . Jaques Lusseyran, *Blindness—a new way of seeing the World*.

5. Wiesenhütter, E., *A View to Beyond*.

6. Wimmer, H., *On Sculpting*.

Living with Forms in Art and Nature

The essence of artistic feeling is to become one with the form, to live with the form.

Rudolf Steiner

As I was sending my modeling book off to the publisher, Michael Martin released his newest work, *Leben mit Formen in Kunst und Natur* (*Living with Forms in Art and Nature*). It is a profound study that enables the reader to experience the forces of transformation in nature and in the whole evolution of human art. I include in this sourcebook a few freely rendered excerpts in connection with modeling and hope that Herr Martin's book will soon be translated in full for readers to experience its inspiring insights into the universal language of form:

We behold the inner surfaces of the hand with which we want to work: they come together in a bowl, a vessel. Within there forms a ball of clay. How the sphere arises out of the amorphous lump of clay in the form of the hands' surfaces is an exciting experience: carefully touching with the hollow of the hand, ever circling, ever sensing the irregularities of the surface. And how peculiar that the eye cannot directly participate while the hand conceals the clay in the process of touching. Only afterwards can the eye, checking from some distance, say whether the form is uniformly round. For the eye itself is a ball and is able to perceive and recognize every unsuccessful deviation overlooked by the hands. .

While having such thoughts, we find the clay has become warm through and through and has developed a dry skin. The ball is finished! How shall our hands let it go and lay it down? The ball has no bottom surface. It has no up or down, no right or left! Its only relation to space is an inside and an outside. Are spheres somehow strangers on earth, in comparison to other objects that at least have a top and bottom? We come to the conclusion: *a ball has to float in space and continually circle around if it is to be true to its form.* That in fact is what the planets and moon do as they orbit on their paths through the universe . . . *Thus in the form of the sphere we feel connected with the earth and heavens.*

(p. 9-10)

In working with clay one receives new ideas which one did not have before. That means that the forces of imagination have been stimulated to develop themselves. *Soft, formless clay can be a willing helper* in the process.

(p.14)

Plants incorporate the fundamental tendency to become *spherical*: the shapes of animals and humans are also determined by *convex* forms. In its purity, this form tendency, come to rest, appears in the universal form of the water drop. (p.54)

Air strives to penetrate, loosen up and dissolve water and earth. When this tendency gains the upper hand,

forms dry out, for the dissolving does not occur in liquid but in the drying air, which, permeated by light and warmth, consumes all growth. Air creates through a *hollowing out* of substance; it opens form to space and shapes inner spaces (concavities). Through the breath of this forming force there arises the (star-like) blossoms of plants. It creates the most varied *concave* forms.

(p. 54–55)

Rudolf Steiner: "The animal is characteristically distinguished by unique pocket-like forms (*das Taschige*) which concavely invaginate the spherical form. The formation of the animal entails special pocket or sack-like forms created from outside into the interior. Observe your eye sockets . . . nostrils . . . alimentary tract from mouth into stomach . . . *Everywhere this concave, pocket-like form enters the spherical form as the transition takes place from the plant to the animal.*"

(Lecture on "The Human Form," November 5, 1921. Complete Works #208). (p. 59)

(In the human being) the development of the (sphere-like) head and [ray-like] limbs does not occur simultaneously; the head is first to form itself out within the *round* germinal figure of the embryo, while the limbs appear stunted or shriveled up. Even during childhood the head is still the most developed. Only at the beginning of adolescence around age twelve do the limbs start to grow dramatically from below upwards, beginning with the feet and followed by the lower and upper thighs . . . We thus find in metamorphosed form the same development *from the early convex bud-like*

shapes into the later ray forms as they confront us in plants. It is a remarkable fact that the growth of our limbs radiates from outside inwards.

(p. 67)

Convexly, roundly sculptured faces project a child-like, youthful countenance, soft and flexible, still unburdened by cares. Faces with *hollows, concavities* and sharp edges appear older and more set as personalities.

(p. 79)

Having discussed and illustrated the language of universal forms in the modeling process and in nature, Michael Martin projects these fundamental insights in a remarkable way into a rich history of sculpture from Greek, Egyptian, and medieval times through the Renaissance to modern art. He presents a fascinating characterization of the dynamics of convexity and concavity, of spherical and ray-like tendencies and their balance and integration in the mystery of the doubly curved surface. His study sheds new light on the evolution of the plastic arts and on human consciousness.

A Waldorf School Sculpture and Modeling Curriculum

from
The Educational Tasks and Content
of the Steiner/Waldorf Curriculum

Martyn Rawson and Tobias Richter, Editors

General aspects and aims for classes four to eight, points of view and general themes:

Wherever appropriate during classes one to three the class teacher will let the children model with clay, wax or plasticine. From their ninth year on, modeling can begin as a complement to form drawing. The starting point might be elementary experiences of the sphere and the pyramid. Modeling is developed from the interplay of the hands, which together form an inner space. It is not a matter of adding bits of clay or plasticine here and there but of working with the whole lump, a given amount that can be changed and shaped. Pressure and counter-pressure shape the form of the surfaces. In drawing, corrections are made by "the will working through the eye" (Steiner); in modeling it is the hand that feels the surfaces, thus becoming a kind of organ of perception and formation. Modeling can add depth to form drawing and also to other main-lesson subjects from which it derives inspiration.

In modeling, the underlying principle is that of the metamorphosis of form. That which is given, the material, is transformed through the activity of the soul in a process that reflects the inner metamorphosis that comes to expression through child development. In modeling, we are working particularly with the formative forces at work within the nature of the developing child. In the process of modeling itself, the senses of form, movement, and touch are especially active. In looking at the work, either in progress or at the completion of a project, the child's powers of "seeing" are activated in a particularly intensive way.

Seeing in this sense means not merely literally using the eyes, though this is in itself no easy achievement, given the tendency to "see" what we want to see rather than what is there. When observing form, we perceive the form activity that the clay actually expresses. This includes its inner movement (frozen in the outer shape) such as direction, expansion, or contraction, but also balance, symmetry, sense of gravity or levity, and sense of life or lifelessness. The children learn to understand the vocabulary of form and how to, read it. This also requires a verbal vocabulary to describe it, and developing this is also part of the task.

When the children are fully engaged in the task of modeling, they are usually quiet, concentrated, breathing deeply, and unaware of their surroundings. This mood is sometimes difficult to achieve. Creating the right mood is important if the children are to connect to their own formative forces. If they are unable to do so, this manifests in lack of concentration, superficial forms, and a tendency to fragment the piece. Respect for the material itself helps, which comes from exploring its properties. The lesson

may begin with simple exercises to familiarize the children once more with the clay or modeling material. Equally important, however is a clear picture of the task in hand. Rather than show the children pictures of what they are to model, giving a verbal description, or even asking the children to act out the mood or form they are to model, is a great help. This need not take long, but it is a major help in engaging their self-activity. When working figuratively or abstractly, it is important that the children have a strong feeling for what the form is going to express.

Objectively describing what has been modeled is an equally important part of the lesson. The children need a certain distance from their own work, perhaps even waiting until the next lesson. Their judgment of form needs to be carefully schooled through accurate observation and description, which encourages them to "slip into" the form and describe what is "happening"; is it sleeping or resting? Is it slowly swelling? Is it reaching out in a certain direction? Is it striving upwards but leaving most of its volume behind? Is it withdrawing? Is it just a hollow shell with no more activity within, shaped not by inner activity but outer forces. like erosion? Such conversations can be held with children using age-appropriate terminology quite soon in modeling lessons, once the children have a good experience of the main elements of form. Especially important is an awareness of the relationship of forms to their surroundings and particularly the way forms respond to each other. This can be done quite simply by placing two forms in different relationships to each other and asking the children to describe what they are saying to each other.

Content suggestions:

Class Four

• Simple solids such as sphere, pyramid, cube, modeled with hollow of the hands.

• In support of the animal main-lesson, beginning with a sphere, make animal forms (sleeping cat, resting deer, cow lying down, etc.).

Class Five

• In the plant main-lesson, beginning with a sphere or egg-shape, make buds, fruits, and other plant forms. These need not be naturalistic; the important thing is to sense a growth movement that forms the unformed material.

• Human figures can be made, at first standing, then sitting. Figures that work with the whole form as an entity, with arms and legs unarticulated (e.g., wrapped in a cloak, crib figures, etc.) are easier for the children before dealing with the static problems of legs. Later the arms can move away from the body, and the legs can take up a stance.

Class Six

• In connection with the geography main lesson, mold the shapes of various types of mountain: granite, chalk and sharp-contoured shapes that resemble crystal forms. Caves and waterfalls with boulders can be modeled.

• Work with figures can proceed to include groups, mother and child, farmer and horse, figures wrestling, etc. Keep the detail of faces, hands, feet, clothing, etc., to a minimum.

Class Seven

- In connection with projection and shadow studies, or with geometry, solids such as the cone, cube, pentagon/dodecahedron, etc., can be modeled. The latter in particular can be obtained from the sphere by using the flat of both hands.

- Starting from the sphere or a geometrical form, a sequence of form transformations can be undertaken.

- In figurative forms, explore gesture and movement, starting from figures turning, bending, pointing, reaching, again leaving facial expression minimal.

Class Eight

Studies linked to the temperaments can be taken up in modeling:

- Studies of earthy dryness (melancholic), fiery flames (choleric), watery softness (phlegmatic), and airy evaporation (sanguine). These can be done abstractly and figuratively.

- Studies in dramatic gesture: adult protecting child, dancing, sleeping, lovers embracing, using whole body language-gestures that first have to be acted out before being modeled.

General aspects and aims for

Classes Nine to Twelve

Once again the important thing is to develop the manual dexterity needed to work appropriately with various materials, but also to become submerged in artistic activity that is free of any specific purpose. The creative process as such is experienced consciously. The youngsters are offered a realm in which step-by-step they can experience the intrinsic laws of art and at the same time the freedom of their own expression. Modeling lessons can help mold and differentiate the pupils' life of feeling while at the same time stimulating their enjoyment of being creative, Modeling proceeds through wood and stone carving to sculpture proper.

Classes Nine or Ten

Points of view and general themes:

The pupils should once again reexperience the basic elements of modeling, volume, surface, transitions between planes, line or edge, and point. The main aims are:

- Recognizing and being able to describe the different qualities of modeled shapes.

- Becoming conscious through observation of the movement of surfaces..

- Experiencing shapes from inside and from outside. This is a new realm of experience for the pupils. They must learn to distinguish between organic and inorganic shapes.

- Becoming competent in the manual skills and techniques involved.

Content suggestions:

Experiment with the basic elements of modeling, using clay to make reliefs, e.g.:

- Compositions arising out of a flat surface.

- Compositions arising from concave and convex surfaces.

- Curved and angular shapes.

- Compositions from surfaces that turn in on themselves.

- Endeavors to find a holistic composition within a specified form language.

The pupils learn to experience the reality of the space around them. Possibly a negative cast of the relief is made in plaster of paris, and then a new positive cast is made from this negative.

- Make masks from a clay base, from the relief form to a complete three-dimensional figure.

- Sphere (a form at rest within itself).

- Model a complete figure that not only looks satisfactory from every angle but also constitutes a plastic whole. As with the relief, the starting point as a rule is a basic geometrical form. These basic forms can be developed into animal figures. Perhaps suitable motifs from history-of-art lessons are taken up.

Techniques:

- Working with clay, either a single lump or using the building up technique used in ceramics (e.g., coil technique).

- The technique of applying plaster of paris.

- Taking a cast in plaster of paris.

- Casting with lead, silicon, or synthetic resin

- Various techniques of mask-making including paper and fabric.

- Woodcarving. Following a clay model, repeat the form by carving in wood. Relief forms are a suitable starting point. Geometric and organic forms are possible.

- Stone carving can be introduced using a soft stone such as chalk or tuff.

Class Eleven

Points of view and general themes:

Once the basic elements of modeling have been practiced in class ten, class eleven can move on to studying the movement of form on the one hand and the psychological expressiveness of form on the other. Stone and woodcarving lead on to monumental sculpture.

Content suggestions:

The modeled form as an *expression of movement:*

- Form movement as a shift of mass.

- Transition from static geometric forms to dynamic movement.

- The surface turned in on itself as an expression of movement.

- A series of shapes showing stages of a movement, e.g., a falling drop, a growth form, etc.).

- Form transformations: variation and metamorphosis (also possible in class twelve).

- Transformation of an organic movement into an artistic form.

The modeled form as a *expression of soul:*

- Suitable modeled expressions are sought for various soul gestures.

- Contrasting feelings (e.g., sorrow/joy) are depicted.

- Conversation between two forms.

- Abstract forms can be taken further to become concrete and figurative.

- Model the human head in three dimensions (e.g., working from inside a hollow form to create the form from within).

Exercises may include:

- Facial proportions as bearers of expression.

- One-sidedness of specific features, (e.g., grimace, caricature, animal-like face).

- Character studies based on the head.

- Physiognomy as a mirror of human moods.

- Self-portraits.

- Contrast opposite types of head and face: man/woman, old/young, beautiful/ugly, laughing/crying, etc.

Techniques:

- Initial designs are usually worked on through sketching, then worked in clay; later other materials are used.

- Plaster of paris techniques.

- Woodcarving.

- Working with other materials (depending on what the school can offer).

Class Twelve

Points of view and general themes:

The pupils should achieve some degree of maturity and independence in their work with modeling and carving; they should develop the ability to work freely with the forms they have discovered.

- Transformation of naturalistic forms into an artistic whole; simplification; stylization.

- Combining separate form elements in a whole work, e.g., incorporating copper and wood, glass and wood or metal, stone and metal (in jewelry and brooches).

- Making use of all experience gained; first attempt at using sculptural techniques on a larger work.

- Working out individual possibilities of expression.

Content suggestions:

Sculpture or modeling as an expression of spiritual intent:

The theme for the year could be: sculpture as an expression of spiritual intention. The important thing is that the students choose a motif or theme that expressed their own artistic aspirations. They should undertake a major artistic project for the year, working through an entire process from initial sketches and studies, through models in wax or clay to a finished exhibited piece in a material, or combination of materials, of their choice. Such a piece

should be accompanied by a description of the theme, the process, and reflections on the outcome.

Techniques:

- Modeling in clay.

- Woodcarving.

- Stone sculpture.

If possible, depending on what the school can offer, other sculptural techniques can be used, e.g., casting in bronze.

References:

1. From notes of a lecture given at a conference on art and education at the Waldorf School, March 1923. This translation is taken from, Jüneman, M. and Weitmann, F., *Drawing and Painting in Rudolf Steiner Schools*, Hawthorn Press, 1994.

2 An introduction to this theory can be found in the book by Jüneman and Weitmann quoted above. This book gives a most comprehensive account of the practice and theory of painting and drawing in Steiner Waldorf education.

3. Steiner, R., *Conferences with the Teachers*, op. cit., meeting of 15th November 1920.

4. Steiner, R., *The Child's Changing Consciousness*, op. cit.. lecture of 19th April 1924.

5. Jüneman and Weitmann, op. cit., p46.

6. Steiner, R., *Conferences with the Teachers*, op. cit., meeting of 5th February 1924.

7. Translated from *Methodische Grundlagen zur Anthrosopie* (GA 30, Dornach 1989, Introduction).

8. Jüneman and Weitmann, op. cit.

9. Kranich, E-M., *Formenzeichnung*, Stuttgart 1985, p30. 10 Kandinsky, *V., Der Blaue Reiter*, Munich, 1979.

11. It is very difficult to describe form drawings in words and considerations of (a different kind of) space prevent the reproduction of drawn examples. The reader is advised to refer to the illustrated booklet, *Formdrawing*, by Arne Breidvik, SSF Resource Books, reprint 1999.

12. Bühler, *E., Formenzeichnung. Die Entwicklung des Formensinns in der Erziehung*, Stuttgart 1985, p 158.

Bibliography

Adam, Paul and Wyss, Arnold. *Platonische und Archimedische Korper, ihre Sternformen und polaren Gebilde*. Stuttgart: Verlag Freies Geistes, 1984. (Numerous illustrations of Platonic solids.)

Aeppli, Willi. *The Care and Development of the Senses*. Forest Row, England: Steiner Schools Fellowship, 1955.

Armstrong, T. *Multiple Intelligences in the Classroom*. Alexandria, VA: Association for Supervision and Curriculum Development, 1994.

Arnheim, R. *Art and Visual Perception: A Psychology of the Creative Eye*. Berkeley: University of California Press, 1967.

Auer, Arthur. *Sculptural Modeling: Its Value and Uses in the Classroom*, 1998. Master's degree manuscript available from the Rudolf Steiner Lending Library, 65 Fern Rd., Ghent, NY 12075, 518-672-7690, rudolfsteinerlibrary@taconic.net

Bender, L., and Woltmann, A. The Use of Plastic Material as a Psychiatric Approach to Emotional Problems in Children, *The American Journal of Orthopsychiatry* 7(3): 283-300, 1937.

Benesch, Friedrich, and Wilde, Klaus. *Silica, Calcium, and Clay: Processes in Mineral, Plant and Man*. Schaumberg, Illinois: Schaumberg Publications, 1995.

Brown, E. Developmental Characteristics of Clay Figures Made by Children: 1970 to 1981. *Studies in Art Education* 26(1): 56-60, 1984.

Clausen, Anke, and Riedel, Martin. *Plastisches Gestalten* (Sculptural Forming). Stuttgart: Mellinger Verlag, 1985. [Profusely illustrated.]

_____. *Plastisches Gestalten mit Holz* (Sculptural Forming with Wood). Stuttgart: Mellinger Verlag, 1985. [Profusely illustrated.]

Clough, P. *Clay in the Classroom*. Worcester, MA: Davis Publications,1996.

Davis, R. *The Gift of Dyslexia*. New York: Berkeley Publishing, 1997.

Dewey, J. *Art as Experience*. New York: Putnam, 1958.

Doczi, Gyorgi. *The Power of Limits: Proportional Harmonies in Nature, Art and Architecture*. Boulder: Shambala, 1981. (On the Golden Ratio or Divine Proportion.)

Ege, Arvia MacKaye. The Human Hand: its Activities and Role in Education, in *Education as an Art* (Journal of AWSNA), no date or volume. Available from the Rudolf Steiner Lending Library, 65 Fern Rd., Ghent, NY 12075, 518-672-7690, rudolfsteinerlibrary@taconic.net

Elwell, E. Clay Modeling, *Child and Man Extracts*. Forest Row, England: Steiner Schools Fellowship, 1975

Feininger, Andreas. *Roots of Art*. New York: Viking, 1975. [Photos of nature forms.]

Gardner, H. *Art, Mind, and Brain: A Cognitive Approach to Creativity*. New York: Basic Books, Inc., 1982.

_____. *Frames of Mind: The Theory of Multiple Intelligences*. New York: Basic Books, Inc., 1985.

Glas, Norbert. *Die Haende Offenbaren den Menschen* (Hands Reveal the Human Being). Stuttgart: Mellinger Verlag, 1994.

Golomb, C. *Young Children's Sculpture and Drawing: A Study in Representational Development*. San Diego: Knapp, 1968.

_____, and McCormick, M. Sculpture: The Development of Three-Dimensional Representation in Clay. *Visual Arts Research*, 1995, 35-49

Gross, Anna-Sophie. The Idea of Metamorphosis in the Sculptural Modeling Lessons in the Waldorf School. In Martin, Michael, editor, *Educating through Arts and Crafts*. Forest Row, England: Steiner Schools Fellowship, 1999.

Haebler, Martha. The Perfection of the Human Hand Lies in its Imperfection, in Pusch, Ruth, editor, *Waldorf Schools*, Vol. I , Spring Valley, N.Y.: Mercury Press, 1993.

Harter, Jim. *Animals: A Pictorial Archive*. New York: Dover, 1979.

Hauck, Hedwig. *Handwork*. Forest Row: Steiner Schools Fellowship Publishing.

Haushka, Rudolf. *The Nature of Substance*. London:Vincent Stuart Ltd., 1950. Available from the Rudolf Steiner Lending Library, 65 Fern Rd., Ghent, NY 12075, 518-672-7690, rudolfsteinerlibrary@taconic.net

Hawkinson, J. *A Ball of Clay*. Chicago: Albert Whitman, 1974.

Heckmann, Hella. Imagination Surpasses Reality in *The Garden Gate: Newsletter of the Keene Lifeways Project*. Winter 2000, 1(2). 6-7.

Heydebrand, Caroline. *The Child at Play*. Stuttgart: Waldorfschul-spielzeug Verlag, no date. Available from the Rudolf Steiner Lending Library, 65 Fern Rd., Ghent, NY 12075, 518-672-7690, rudolfsteinerlibrary@taconic.net

Huber, Hanne. *Gestalten mit Bienwachs im Vorschulalter* (Beeswax Modeling in Preschool), Stuttgart: Verlag Freies Geistesleben, 2001.

Husemann, A.*The Harmony of the Human Body: Musical Principles in Human Physiology*. Edinburgh: Floris Books, 1989.

Kiersch, Johannes. *Foreign Language Teaching in Steiner/Waldorf Schools*. Forest Row, England: Steiner Schools Fellowship and AWSNA Books, 1997.

Klein, Elisabeth. Modeling as the Expression of the Child's Inner Being. In Pusch, Ruth, editor. *Waldorf Schools*, Vol.I. Spring Valley, NY: Mercury Press, 1996.

Langstaff, N., and Sproul, A. *Exploring With Clay*. Washington, DC: Association for Childhood Education International,1979.

Lissau, Magda. *The Temperaments and the Arts*. Chicago:privately published, no date. Available from the Rudolf Steiner Lending Library, 65 Fern Rd., Ghent, NY 12075, 518-672-7690, rudolfsteinerlibrary@taconic.net

Loewe, Hella. Plastizieren in der Unterstufe, [Modeling in the Lower Grades.] in *Rundbrief* des Bundes der deutschen Waldorfschulen, December, 2000.

Lowenfeld, V. *Creative and Mental Growth*. New York: MacMillan,1995.

Mann, William. Modeling, in *Child and Man Extracts*. Forest Row, England: Steiner Schools Fellowship, 1975. Available from the Rudolf Steiner Lending Library, 65 Fern Rd., Ghent, NY 12075, 518-672-7690, rudolfsteinerlibrary@taconic.net.

Martin, Michael. *Leben mit Formen in Kunst und Natur* (Living with Forms in Art and Nature). Stuttgart: Verlag Freies Geistesleben, 2000.

_____. Some Thoughts Concerning the Methods in the Formative Lessons. In Martin, Michael, editor, *Educating through Arts and Crafts*, Steiner Schools Fellowship, Forest Row, England, 1999.

Mitchell, David, and Livingston, Patricia. *Will-Developed Intelligence*. Fair Oaks, CA: AWSNA Publications, 1999.

Niederhauser, Hans, and Frohlich, Margaret. *Form Drawing*. New York: Mercury Press, 1974.

Piaget, J., and Inhelder, B. *The Child's Conception of Space*. London: Routledge and Kegan Ltd.,1956.

Rawson, Martyn, and Richter, Tobias, editors. *The Educational Tasks and Content of the Steiner/Waldorf Curriculum*, Forest Row, England: Steiner Schools Fellowship, 2000.

Read, H. *The Art of Sculpture*. (2nd edition). New York: Bollingen Foundation,1961.

Rottger, E. *Creative Clay Design*. New York: Van Nostrand, 1962.

Sapiro, M. *Clay: Hand Building*. Worcester, MA: Davis Publications, 1979.

Scherer, Margaret, editor. How the Brain Learns. *Educational Leadership*, 56(3), 1998.

Schwenk, Theodor. *Sensitive Chaos*. London: Rudolf Steiner Press, 1965.

Schubert, Ernst, and Embrey-Stine, Laura. *Form Drawing: Grades One Through Four*. Fair Oaks, CA: Rudolf Steiner College Press, 1999.

Smilansky, S., Hagan, J.,& Lewis, H.*Clay in the Classroom. New* York and London: Teachers College Press. 1988

Sobel, D. *Children's Special Places*. Tucson: Zephyr Press, 1993.

Steiner, Rudolf. *Child's Changing Consciousness*. New York: Anthroposophic Press, 1988 (Reprint).

_____. *The Arts and their Mission*. New York: Anhroposophic Press, 1964 .

_____. *Bees*. New York: Anthroposophic Press, 1998.

_____. *Der Dornacher Bau* (The Dornach Building). Stuttgart: Verlag Freies Geistesleben, 1966.

_____. *Discussions with Teachers* (including *Three Lectures on the Curriculum*) New York: Anthroposophic Press, 1997(Reprint).

_____. *Education for Adolescence*. New York: Anthroposophic Press, 1996 (Reprint).

_____. *The Education of the Child*. New York: Anthroposophic Press, 1996 (Reprint).

_____. *Essentials of Education*, New York: Anthroposophic Press, 1997(Reprint).

_____. *Faculty Meetings*, Vols.1-2. New York: Anthroposophic Press, 1998 (Reprint).

_____. *Foundations of Human Experience*. New York: Anthroposophic Press, 1996 (Reprint).

_____. *Human Values in Education.* London: Rudolf Steiner Press, 1971 (Reprint).

_____. *The Kingdom of Childhood.* New York: Anthroposophic Press,1999 (Reprint).

_____. *Kunst and Kunsterkennnis* Dornach, Switzerland: Verlag der Rudolf Steiner- Nachlassverwaltung, 1961.

_____. *Man as Symphony of the Creative Word.* London: Rudolf Steiner Press, 1991(Reprint).

_____. *A Modern Art of Education.* New York: Anthroposophic Press, 1999.

_____. *Practical Advice to Teachers.* New York: Anthroposophic Press, 1999 (Reprint).

_____. *Renewal of Education.* Forest Row, England: Steiner Schools Fellowship, 1989.

_____. *Roots of Education.* New York: Anthroposophic Press, 1997 (Reprint).

_____. *Soul Economy and Waldorf Education.* New York: Anthroposophic Press, 1986.

_____. *Waldorf Education and Anthroposophy,* Vol.II. New York: Anthroposophic Press, 1996 (Reprint).

_____. *Ways to a New Style in Architecture.* London: Anthroposophical Publishing House, 1927.

Stockmeyer, Karl. *Rudolf Steiner's Curriculum for Waldorf Schools.* Forest Row, England: Steiner Schools Fellowship, 1965.

Stolfo, Patrick. Sculpture in the Waldorf Curriculum, in *Renewal: Journal for Waldorf Education,* Spring/Summer, 1995.

Strauss, Michaela. *Understanding Children's Drawings.* London: Rudolf Steiner Press, 1988.

Topal, C. *Children, Clay and Sculpture.* Worcester, MA: Davis Publications, 1983.

Wigg, Phillip, and Hasselschwert, Jean. *A Handbook of Arts and Crafts.* Boston: McGraw-Hill, 2001.

Wilson, Frank R. *The Hand: How It Shapes the Brain, Language and Culture.* New York: Pantheon Books, 1998.

_____. The Real Meaning of Hands-On Education.*Waldorf Education Research Bulletin,* January 2000, V (1), 2-14.

Stories to Light up the Imagination

Learning to Tell Stories

Mellon, Nancy. *Storytelling and the Art of Imagination. Rockport*, MA: Element, 1992.

Mellon, Nancy. *Storytelling with Children*. New York: Anthroposophic press, 2001.

Ages 6-7

Afanasev, Alexander. *Russian Fairy Tales*. New York: Pantheon, 1975.

Cole, Joanna, editor. *Best Loved Folk Tales of the World*. New York: Doubleday, 1982.

The Complete Grimm's Fairy Tales. New York: Pantheon, 1972.

Poulsson, Emile. *Finger Plays for Nursery and Kindergarten*. New York: Dover.

Yolen, Jane, editor. *Favorite Folktales from Around the World*. New York: Pantheon, 1986.

Ages 7-8

*Aesop's Fables.*New York: Avenel, 1912 Facsimile Edition.

Knijpenga, Siegwart. *Stories of the Saints*. Edinburgh: Floris Books, 1993.

Streit, Jakob. *Animal Stories*. Dornach, Switzerland: Walter Keller Press, 1974.

Synge, Ursula. *The Giant at the Ford and Other Legends of the Saints*. New York: Atheneum, 1980.

Ages 8-9

Erdoes, Richard. *American Indian Myths and Legends*. New York: Pantheon, 1984.

Holling C. Hollings. *Book of Indians*. New York: Platt and Munk, 1935.

Spence, Lewis. *North American Indians: Myths and Legends*. New York: Avenel Books, 1985.

Streit, Jakob. *And There Was Light: From the Creation of the World to Noah's Ark*. Dornach, Switzerland: Walter Keller Press, 1976.

_____. *Journey into the Promised Land*. Fair Oaks, CA: AWSNA Publications,

1999.

Ages 9-10

Burton, Robert. *Egg: A Photographic Story of Hatching*. London: DK Publishing, 1994.

D'Aulaire, Ingri, and D'Aulaire, Edgar. *Norse Gods and Giants*. New York: Doubleday, 1967.

Green, Roger. *Myths of the Norsemen*. New York: Puffin Books, 1988.

Ages 10-11

Bryson, Bernarda. *Gilgamesh*. New York: Holt, Rinehart and Winston. No year.

D'Aulaire, Ingri, and D'Aulaire, Edgar. *Book of Greek Myths*, New York: Doubleday, 1962.

Green, Roger. *Tales of Ancient Egypt*. New York: : Puffin Books, 1979.

Grohmann, Gerbert, *The Living World of Plants*. Fair Oaks, CA: AWSNA Publications, 1967.

Harrer, Dorothy. *Chapters from Ancient History*. New York: Mercury Press, 1998.

Kovacs, Charles. *Ancient Mythologies: India, Persia, Babylon, Egypt*. Stourbridge, England: Wynstones Press, 1999.

Ages 11-12

Harrer, Dorothy. *Roman Lives in Biographic Vein*. New York: Mercury Press, 1998.

Hartmann, Gertude. *Medieval Days and Ways*. New York: MacMillan, 1956.

MacDonald, Fiona. *A Medieval Castle*. New York: Bedrick Books, 1990.

Ages 12-13

Blisset, Rose. *Stories from Africa: Tsie Na Atsie*. London: Temple Lodge, 1993.

Staley, Betty. *Hear the Voice of the Griot! A Guide to African Geography, History, and Culture*. Fair Oaks, CA: Rudolf Steiner College Press, no date. Available from the Rudolf Steiner Lending Library, 65 Fern Rd., Ghent, NY 12075, 518-672-7690, rudolfsteiner library@taconic.net.

Ages 13-14

Kretz, Harry. *Solid Geometry for the 8th Grade.* Fair Oaks, CA: AWSNA Publications, 2000.

Mees, L.F.C. *Secrets of the Skeleton: Form in Metamorphosis.* New York: Anthroposophic Press, 1984.

Parker, Steve. *Skeleton.* New York: Knopf, 1988.

SEND IDEAS AND COMMENTS

In anticipation of a possible future revision, I welcome readers to send me comments and suggestions about the book (how you have used it, what could be more clearly described, etc.). In addition, you may also submit clearly explained modeling ideas, subjects, methods, and sources that have worked for you and for what ages. These could possibly be included in a future edition. It would be very helpful if ideas could be illustrated with sketches when appropriate. I reserve the right to choose what is included.

Materials may be e-mailed to me at:
arthurauer@tellink.net or aauer@antiochne.edu
or
mailed to me at 53 Old Temple Road, Lyndeborough, NH 03082

Made in United States
Orlando, FL
28 February 2023

30482704R00128